BLANTON MUSEUM OF ART
GUIDE TO THE COLLECTION

BLANTON MUSEUM OF ART

THE UNIVERSITY OF TEXAS AT AUSTIN

© 2006 Blanton Museum of Art

Published by the Blanton Museum of Art, The University of Texas at Austin

Library of Congress Control Number: 2005936150
ISBN: 0-9771453-2-8

Front cover: Simon Vouet, *Saint Cecilia*, c. 1626, oil on canvas

Managing editor: Sheree Scarborough
Photography: Rick Hall, pp. 14–253; Marsha Miller, pp. 6, 8
Designer: Zach Hooker
Copyeditors: Polly Koch and Chris Keledjian
Proofreader: Sherri Schultz
Separations by iocolor, Seattle
Produced by Marquand Books, Inc., Seattle
 www.marquand.com
Printed and bound by CS Graphics Pte., Ltd., Singapore

CONTENTS

PREFACE

Every great university should have a great art museum.

For forty years, in various locales around our campus, The University of Texas has exhibited, stored, and preserved the distinctive, highly regarded art collections that have come to us through generous patrons and collectors. The collections range in scope from the Renaissance and Baroque periods to contemporary American and Latin American artwork by living, working artists. This body of artistic expression serves as an excellent teaching tool for students and as a rare source of knowledge for scholars. But our collections have long needed a single, central place that would exhibit them gracefully and with purpose, preserve their value for the ages, and share their rich legacy with students, scholars, schoolchildren, and the general public.

A personal connection to the visual arts and a fundamental recognition of art history are as essential to education as the study of sciences, literature, and languages. Art captures the ethos of its time, revealing creative genius, inspiring awe and wonder, and elevating the human spirit. Through its now unified collections, exhibitions, and educational programs, the new Blanton Museum of Art provides an elegant space for visitors and the university community to discover and experience the visual arts.

The Blanton Museum's prominent location, at the intersection of Congress Avenue and Martin Luther King Jr. Boulevard, creates an inviting and aesthetic gateway to The University of Texas campus. In addition, the new Education and Visitor Pavilion, available for classroom use and public lectures, will significantly enhance the university's mission to educate and serve the people of Texas. And as a neighbor to the Bob Bullock Texas State History Museum, the Blanton works in tandem to form a new museum district for visitors to Austin. This gives the public an opportunity to enjoy the treasures of Texas history, and then to cross the street to view centuries of world-renowned artworks from Europe, the United States, and Latin America.

The outstanding collections in the Blanton Museum of Art connect us all—from the very youngest to the most seasoned museumgoers—to the long march of ideas, beliefs, passions, and cultural distinctions as they have been represented in various media, by numerous artists, over hundreds of years. And in doing so, the Blanton adds a vital dimension to The University of Texas at Austin, making us a stronger, more responsive academic institution, better able to teach, to serve, and to inspire generations who will visit our marvelous museum.

Larry R. Faulkner, President, 1998–2006
The University of Texas at Austin

INTRODUCTION

Our selection of *Saint Cecilia* as the cover image of this new guide to the collections of the Blanton Museum of Art came after much deliberation. The process of boiling down all of our riches to a single iconic image is always difficult, like asking a parent to single out one especially talented and beautiful child without seeming to slight all of her siblings.

At the end of our deliberations, however, we realized that Simon Vouet's seventeenth-century masterpiece—rooted though it is in its own time and place—is a perfect representative of the dynamic and thoroughly contemporary institution that is the new Blanton Museum of Art. Long identified in church tradition as the patron saint of music, Cecilia continues to stand for artistic inspiration. Hers is a welcoming image for artists, students, and all who are engaged in creative pursuits. Enter these pages, enter this museum, she seems to say, and you will be inspired by a glorious and multifaceted visual experience.

At the Blanton, that experience is rooted in our extraordinary collections, which carry the visitor across time and space and ideas, from the world of Renaissance and Baroque Europe, through the heady artistic revolutions of twentieth-century America and Latin America, and on into the increasingly intertwined culture of these worlds in the century that has just begun.

We are pleased to present highlights of the collection in this volume. It is published just as the Mari and James A. Michener Gallery Building opens, the first of two that will comprise the new Blanton. For the first time in our forty-two-year history, we are now able to show the collections together, under one roof, in a magnificent setting designed just for them.

Background of the Blanton Museum of Art

The art museum of The University of Texas at Austin was born of a generous gift from an unexpected source. In 1927 Archer M. Huntington, a New Yorker and the son of railroad magnate Collis P. Huntington, donated four thousand acres of land in Galveston, Texas, to the university with instructions that it "be dedicated to the support of an art museum." His interest seems to have stemmed from the fact that his wife, Anna Hyatt Huntington, was a noted sculptor; indeed two of her works had recently been given to the university. The proceeds from the eventual sale of that land created an endowment for museum operations and provided a portion of the cost for the construction in 1963 of a new building for the art department of the university, including some gallery space that was formally named the University Art Museum.

A number of important collecting areas quickly took shape during the 1960s and 1970s. One well-known acquisition began with the gift in 1968, continuing into the early 1990s, of approximately four hundred twentieth-century American paintings from novelist James Michener and his wife, Mari, for whom the Blanton's new gallery building is named. The Micheners' interest

in collecting the art of their time and in supporting the work of emerging artists continues to be an important guiding principle for ongoing development of our contemporary collections.

The museum's distinctive collection of Latin American art was greatly enriched, beginning in 1971, with the donation of some two hundred paintings and 1,200 drawings from the collection of John and Barbara Duncan. The Blanton's early leadership in this field, which is only now being accorded the importance it deserves by the museum world at large, is owing to the Duncans' visionary gift.

Other notable early gifts included the C. R. Smith Collection of Paintings of the American West, given over a period of years between 1965 and 1985, and a donation in 1968 by Charles Clark of McAllen, Texas, of nearly one thousand contemporary prints.

By 1972 the museum was bursting at the seams. Greatly expanded by the generous Michener gift, the permanent collection moved to gallery spaces in the Harry Ransom Humanities Research Center, while the Print Study Room and galleries for temporary exhibitions remained in the Art Building.

In 1980 the University Art Museum was renamed the Archer M. Huntington Gallery, and a decade of growth followed, including the acquisition of a number of fine antiquities and a small number of Old Master works and contemporary American paintings. This period also saw rapid growth in the prints and drawings collection at the Blanton. Now widely recognized for its breadth and depth, that collection is considered one of the finest in the nation.

With continuing growth came the vision of an expanded home for the Huntington. In late 1994 a bequest of $5 million by Mari Michener for the construction of a new museum building lent momentum to a building campaign. When Houston Endowment Inc. stepped forward in 1997 with a $12 million building gift in honor of its former chairman, the Huntington became the Jack S. Blanton Museum of Art.

The growth and character of the collections took a dramatic turn in 1998 with the important acquisition of the Suida-Manning Collection, which was made possible through the generosity of numerous individuals. Assembled by two generations of art historians, the collection is one of the nation's preeminent collections of Renaissance and Baroque art. It features 230 paintings and four hundred drawings by many significant painters and draftsmen. Almost overnight, the Blanton's Old Master holdings multiplied from around thirty works to one of the finest such collections in the nation.

The American and Latin American collections have similarly been expanding at a rapid pace. Today the Blanton's collection of modern and contemporary American art is a significant resource of more than four thousand paintings, prints, drawings, sculptures, and works in new media from the mid-nineteenth century to the present.

The Latin American collection of modern and contemporary art now contains more than 1,800 modern and contemporary paintings, prints, drawings, and sculptures, reflecting the great diversity of Latin American art and culture. More than six hundred artists from Mexico, South and Central America, and the Caribbean are represented in the collection.

All told, the Blanton collection today numbers more than 17,000 works, four thousand of which have been added in the last five years. Noted art historian and critic Leo Steinberg donated his impressive, encyclopedic collection of 3,200 prints in 2002, at once acknowledging and enhancing the distinguished reputation of the Blanton's prints and drawings. We take enormous pride in the great depth we have achieved by concentrating our collecting efforts on works from specific periods, movements, and artists. This approach to acquiring works creates significant opportunities for teaching, in-depth scholarship, and educational programs.

The long-held vision of a new museum building became a reality with the groundbreaking for a new facility in October 2003. The new complex, designed by Kallmann McKinnell & Wood Architects, will comprise the Mari and James A. Michener Gallery Building, a 124,000-square-foot space that will house the permanent collection and temporary exhibitions; a 56,000-square-foot Education and Visitor Pavilion that will feature a café, museum shop, classrooms, auditorium, and offices; and a 145,000-square-foot public plaza and garden designed by Peter Walker and Partners.

As the only art museum in Austin with a permanent collection of substantial range and depth, the Blanton has embraced a mission of serving as a "cultural gateway" between the university and the community. In our new home, with its rich and versatile collections, magnificent galleries, flexible programming spaces, and an enthusiastic and committed group of staff and volunteers, the museum will at last be able to live this mission fully.

ACKNOWLEDGMENTS

Preparation of this guide has been the work of many hands. I thank Ed Marquand of Marquand Books, and his talented and patient staff, for their assistance in compilation, design, and production. Thanks are also due associate director Ann Hume Wilson, Sheree Scarborough and Brady Dyer of our public relations and marketing department, and editorial consultants Polly Koch and Chris Keledjian for their meticulous editing. Blanton photographer Rick Hall and registrar Sue Ellen Jeffers spent many hours completing necessary photography.

Jonathan Bober, curator of prints, drawings, and European paintings; Annette DiMeo Carlozzi, curator of American and contemporary art; and Gabriel Pérez-Barreiro, curator of Latin American art, collaborated beautifully to ensure the right balance from across all areas of the collection. They spent hours writing and editing, ably supported by their respective

assistant curators Cheryl Snay, Kelly Baum, and Cecilia Brunson, as well as staff Rebekah Morin and Courtney Gilbert. I continue to be grateful for the tremendous commitment, singular intellectual gifts, and extraordinary collegiality of our superb curators.

The Blanton acknowledges with gratitude the generous support of Christie's in making this publication possible.

Finally, I would like to offer special thanks to Larry Faulkner, whose long and distinguished term as president of The University of Texas at Austin comes to a close just as we publish this book, open the first of the two buildings that will comprise the new Blanton Museum of Art, and thus enter this significant new phase in our institution's history. President Faulkner's vision for the university has been one of constantly widened horizons and ever greater achievements, and the growth of our collections and the construction of our magnificent new home would not have happened without his determined and enthusiastic leadership. The Blanton Museum of Art gratefully dedicates this handbook to him.

Jessie Otto Hite, Director

EUROPEAN ART

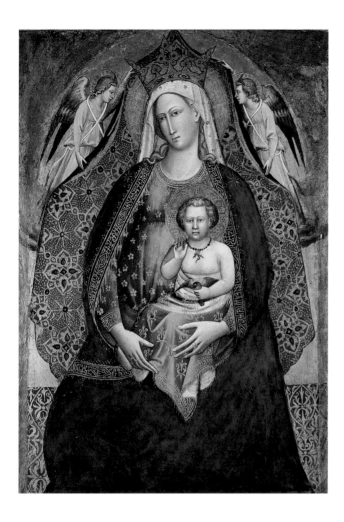

Giovanni di Marco, called GIOVANNI DAL PONTE

Florence, 1385–1437

Madonna and Child with Angels, 1410s

Tempera and tooled gold leaf on panel; 34¾ × 22¾ in.
(88.3 × 57.8 cm); Bequest of Jack G. Taylor, 1991; 1991.101

THE ICONOGRAPHY AND TECHNIQUE of this
panel are medieval. Set against a cloth of honor
held by angels and wearing a crown, the Virgin
appears as Queen of Heaven. This is also implied
by her seated position; before it was cut along the
bottom edge, the panel may have shown the step
of a throne. Christ's erect posture and gesture of
benediction signal his theological identity as the
New Church, while his finch and strand of coral
symbolize the Passion, fate of his human incar-
nation. The exposed upper corners prove that
the panel originally had an attached gilt frame.
In a typical arrangement, the painting would have
been the central image of a many staged altar-
piece, with panels of saints to either side.

If the austere composition and bold shapes
hark back to early Florentine painting and the
work of Giotto, a pronounced stylization and a
remote feeling reflect intervening developments in
the later fourteenth century. At the same time, the
intricate ornamentation, the curvilinear rhythm
in the Child's cloth and the Virgin's hem, and even
the hint of graduated modeling in their flesh are
evident responses to the extreme refinement and
incipient realism of International Style painting.
The work of a conservative master, in beautiful
condition, the painting sums up currents in Floren-
tine painting on the eve of the Renaissance.

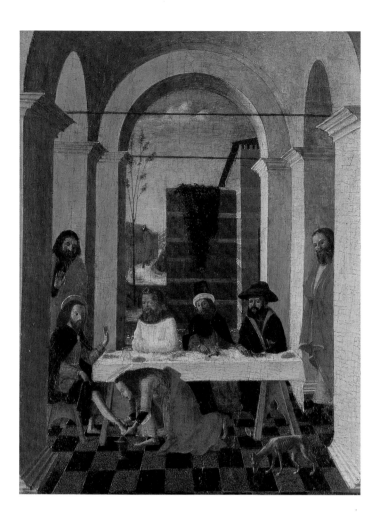

BERNARDO BUTINONE

Treviglio (Bergamo), Italy, before 1453–1528

The Supper at Bethany, 1490s

Tempera on panel; 10 × 8¹⁄₁₆ in. (25.4 × 20.5 cm); The Suida-Manning Collection, 1999; 71.1999

COMING TO THE TOWN OF BETHANY, Christ and his disciples were served supper in the house of Lazarus. When Mary Magdalene anointed Christ's feet with costly ointment, Judas objected that the substance should instead be sold to help the poor (John 12:1–8). With these prefigurations of the Entombment and the Betrayal, this panel belongs to a series of fifteen scenes from the life of Christ that are scattered in public and private collections. These panels and others since lost probably constituted an altarpiece for private devotion, with the images arranged and read sequentially like those in a monumental fresco cycle.

Bernardo Butinone and his frequent collabo-rator Bernardo Zenale were leading painters in late fifteenth-century Milan. Basically conservative, their works tend to be anecdotal in description and decorative in effect. They do, however, incorporate some of the most advanced developments of the Po Valley: rigorous perspectival construction derived from Andrea Mantegna and, in Butinone's case, the eccentric types and lively characterization of contemporary Ferrarese painting. The miniature panels of the life of Christ are close in style to the *predelle* panels—the small, secondary narrative scenes—in Butinone and Zenale's most celebrated project, the so-called Golden Altarpiece begun in 1485 for their native town.

William Suida was a pioneering scholar of Milanese painting of the Renaissance. *The Supper at Bethany* is one of the seven paintings of the school that come from his collection.

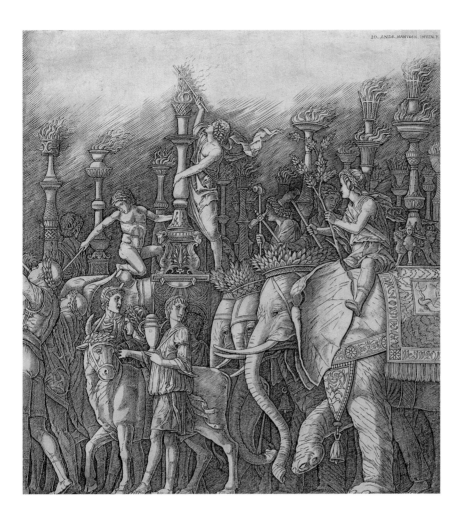

GIOVANNI ANTONIO DA BRESCIA

Brescia (?), Italy, c. 1460–Rome (?), c. 1525

The Triumph of Caesar: The Elephants, c. 1500,
after Andrea Mantegna

Engraving, Bartsch 8, Hind 14a, only state; Sheet: 11¼ × 10½ in.
(28.5 × 26.6 cm); Archer M. Huntington Museum Fund, 1987;
1987.47

ONE OF THE GENIUSES of the Renaissance,
Andrea Mantegna brought Florentine inventions
to north Italy and laid the foundation for develop-
ments across the Po Valley and in Venice. From
the outset his work was demanding in concept
and incomparable in technique. During long ser-
vice to the Gonzaga family at Mantua, he realized
projects of unprecedented intellectual, archaeo-
logical, and pictorial ambition. That Mantegna's
achievements had such influence is due also to his
pioneering efforts in another sphere, the use of
engraving to disseminate artistic ideas and fame.

This engraving pertains to a famous project
for the Gonzagas, *The Triumph of Caesar*. Exe-
cuted between 1486 and 1494, the series of eleven
canvases was based upon ancient descriptions of
victorious Roman processions and inspired by the
monumental reliefs the artist saw on an interven-
ing visit to Rome. Furthering the dynastic propa-
ganda and satisfying curiosity about the project,
Mantegna directed the engraving of three alterna-
tive drawings for the series. There are seven ver-
sions by three different printmakers, with those
of Giovanni Antonio da Brescia the most refined
and regular. All adhere to Mantegna's own system
of engraving, close in style to his drawing. Their
delicate and dense hatching wore rapidly in print-
ing. This is an unusually fine, early impression,
capturing the master's subtlety and the intended
effect of relief sculpture.

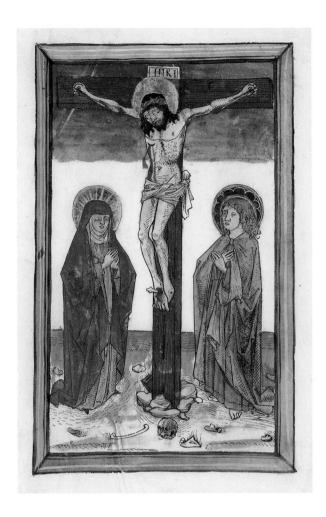

Anonymous German (Bamberg and Regensburg)

Christ on the Cross between the Virgin and Saint John (Canon Crucifixion), before 1485

Woodcut with hand coloring, gilding, and silvering on vellum, Schreiber 375, only state; Image: 11⁷⁄₁₆ × 7¼ in. (29 × 18.4 cm); Sheet: 14⅝ × 9³⁄₁₆ in. (37.2 × 23.4 cm); Purchase through the generosity of the Still Water Foundation, and the Archer M. Huntington Museum Fund, by exchange, 1996; 1996.171

THIS, THE CENTRAL IMAGE of the Christian faith, commonly appeared before the Canon of the Mass in medieval manuscript missals, the books containing all that is said or sung at mass during the entire year. As these were replaced by printed volumes in the second half of the fifteenth century, the *Kanonbild*, or Canon Crucifixion, was translated into woodcut, printed separately, then pasted into the volumes or sold as an independent devotional image. This particular version appears in missals published by Johann Sensenschmidt with various partners in Bamberg and Regensburg between 1485 and 1492. The museum's impression was printed on vellum, colored by hand, and gilded and silvered in the halos in order to imitate the appearance of a manuscript leaf. There are three other such deluxe impressions in the United States. Deeply conservative in function and materials, they are excellent examples of the relationship between the manuscript tradition and early prints, especially in northern Europe. At the same time, amid the explosion of book illustration in the late fifteenth century, *Kanonbilder* were much larger in size, more articulate in cutting, and more expressive—note the body of Christ—than the typical product of the day. Within a decade, Albrecht Dürer would introduce virtuoso artistic woodcuts. The *Kanonbilder* point in their direction and help explain their origin.

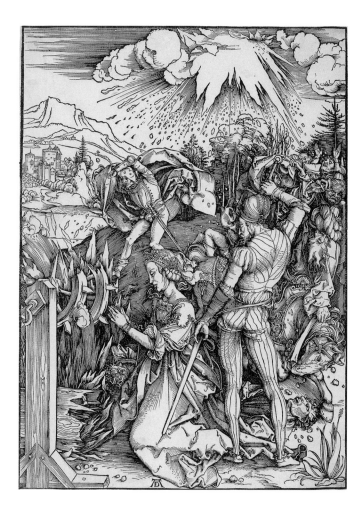

ALBRECHT DÜRER

Nuremberg, Germany, 1471–1528

The Martyrdom of Saint Catherine,
c. 1497–1498

Woodcut, Bartsch 120, Meder 236, state a–b of g; Sheet:
15⅜ × 11⁵⁄₁₆ in. (39 × 28.7 cm); Purchase through the
generosity of the Still Water Foundation, 1995; 1995.36

AMID WORK ON HIS two earliest series, the *Apocalypse* and the so-called *Great Passion*, Albrecht Dürer created a number of individual woodcuts of the same large size and style. One of these prints, *The Martyrdom of Saint Catherine*, combines the stages of the saint's execution: a first attempt upon a spiked wheel, its thwarting by divine intervention, and a second, successful attempt at the hand of a swordsman. Dürer crowded the composition with an extraordinary amount of information; missed no opportunity for conspicuous invention,

from the exploding heavens to the splendid executioner; and boasted an unprecedented variety of mark and complexity of effect.

Prior to Dürer's activity, woodcut had been bound by simple conventions and popular functions. Flush with creative as well as commercial ambition, the young artist applied his singular imagination and audacious skill to the technique, single-handedly elevating it to the level of a high and personally expressive art. The success of such woodcuts spread Dürer's compositions and fame across Europe. Later he would explore other possibilities of the technique, first more pictorial, then also schematic, finally more abstract. These would dominate sixteenth-century production and, long after woodcut had returned to its basic tendencies and associations, remain the measure of artistic achievement in the technique.

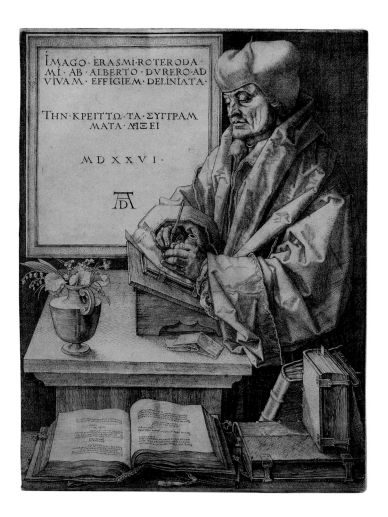

ALBRECHT DÜRER

Nuremberg, Germany, 1471–1528

Erasmus of Rotterdam, 1526

Engraving, Bartsch 107, Meder 105, state a of i; Sheet: 10 × 7¹¹/₁₆ in. (25.4 × 19.5 cm); Purchase through the generosity of the Still Water Foundation, 1991; 1991.114

PORTRAIT ENGRAVING WAS a significant aspect of Albrecht Dürer's late activity. His portrait of the great humanist Desiderius Erasmus is his largest and most complex. Dürer had drawn the sitter on a visit to the Netherlands in 1520. By 1525 Erasmus lamented that he had still not seen the promised print. Returning to the project, Dürer borrowed the composition from a painting of Erasmus by Quentin Massys (Louvre, Paris) and inserted his earlier bust-length study. Seeing the engraving, Erasmus noted that the likeness was "not altogether striking." Later observers have often criticized the composition as awkward. Dürer's technique, however, rises to a level of differentiation unusual in the late engravings. In their focus and conspicuous detail, numerous passages approach still-life. The light has a pervasiveness and a mystery that suggest both the scholar's theological concerns and the artist's own late spirituality. Then there is the conceit of the frame in the background, rhyming with the print's shape, shedding light like a window but instead bearing inscriptions. The first, in Latin, identifies the artist and the sitter. The second, in Greek, notes, "His writings offer a better likeness." These inscriptions may refer to the circumstances of the engraving's creation. In any case, the portrait becomes an extraordinarily modern meditation upon the nature and limits of visual representation.

HEINRICH ALDEGREVER

Paderborn, Germany, 1502–Soest (Westphalia), Germany, c. 1561

Marcus Curtius, 1532

Engraving, Bartsch, Hollstein 68, only state; Sheet: 6 × 4³⁄₁₆ in. (15.3 × 10.6 cm); The Leo Steinberg Collection, 2002; 2002.757

THE ANCIENT ROMAN HISTORIAN Livy recounts the legend of the soldier Marcus Curtius. When a chasm opened in the Forum, an oracle said that it could be filled only with the city's greatest treasure. Believing this to be valor, Curtius leaped on horseback into the chasm, which then closed. The legend explained a pond once visible in the Forum and epitomized Roman civic virtue, which was a frequent subject during the Renaissance. Here, the antique flavor is intensified by the group of female nudes with affected postures and a plasticity worthy of statuary.

Heinrich Aldegrever was one of the so-called Little Masters who dominated printmaking in Nuremberg in the wake of Albrecht Dürer. Inspired by the style and success of the master's engravings, they specialized in miniature work of humanistic subject and superb craft. Their engravings demonstrate the technique's traditional relation to goldsmithing, tendency toward precision, and inherent preciousness. They were intended for collectors for whom such material properties made them desirable objects. Its subject and extraordinary quality make this impression a superb example.

The museum possesses an excellent group of work by the Little Masters, with sixteen by Aldegrever, thirty-eight by Hans Sebald Beham, and twenty by Georg Pencz, to name the principals.

Lucas van Leyden

Leiden, Netherlands, c. 1494–1533

Holy Family, c. 1508

Engraving, Bartsch, Hollstein 85, only state; Sheet: 7¾ × 5¾ in. (19.6 × 14.5 cm); Purchase with funds provided by M. K. Hage, Jr., Helen Lea, Marvin Vexler, '48, the Friends of the Archer M. Huntington Art Gallery, and the Dean's Associates of the College of Fine Arts, 1992; 1992.2

THIS IS A PERFECT EXAMPLE of the qualities that place Lucas van Leyden among the greatest engravers of the sixteenth century. Its lovely invention, the Holy Family sharing a bite on the outskirts of a town, blurs the boundaries between a traditional Rest on the Flight into Egypt and a generic devotional image. The observation of the world is searching and minute, like that of early Netherlandish painting. Tender, quietly absorbed, unassuming despite their bulk and rather heavy proportions, the figures and their interaction communicate a harmonious and intimate domesticity. In van Leyden's later development, the influence of Italian style would inhibit this whimsy and sincerity, which, undiluted in early works like this, lies at the root of Dutch realism.

Van Leyden's technique was just as singular in conception and nuanced in effect. His engraving tool, or burin, seems to have barely grazed the plate, leaving exceptionally shallow strokes that yield mere filament lines. Built in gossamer layers, his textures appear silken, light soft, tone silvery and almost continuous in gradation. Again, these properties are most pronounced in the early engravings and are evident in only the earliest impressions. These properties also indicate a distinctive source of van Leyden's style in the appearance of metalpoint drawing, as they point to tendencies of engraving in the north Netherlands through the century.

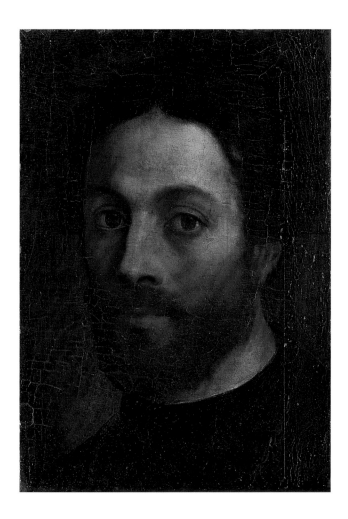

Sebastiano Luciani, called **Sebastiano del Piombo**

Venice, c. 1485–Rome, 1547

Portrait of a Man, c. 1516

Oil on wood panel; 14⅜ × 10³⁄₁₆ in. (36.5 × 25.9 cm); The Suida-Manning Collection, 1999; 524.1999

THIS SMALL PANEL is a fine example of High Renaissance painting. Its extraordinarily subtle light and graduated modeling tell of the artist's Venetian origins, specifically his training in Giorgione's workshop. The lucid geometry of the man's face and the regularity of its drawing are also based upon Giorgione's lessons, but they have been reinforced and refined by Sebastiano del Piombo's experience of the new classical style in Rome, to which he relocated in 1511. This arresting personality seems inspired by another aspect of that style: Raphael's human characterization. Coherent, utterly individual,

but also inflected toward an ideal type, his presence is the psychological equivalent of the painting's perfectly balanced forms.

Given the figure's contemporary dress, the dark green background, and above all the strong sense of presence, this representation is without doubt a portrait. The painting was not, however, originally of this format. Examination of the panel reveals that at some early stage it was cut down from a much larger composition and later, probably in the early twentieth century, balanced with the addition of a narrow strip along the right edge. Comparison with the proportions of other portraits by del Piombo suggest that the format would have been three-quarters length, very similar to that of the slightly later *Portrait of a Humanist* (National Gallery, Washington, D.C.).

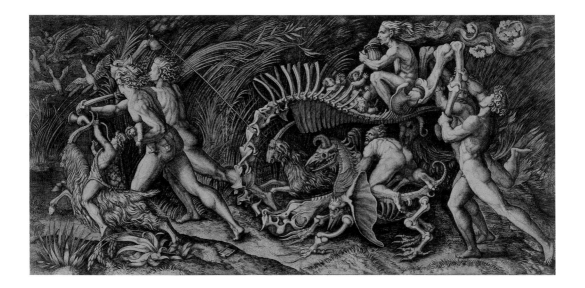

MARCANTONIO RAIMONDI

Argini (?) (Bologna), Italy, c. 1480–Bologna (?), Italy, c. 1534

Lo Stregozzo [The Witches' Procession],
c. 1518–1520, after Giulio Romano (?)

Engraving, Bartsch 426, first state of two; Sheet: 11¹³⁄₁₆ ×
24¹³⁄₁₆ in. (30 × 63 cm); The Leo Steinberg Collection, 2002;
2002.1676

IF HE DID NOT INVENT reproductive engraving, Marcantonio Raimondi was the first to develop it systematically. First active in Bologna, he went to Rome around 1510. There he entered a collaborative relationship with Raphael and dedicated himself to interpreting the master's designs. A prime manifestation of the new classical style, these engravings established the conventions and demonstrated the profitability of translating works of art into print. Through them Raphael's style became the coin and foundation of European art. And from them stems the tradition that would dominate engraving for nearly four centuries.

This is perhaps Raimondi's most intriguing print. It features a witch astride a giant animal's skeleton and conjures other elements associated with witchcraft. Whatever the meaning, there is no mistaking the extension of an archaeological spirit to fantastic lore. Especially coherent and warm, this impression underscores the reference to low-relief sculpture. Extravagant and stylized, the invention was likely owed to Raphael's principal assistant, Giulio Romano. The tremendous variety and responsiveness of stroke indicate that the engraving, sometimes attributed to Agostino Veneziano, is a late masterpiece of Raimondi.

The museum possesses seventy engravings by Raimondi and his principal assistants, Veneziano and Marco Dente.

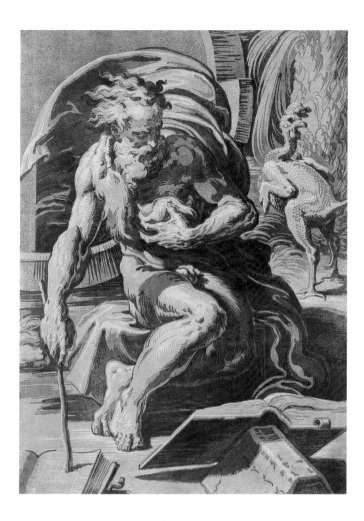

UGO DA CARPI

Carpi (Modena), Italy, c. 1480–Bologna (?), Italy, 1532

Diogenes, c. 1527–1530, after Parmigianino

Chiaroscuro woodcut from four blocks, Bartsch 10, Le Blanc 24, first state of two; Sheet: 18¾ × 13¾ in. (47.7 × 35 cm); Purchase through the generosity of Jill and Stephen Wilkinson, 2005; 2005.16

FROM THE MOMENT OF ITS CREATION, this has been the most celebrated woodcut of sixteenth-century Italy. Diogenes was the ancient Greek philosopher for whom the pursuit of virtue was the sole good. Here he appears as a heroic figure before the wooden barrel in which he lived, the billowing drape his only clothing and the plucked chicken a reference to his mocking of Plato's definition of man as "a featherless biped." Equally striking is the mastery of technique in which separate blocks were printed in successively darker tones to suggest modeling. In no work of the kind was the cutting more virtuoso, the printing better coordinated, or the scale more audacious.

Ugo da Carpi was the first and greatest master of chiaroscuro woodcut in Italy. Active in Venice as an illustrator, he learned the technique from the circulation of early German examples. Going to Rome in 1516, he turned to reproducing Raphael's drawings in brush and wash with white heightening. With its Michelangelesque form, suave rhythms, and improbable grace, *Diogenes* depends upon a lost drawing of Parmigianino's period in Rome. Surely it was the challenge of interpreting his difficult and utterly personal style that brought da Carpi to the unequaled heights of this print.

Diogenes was reprinted through the sixteenth century in various colors and with increasing coarseness. Extremely rare, the blue-green scheme and clarity of this impression correspond to the earliest printings.

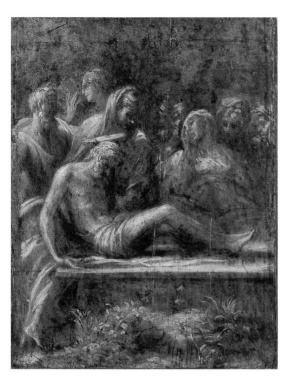
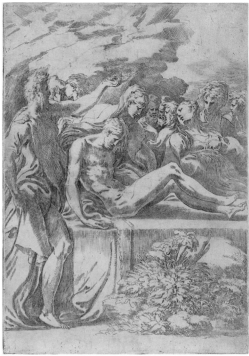

Francesco Mazzola, called **PARMIGIANINO**

Parma, Italy, 1503–Casalmaggiore (Cremona), Italy, 1540

The Entombment of Christ, c. 1525–1527

Oil on wood panel; 9⅝ × 7⅜ in. (24.4 × 18.8 cm); The Suida-Manning Collection, 1999; 390.1999

The Entombment of Christ, c. 1527–1530

Etching, Bartsch 5, first state of two; Sheet: 12¹⁵⁄₁₆ × 9⅜ in. (32.9 × 23.8 cm); Purchase through the generosity of Frank C. Guthrie, Carolyn Frost Keenan, and Isaac C. Kerridge, Jr., in honor of Ruth Stewart Kerridge, 1999; 1999.42

PARMIGIANINO was the most elegant and refined of all sixteenth-century Italian artists. Provincial but inspired by his visionary compatriot Correggio, he tended from the outset toward eccentric form and idiosyncratic expression. Affected by Raphael during a sojourn in Rome, his style became more self-conscious and rigorous. Increasingly abstracted and impossibly beautiful, Parmigianino's late works determined the course of Mannerism and remained the measure of high artifice through the eighteenth century. His etchings were the first to essay the technique's conceptual relation with drawing and potential for original expression.

This small panel is the most important surviving link between Parmigianino's painting and print-making. It was once regarded as a copy after his most developed and famous etching. The two compositions, however, differ in numerous details, and the elaboration of the panel departs from a loose underdrawing in dark pigment—indicative of an evolving rather than a derivative conception. The quality of the painting is confirmed by the soundness of its figures, the modulation of light, and the incisiveness of touch. Still close to Raphael's designs, the painting was probably executed in Rome. Later, in Bologna, it would have served as the model for the etching.

Polidoro Caldara, called **Polidoro da Caravaggio**

Caravaggio (Bergamo), Italy, 1499/1500–Messina, Italy, c. 1543

The Adoration of the Magi, c. 1527

Pen and brown ink with brush and brown wash and white
heightening on ochre washed antique laid paper, laid down;
8¹/₁₆ × 11⅛ in. (20.5 × 28.3 cm); The Suida-Manning Collection,
1999; 480.1999

Polidoro da Caravaggio was the most inventive and idiosyncratic of Raphael's followers. From his earliest participation in the master workshop, his irregular and dramatic language was distinct. Later he created a new type of decoration for palace façades, with chiaroscuro frescoes suggesting low-relief sculpture in the style of ancient classical models, brought to life through eccentric form. His pioneering landscapes were similarly inspired by ancient Roman painting, interpreted with such vitality that they anticipate classical landscapes of the next century. After the sacking of Rome, he went to Naples, then Messina. Aggressively deformed, deliberately rude, and profoundly moving, the late works are fully expressionistic.

This is a magnificent example of the artist's most pictorial and dramatic style of drawing from the height of his activity. The composition still involves an underlying geometry and develops from a single plane like an antique low relief, but it is already swept by larger movements and charged with intense feeling. Similarly, the figures are still monumental and declamatory, but are beginning to slip from balance and to warp with individualized response. In terms of technique, form is defined through broad washes, limited pen-and-ink, and summary modeling, as opposed to the previous delicate description, in white heightening. With the reminiscences of Rome fresh and rather poignant, the drawing probably dates from the beginning of the Neapolitan sojourn.

GIOVANNI BATTISTA DELLA CERVA

Novara (?), Italy, c. 1515–Milan, 1580

The Coronation of the Virgin, c. 1541

Oil on wood panel; 34¼ × 28⅛ in. (87 × 71.5 cm); The Suida-Manning Collection, 1999; 242.1999

GAUDENZIO FERRARI was the most important painter of the sixteenth century in northwest Italy. His style, combining the lessons of Leonardo da Vinci's Milan, Raphael's Rome, and German art, including Dürer's prints, was the most advanced and influential in the area that is now Piedmont. Through his early maturity, this style featured generalized forms but an extraordinarily modern light, at once coherent and unidealized, and touchingly earnest human expression. From the late 1520s, and especially after his move to a newly conservative Milan in the early 1530s, his paintings became more self-conscious, formulaic in their composition, and ornamental in their finish.

This panel was long considered a late work by Ferrari himself. It was in fact painted by Giovanni Battista della Cerva, his principal assistant and closest follower during the period in Milan. The gentle Coronation and the expansive God-the-Father amid putti were devised by Ferrari for a major altarpiece of 1541 in Busto Arsizio, just north of Milan. The latter motif was frequently repeated by della Cerva and another assistant, Bernardino Lanino, as in their frescoes of 1548–1549 for the Milanese church of San Nazaro. Della Cerva's variation upon the master's language is distinguished by busier description, milder sentiment, and a softer touch. In superb condition, this painting is among the best examples of Ferrari and his school in this country.

Antonio Fantuzzi

Bologna (?), Italy, c. 1510–Fontainebleau, France, after 1550

Jupiter and Antiope, c. 1544, after
Francesco Primaticcio

Etching, Herbert 51, Zerner 71, only state; Sheet: 6¹⁵⁄₁₆ ×
10⁹⁄₁₆ in. (17.6 × 26.9 cm); The Leo Steinberg Collection,
2002; 2002.1838

As part of his creation of the first modern
nation-state, Francis I brought leading Italian art-
ists to France and, principal among his projects,
had them decorate the royal country palace at
Fontainebleau. A group of printmakers reproduced
both drawings by the most stylish Italian masters,
like Parmigianino, and studies for the villa's highly
intellectual decoration. If this kind of printmak-
ing was itself Italian, the cultivation of etching to
accentuate fluent design and rarified substance was
novel. The etchings of the School of Fontainebleau

represent one of the most original and influential
manifestations of Mannerism.

Along with Léon Davent and Jean Mignon,
Antonio Fantuzzi was the leading etcher at Fon-
tainebleau. This print epitomizes the school's in-
terests. The subject, from Ovid's *Metamorphoses*,
is the seduction of Antiope by Jupiter in the form
of a satyr. In Francesco Primaticcio's composition,
the overt interaction is minimal and in ways subtle.
His hand disappears into shadow between her legs.
Her form, recalling the Sleeping Ariadne of ancient
statuary, stirs to life. Her toe brushes his hoof. The
erotic meaning is developed equally in the play of
form: the rhyming angles of their bodies, the spill-
ing fruit beneath her, the labial parting of the back-
ground's drapery. Bold and languorous, warm and
remote, Fantuzzi's technique does not just serve
the subject but adds another metaphoric layer.

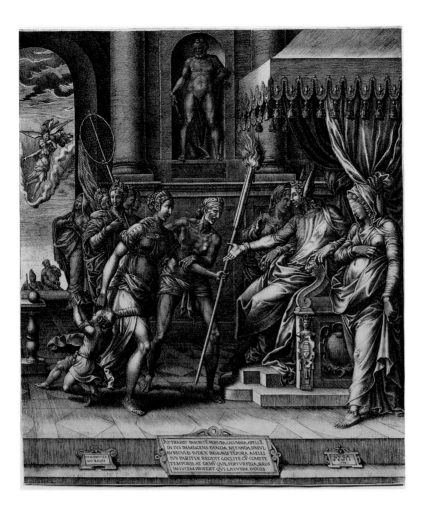

GIORGIO GHISI

Mantua, Italy, 1520–1582

The "Calumny" of Apelles, 1560, after
Luca Penni

Engraving, Bartsch 64, Lewis & Lewis 27, third state of six;
Sheet: 14½ × 12½ in. (36.8 × 31.8 cm); Archer M. Huntington
Museum Fund, 1987; 1987.49

APELLES WAS THE MOST FAMOUS painter in
ancient Greece. Maligned by an envious colleague,
he devised an allegory of Calumny. In an essay
on the theme, the Roman satirist Lucian gave the
only description of the painting to survive. Its
re-creation became a favorite challenge for Renais-
sance artists. Giorgio Ghisi's engraving is one of
the best-known versions. Reproducing Luca Penni's
design, it closely follows Lucian's description:
Calumny, accompanied by Deceit and Envy, drags
Innocence before a donkey-eared man, flanked by
Ignorance and Suspicion. Penni's embellishments

include the background motif of Time rescuing
Truth.

Formed in Giulio Romano's orbit in Mantua
and active in Rome at an early stage of his career,
Ghisi mastered the conventional system of repro-
ductive engraving. In Antwerp and then Paris for
much of the 1550s and 1560s, he incorporated the
material values and the high craft of the northern
traditions. The combination of ideal design, rich
stuffs, and extraordinary modulation of tone in
this print makes it a capital example of his mature
style. Such works anticipated the virtuosity and
the pictorial qualities that would characterize late-
century engraving and bring it into close relation
with painting.

The collection includes eighteen engravings
by Ghisi, a recently identified preparatory study
for one, and another twenty-six engravings of the
Mantuan school.

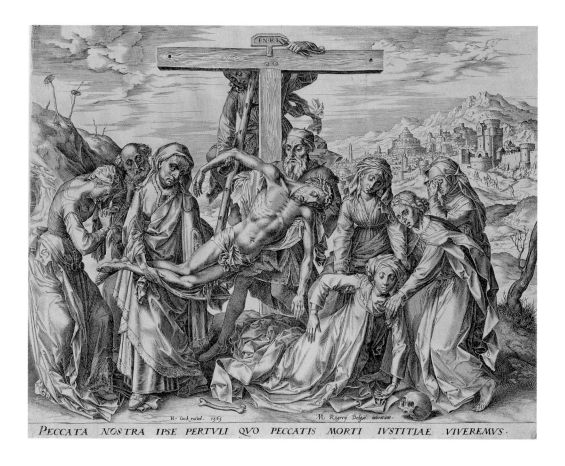

PECCATA NOSTRA IPSE PERTVLI QVO PECCATIS MORTI IVSTITIAE VIVEREMVS·

CORNELIS CORT

Hoorn (Alkmaar), Netherlands, 1533/1536–Rome, 1578

The Descent from the Cross, 1565, after
Rogier van der Weyden

Engraving, Le Blanc 82, Wurzbach, Bierens de Haan, Hollstein
90, New Hollstein 65, second state of six; Sheet: 12⅝ × 16³⁄₁₆ in.
(32.1 × 41.1 cm); The Leo Steinberg Collection, 2002; 2002.2103

AROUND 1435 Rogier van der Weyden painted
a triptych for the Archer's Guild at Louvain. By
1549 the central panel, depicting the Descent from
the Cross, had been acquired by Mary of Hungary,
who later gave it to her nephew Philip II of Spain.
Today in the Prado, Madrid, the picture is one
of the masterpieces of early Netherlandish art.
In 1565, undoubtedly due to recent interest in the
painting, the Antwerp publisher and impresario
Hieronymus Cock had Cornelis Cort engrave the
composition. The resulting print was unusual for
Cort, who was primarily concerned with Italianate

and then Italian subjects. More important, it was
the first explicit reproduction of a fifteenth-century
Netherlandish painting. The print is extremely
rare, however, this being one of only two impres-
sions in the United States.

The most innovative and influential engraver
of the third quarter of the century, Cort reconciled
the earlier emphasis on design and ideal appearance
with more varied description and closer approxi-
mation of pictorial effects. Formed and first active
in Cock's workshop, he went to Italy in 1565.
Becoming Titian's preferred interpreter, he devel-
oped an unprecedentedly rich and differentiated
system of engraving. Point of departure for Hen-
drick Goltzius in the Netherlands and Agostino
Carracci in Italy, this system would help determine
the development of the technique.

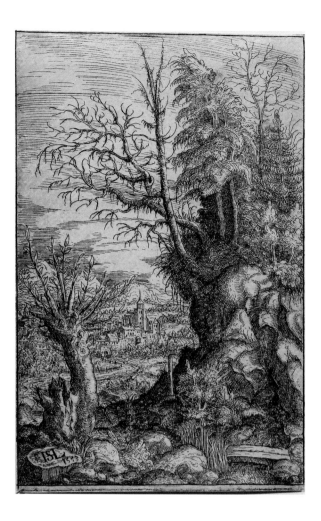

HANNS LAUTENSACK

Bamberg (?), Germany, 1520/1524–Vienna, 1564/1566

Landscape with a Pollard Willow, 1553

Etching, Bartsch 26, Schmitt 61, Hollstein 16, first state of two; Sheet: 6⅞ × 4⁷⁄₁₆ in. (17.4 × 11.2 cm); Purchase with funds provided by M. K. Hage, Jr., the Dean's Associates of the College of Fine Arts, and the Archer M. Huntington Museum Fund, 1993; 1993.97

FROM AROUND 1520 a distinctive style developed in the Danube Valley. Its artists, led by Albrecht Altdorfer, cultivated a self-consciously native style opposite to the classical, Italianate style popular in Nuremberg and Augsburg. Its compositions organic, its forms fluid, and its light supernatural, the style lent itself to expressionism in figural subjects and animism in the rendering of nature. The Danube School is the first in history to explore the metaphoric personality of pure landscape. Altdorfer, followed by Augustin Hirschvogel, was also the first to realize the aptness of etching for conveying the appearance and suggesting the character of nature.

A Nuremberg printmaker, Hanns Lautensack brought a distinctively German landscape etching into a third generation. His principal work in the genre is a loose series of twenty plates executed in 1553 and 1554. Having generally deep perspectives with elaborately layered space, these plates impose a more regular structure and professional hand on the dramatic topography and dense growth associated with the Valley. In this plate the principal motifs—the gnarled outcrop, the leafing pollard, the spindly pines, and the dwarfed habitation—are especially clear and knowing citations of the Danube School. With its rich tone and soft luminosity, this very early impression retains something of the mystery and subjectivity of Altdorfer and Hirschvogel.

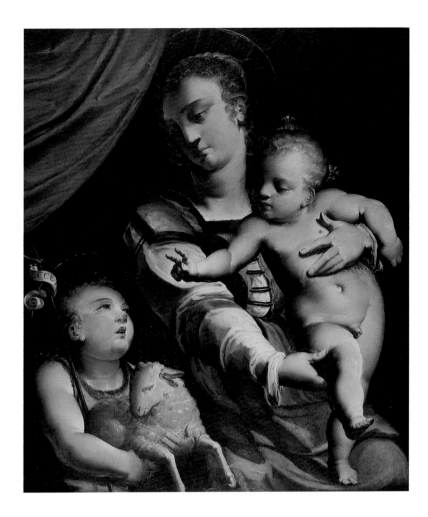

LUCA CAMBIASO

Moneglia (Genoa), Italy, 1527–Madrid, 1585

Madonna and Child with the Young Saint John the Baptist, c. 1550

Oil on wood panel; 36 × 31 11/16 in. (92 × 80.5 cm); Purchase as a gift of the Cain Foundation in honor of Charmaine Hooper Denius, 2004

THIS IS AN EARLY WORK by Luca Cambiaso, the first great master of sixteenth-century Genoa and the virtual founder of its distinctive school of painting. The monumentality of the Virgin, the thrust of the Child, and the bold plasticity of every form suggest study with the followers of Michelangelo in mid-century Rome. At the same time, this powerful description has been circumscribed by Cambiaso's exaggerated regularity of shapes, as in the figures' heads, and embellished with the unnatural grace of their extremities, which recalls the works that Raphael's follower Perino del Vaga

had created for Genoa. Throughout, from the luscious frosting of the Virgin's white sleeve to the exquisite filaments about the eyes, there is evident delight in the sheer matter of paint and possibilities of the brush. This virtuosity is conspicuous because of the work's execution on panel and the excellent preservation of most of its surface. The painting demonstrates the young artist's startling ambition, explains his first synthesis of influences, and predicts his place among the major figures of Mannerism.

The Suida-Manning Collection includes six paintings and at least two dozen autograph drawings by Cambiaso. These represent the most significant holdings of his work outside Genoa. Preceding the earliest Suida-Manning picture by some fifteen years, and the only example on panel, this painting is the cornerstone of the entire group.

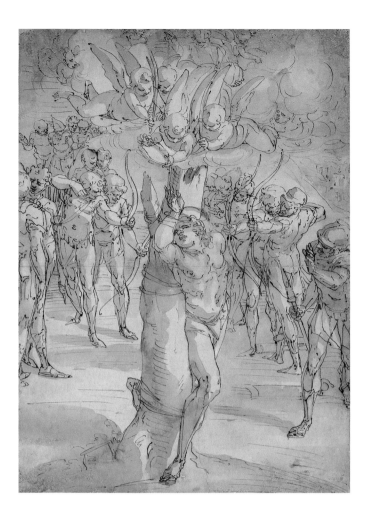

LUCA CAMBIASO

Moneglia (Genoa), Italy, 1527–Madrid, 1585

The Martyrdom of Saint Sebastian, c. 1560

Pen and brown ink with brush and brown wash over traces of black chalk on cream antique laid paper, laid down; 22⅜ × 16⁷⁄₁₆ in. (56.9 × 41.8 cm); The Suida-Manning Collection, 1999; 116.1999

THIS IS A MASTERPIECE of Luca Cambiaso's early maturity. Although still Michelangelesque, its forms have been disciplined, smoothed into more regular shapes, and given more elegant proportion. Around this time he began to employ lines of more varied weight, length, and velocity, which allowed elliptic description and flexible structure. This drawing also demonstrates a new level of spatial mastery. While the archers define a horizontal concavity, the saint and angels create a vertical convexity. These intersecting curves involve the entire composition in an energizing tension and virtuoso resolution. Finally, the drawing attains consonantly refined expression of the saint's pathos, lyrical in his face, then woven through the fabric of the whole work.

The Martyrdom of Saint Sebastian is no less sophisticated in function. Cambiaso's earlier drawings still pertain to the graphic system of the early sixteenth century. This drawing was rendered at the high speed and with the summary notation of an advanced compositional study within that system. It was not, however, preparatory, rather conceived and executed as an autonomous work of art. Its remarkable size only confirms this function. Such drawings enjoyed a tremendous success with the same ambitious patrons of the artist's paintings. The resulting production established the very idea of an independent market for drawings in which graphic character and individual personality are the commodities.

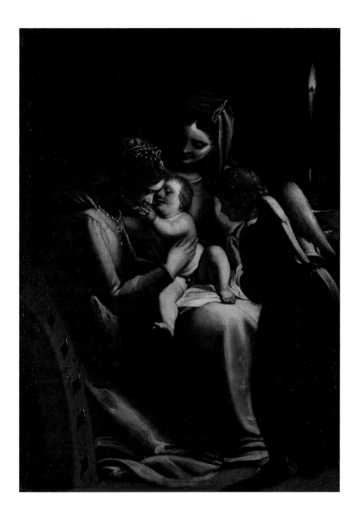

LUCA CAMBIASO

Moneglia (Genoa), Italy, 1527–Madrid, 1585

*Madonna and Child with Saint Catherine
and an Angel*, c. 1570

Oil on canvas; 55½ × 40¼ in. (140.9 × 102.2 cm); The Suida-
Manning Collection, 1999; 127.1999

CONCLUDING JUST YEARS BEFORE the execution
of this painting, the Council of Trent proposed the
systematic reform of the Catholic Church, largely
in response to the Protestant Reformation. The
Council and its subsequent interpreters insisted
that religious painting should be scripturally accu-
rate, clearly legible, and stirring of devout feeling in
the viewer. After a long collaboration with the bril-
liant architect Bergamasco and an increasing man-
ufacture during the 1560s, Luca Cambiaso had
already developed a more calculated, spare, and
efficacious style. For the later religious works,

consonant with, if not explicitly serving, the new
ideals, he perfected a mode that is diagrammatic
in subject and radically pared of obvious material
appeal. To relieve the abstractness, to cue a senti-
mental response, and certainly also to satisfy his
own instincts as a painter, Cambiaso equipped this
mode with passages of stunning natural observation
and tender human interaction. The most original
and striking of these paintings are the nocturnes,
concentrated in the early 1570s. This picture is the
grandest of three examples in the Suida-Manning
Collection. While the general conception and func-
tion of these nocturnes point toward Cambiaso's
last activity, as official painter to the Spanish king
Philip II at the monastery of the Escorial, their
coherent light and authentic feeling anticipate the
tenebrism of the early Baroque, from Caravaggio
to Georges de La Tour and Gerrit van Honthorst.

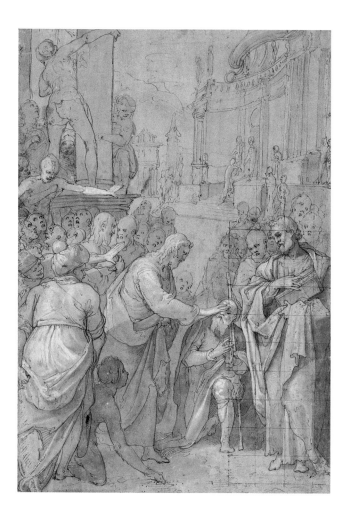

FEDERICO ZUCCARO

Sant'Angelo in Vado (Urbino), Italy, c. 1541–Ancona, Italy, 1609

Christ Healing the Blind Man, 1568

Pen and brown ink with brush and brown wash and white heightening (partly oxidized) on ochre prepared paper, partly squared in black chalk, laid down; 15½ × 10¾ in. (39.4 × 27.3 cm); The Suida-Manning Collection, 1999; 616.1999

IN HIS ENCYCLOPEDIC STYLE and substantial intellectual activity, Federico Zuccaro is a fundamental figure of late Mannerism. His initial graphic language was a synthesis of developments in central Italy, with a vital accent from Venetian painting and Correggio. Principally in Rome, his later work became more deliberately classicizing and formulaic. His thought was also expressed in the founding of the Roman academy and his publication of *Idea de' pittori, scultori, ed architetti* (1607), the most articulate statement of the period's artistic theory.

In 1568 Zuccaro was commissioned for a pair of altarpieces for the Duomo at Orvieto. This drawing corresponds to a preliminary stage of one composition. It differs from the painting in the kneeling figure at the lower left and in a few minor details. Another version of the drawing (Louvre, Paris) is identical in size, technique, and virtually every mark, but its revisions are more logical and its line is more responsive. The Suida-Manning drawing is an autograph replica. It may have had a functional role in the project, as suggested by the squaring of one figure for transfer, or it may have been intended for a collector.

The Suida-Manning Collection includes two more compositional studies for major frescoes: *The Adoration of the Magi* in San Francesco della Vigna, Venice (1563–1564), and the *Prophet and Sibyl* in the Oratorio del Gonfalone, Rome (1573).

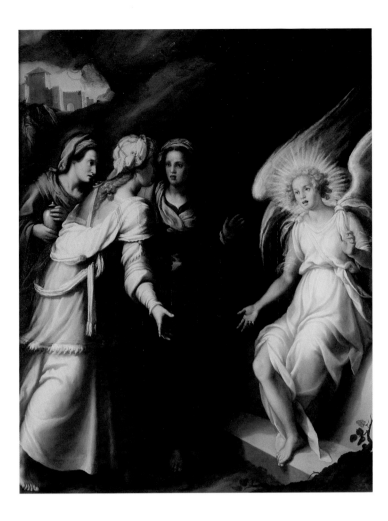

Jacopo Chimenti, called **JACOPO DA EMPOLI**

Florence, 1551–1640

The Three Maries at the Tomb, 1570s

Oil on wood panel; 71 9/16 × 59 1/4 in. (181.7 × 150.5 cm); Blanton
Ball Purchase, 2002; 2002.2824

THIS SCENE IS BASED upon the account of the
Resurrection in the Gospel of Matthew (28:1–10).
Mary Magdalene and Mary, mother of James and
Joseph, have come to the Sepulcher. A third woman,
called Salome in Mark and Joanna in Luke, had
become associated with the Virgin Mary and so
entered the standard iconography. "His raiment
white as snow," an angel sits upon the stone and
declares, "He is not here; for he has risen." In the
background vignette, the two women return to
Galilee and encounter the risen Christ.

 This altarpiece presents the drama with
the simplified structure, wide interval, and clear
enunciation that reflect generally the interests of
the Counter-Reformation. The constellation of
gesture at the center of the composition epito-
mizes the new concern with visual and expressive
legibility. Yet the painting retains the stylized
form, calculated drawing, and polished surface
of the previous generation, Giorgio Vasari and
his school. Characteristic of Jacopo da Empoli's
first works, the elegant types, vague faces, and
palette quote early sixteenth-century Florentine
painting, Andrea del Sarto and Pontormo in
particular. In Florence, where the most refined
Mannerism had been born and flourished, the
reform of that style was more internally driven
and ambivalent. Empoli was among the first to
embrace this reform and the last to surrender
its transitional language after other, naturalistic
currents had taken hold in the city.

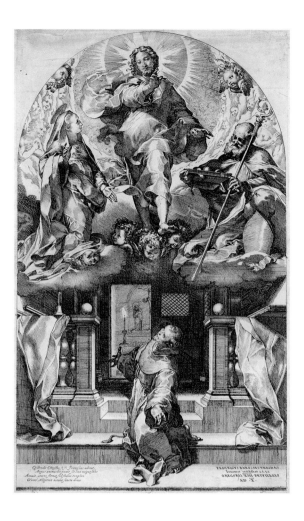

FEDERICO BAROCCI

Urbino, Italy, c. 1535–1612

The Vision of Saint Francis (Il perdono d'Assisi),
1581

Etching and engraving, Bartsch 4, Pillsbury & Richards 73,
only state; Plate: 21⅛ × 12¾ in. (53.7 × 32.4 cm); Sheet: 21¾ ×
13⁹⁄₁₆ in. (55.3 × 34.5 cm); The Leo Steinberg Collection, 2002;
2002.1775

FEDERICO BAROCCI, a painter of extreme sensi-
tivity and incipient naturalism, had a fundamental
role as a precursor of the Baroque. Although they
are still essentially idealized, his works built upon
the innovations of Titian and especially Correggio
to achieve unprecedented optical sensation and
affecting sentiment. Later in his career, he experi-
mented with printmaking, making four etchings.
This, one of two large and complex plates, repro-
duces his own altarpiece of 1576 for the church
of San Francesco at Urbino. Its subject is Saint
Francis's vision of Christ granting indulgences
to the pilgrims who would visit the saint's chapel
at Portiuncola. The etching translates not just the
composition but the vibrance and ecstatic feeling
of the prototype.

Extremely important despite being few in
number, Barocci's prints set the course of Italian
Baroque etching. Combining the plastic values of
late-century engraving with the graphic freedom
of etching, they were the first to accommodate
the naturalism and inherent expressiveness of
the emergent style of painting. Immediately, they
helped reinforce and further Barocci's influence.
More generally, they established the proposition
of painters conveying their full style, not merely
their composition or drawing, through printmak-
ing. Most of the etchers of the next century would
be painters first, and many of their finest plates
would interpret their own works.

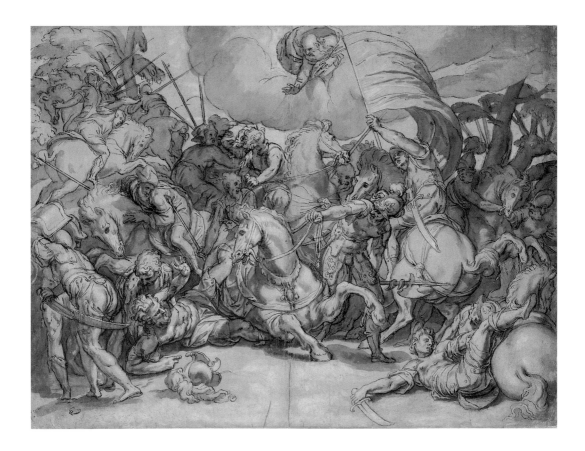

PAOLO FARINATI

Verona, Italy, 1524–1606

The Conversion of Saint Paul, late 1580s

Pen and brown ink with brush and brown wash and white
heightening over black and lead white chalks on beige
antique laid paper, laid down; 16⅞ × 22¹³⁄₁₆ in. (42.8 × 58 cm);
The Suida-Manning Collection, 1999; 237.1999

UNUSUALLY FORCEFUL AND PROLIFIC, Paolo
Farinati was a leading painter at Verona. Exagger-
ating the school's tendencies, his style combines
the color and mobile light of the Venetian tradi-
tion with the pronounced form of Giulio Romano's
work at nearby Mantua and the elegant styliza-
tion of Emilian painting. Later, he would be in-
fluenced by the more thorough synthesis of these
elements in the work of his illustrious compatriot,
Paolo Veronese. True to his Roman and Mannerist
interests, Farinati was an incessant and resolute
draftsman.

This drawing renders the vision of the Roman
soldier Saul and his conversion to Christianity
as a frieze of spectacular incident and stunning
plasticity. This kind of arrangement, horizontal
format with surging population, was typical of
Farinati's most imposing paintings. Here, dilated
into a sweeping panorama and bound by sustained
rhythms, the composition is especially dynamic
and coherent. Similarly, the complicated surface,
rich color, and elaborate finish are characteristic
of Farinati's preferred mode of drawing. This work
reflects his latest graphic development, with rela-
tively restrained heightening and varied washes
animating the surface, even hinting at naturalism.
So insistent in drawing but then so concentrated in
pictorial effect, Farinati's graphic style lent itself
to the production of autonomous works for collec-
tors. Due also to its size and condition, the Suida-
Manning drawing is among the greatest examples.

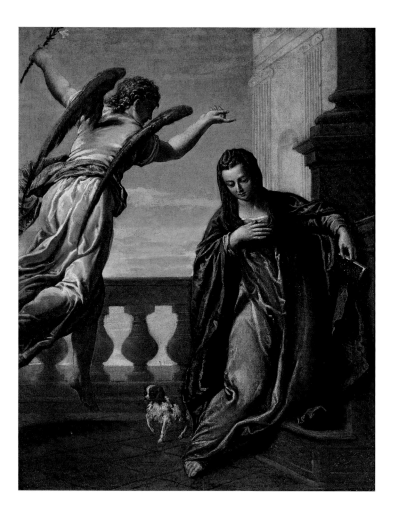

Paolo Caliari, called **PAOLO VERONESE**

Verona, Italy, 1528–Venice, 1588

The Annunciation, c. 1585

Oil on canvas; 41⅛ × 32⅝ in. (104.5 × 82.9 cm); The Suida-Manning Collection, 1999; 586.1999

OF THE GREAT VENETIAN PAINTERS of the sixteenth century, Paolo Veronese was the most systematic and subtle in exploring the action, formal implications, and even expressive meanings of light upon color. Early in his development, the forms had been quite arbitrary and the result stylish but implausible. Steadily, his design was regularized according to classical models, his palette reached an unprecedented optical range, and his light became naturalistically descriptive. A small altarpiece probably for private devotion, this picture sets the Virgin and the archangel Gabriel in a handsome loggia, like that of an actual villa by Palladio, with whom the artist often collaborated. It is one of numerous late versions of the subject, with no sign of the workshop participation that had become frequent by then. The highlights have lost little of their energy, coursing across the surfaces and infusing the work with a metaphoric vitality. The figures, however, have been simplified in shape, their cadence slowed and their gesture subdued. And the palette is relatively restricted and uniform in value. In such paintings, the heroic splendor of the artist's mature style yields to something less calculated and more reflective.

The Suida-Manning Collection includes two other paintings from the same period, each a fragment from a larger composition.

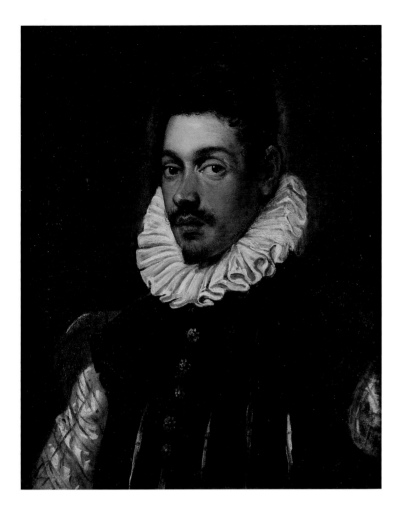

Domenico Robusti, called DOMENICO TINTORETTO

Venice, 1560–1635

Portrait of a Gentleman, c. 1585–1590

Oil on canvas; 24³⁄₁₆ × 19⁹⁄₁₆ in. (61.5 × 49.8 cm); The Suida-Manning Collection, 1999; 555.1999

THE DYNAMIC COMPOSITION, mobile light, and inherent expressiveness of the Venetian tradition were carried to their extreme in the painting of Jacopo Tintoretto. However arbitrary his compositions and complicated his devices, their visual energy and the viewer's visceral sensation return to inform the ostensible subject. In this sense his work represents both the height of a distinctively Venetian Mannerism and a critical source of the Baroque, Rubens's work in particular. So vital and economical, this style lent itself to portraiture. At their best, Tintoretto's portraits combine audacious painterliness and powerful characterization.

Often, due to the intervention of assistants, they also appear formulaic and unfelt.

This portrait, by Jacopo's eldest son, is an extraordinary example. The drawing is unusually firm, the surface compact, and the light varied, from the glistening corner of the sitter's eye to the faint glow about his head. This description of a very specific appearance is matched by the psychology, not just generically present but momentary and penetrating. During the 1580s Agostino and Annibale Carracci traveled frequently to Venice and assimilated the school's most advanced developments: color and classicizing form from Paolo Veronese, and of course dynamic and light from Jacopo Tintoretto. This painting involves the opposite phenomenon: Domenico Tintoretto's response to the revolutionary experiments of the Carracci. It joins their work on the threshold of the Baroque.

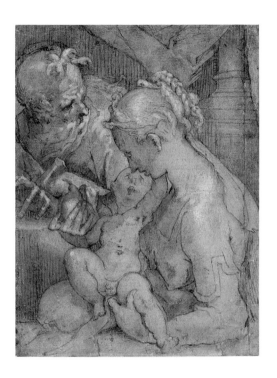

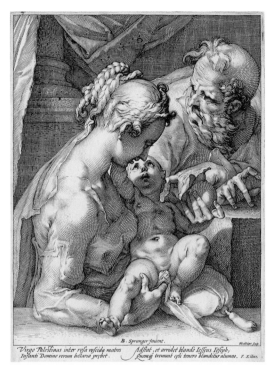

BARTHOLOMAEUS SPRANGER

Antwerp, 1546–Prague, 1611

Holy Family, c. 1589

Pen and brown ink, with brown and gray washes, white and sanguine gouaches, on cream antique laid paper indented for transfer; 10⅜ × 7⅞ in. (26.3 × 20 cm); Archer M. Huntington Museum Fund, 1982; 1982.710

HENDRICK GOLTZIUS

Mülbracht (Bracht-am-Niederrhein), Germany, 1558–Haarlem, Netherlands, 1617

Holy Family, 1589, after Bartholomaeus Spranger

Engraving, Bartsch 275, Hollstein 319, Strauss 281, only state; Plate: 11⁵⁄₁₆ × 8⁷⁄₁₆ in. (28.7 × 21.4 cm); Sheet: 11⁷⁄₁₆ × 8⁹⁄₁₆ in. (28.8 × 21.7 cm); Purchase through the generosity of the Still Water Foundation, 1993; 1993.176

TRAINED IN ANTWERP, inspired by Italian Mannerism, Bartholomaeus Spranger cultivated a brilliantly artificial and highly subjective style. In long service to Rudolf II, he gave shape to the emperor's erudite taste and more than any other artist defined the School of Prague's extravagant style.

By the late 1580s Hendrick Goltzius was celebrated as the greatest engraver of his time. He developed a commanding burin stroke, a strict organization of mark, and an unprecedented ability to convey pictorial properties. In reasserting the intellectual dimension of engraving, Goltzius's style was itself one of the major developments of late Mannerism.

One of the last of Spranger and Goltzius's seven collaborations, this engraving is relatively simple in iconography and obviously Parmigianin-esque in vocabulary. Identical in size, its contours indented from transferring the design, the drawing is the very sheet from which the plate was prepared. This superb impression of the print matches the rarified beauty of its prototype.

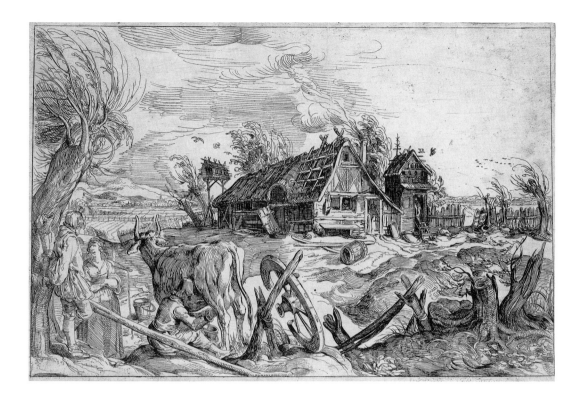

After Jacob de Gheyn II

Antwerp, 1565–The Hague, Netherlands, 1629

Landscape with a Farmhouse, c. 1603

Etching, Hollstein 293, only state; Sheet: 8¼ × 12¹¹⁄₁₆ in.
(21 × 32.2 cm); The Leo Steinberg Collection, 2002; 2002.1992

EXTENDING AND ELABORATING upon Hendrick
Goltzius's audacious style, his pupils constituted
a true school of engraving in Haarlem, Holland.
Beside Jacob Matham, Jan Saenredam, and Jan
Muller, Jacob de Gheyn was the most refined in
drawing and subtle in effect. In his early work,
he often translated the master's designs, then he
turned to the extravagant compositions of paint-
ers, especially Abraham Bloemaert, as well as to
his own inventions. De Gheyn was an equally
remarkable draftsman, nearly matching Goltzius's
combination of acute observation and virtuoso
hand.

This etching imposes a contrived arrangement,
surging composition, and stylized description
upon a seemingly familiar countryside. Because
it displays the sinew and flourish of De Gheyn's
work in pen, the print was long attributed to the
artist himself. In fact, there exists a virtually iden-
tical drawing in the Rijksmuseum, Amsterdam.
Very rare, the etching is now generally thought
to be a contemporary reproduction by an anony-
mous printmaker. Whether by De Gheyn himself
or an interpreter, this project suggests the taste
and burgeoning market for such graphic display.
More generally it points to the emergence of etch-
ing as the preferred technique for rendering natu-
ral subjects and portends an essential type of
seventeenth-century Dutch printmaking.

The collection contains sixty-nine engravings
by De Gheyn, including his most important series.

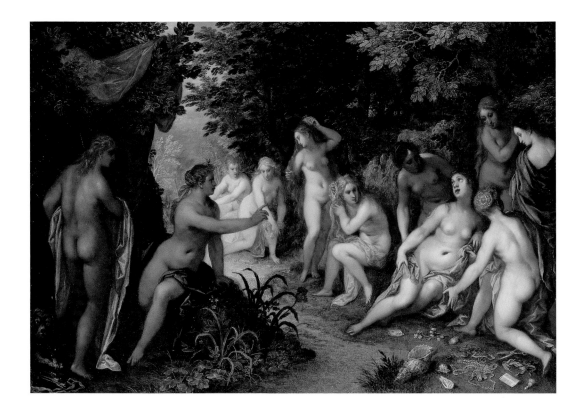

JAN BRUEGHEL THE ELDER and HENDRICK VAN BALEN

Brussels, 1568–Antwerp, 1625
Antwerp, c. 1575–1632

Diana and Callisto, c. 1605–1608

Oil on copper; 10¼ × 14¹³⁄₁₆ in. (26 × 37.6 cm); Archer M.
Huntington Museum Fund, 1982; 1982.182

SON OF THE FAMOUS Pieter Brueghel the Elder,
Jan Brueghel was probably the most significant
painter in oil on copper. Noted for their special-
ized craft, fine material, and exquisite finish,
paintings in this technique were in vogue through-
out Europe during the period. Brueghel apparently
learned the technique from other Netherlandish
painters in Rome and cultivated it while he was the
guest of Federico Borromeo in Milan. A good half
of his surviving production is oil on copper, and
half of that involves landscape. These landscapes
tend to his father's types, but with the subtle

invention and complex conventions of the late-
Mannerist painters.

Like many painters on copper, Brueghel often
collaborated with other artists. Hendrick van
Balen, the leading Romanist painter in Antwerp,
was his favorite partner. Van Balen was responsible
for the classicizing figures in many of Brueghel's
paintings after his return from Italy in 1597. This
painting is an excellent example of their collab-
oration. Typically, its small size makes the ample
composition, full pictorial development, and luxu-
riant atmosphere inherently wondrous. In excel-
lent condition, the surface conveys the exceptional
material beauty of Brueghel's style. Based upon
Ovid's *Metamorphoses*, Diana's discovery of the
nymph Callisto's pregnancy by Jupiter was a fre-
quent subject of large-scale mythological pictures
of the sixteenth century.

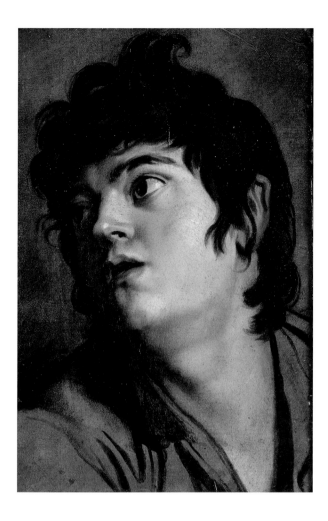

PETER PAUL RUBENS

Siegen (Westphalia), Germany, 1577–Antwerp, 1640

Head of a Young Man, 1601–1602

Oil on paper, mounted on panel; 13¾ × 9³⁄₁₆ in. (34.9 × 23.4 cm);
The Suida-Manning Collection, 1999; 507.1999

THE TECHNIQUE OF DRAWING in oil on paper
developed in the late sixteenth century and was
favored by Venetian artists. The oil sketch became
Rubens's preferred method for anticipating the
pictorial character of individual motifs and entire
compositions. An homage to Caravaggio in type
and basic conception, this study captures the
emphatic physicality, momentary reaction, and
intense psychology of a live model. This head
was first utilized for the figure of a page in *The
Mocking of Christ*, one of three paintings for the
Roman church of Santa Croce in Gerusalemme
that were Rubens's first public commission. Prob-
ably based upon this very study, the same head of

a youth would reappear in at least four subsequent
works by the artist. This is one of the earliest,
most powerful, and evidently most useful of all
the oil sketches.

If not the creator of Baroque style, Rubens
gave it the most complete expression. In all sub-
jects, whether of vast or intimate scale, his paint-
ing is predicated upon rhythmic organization of
composition, dynamic construction of form, and
vibrant handling. In his early Italian works, these
tendencies were somewhat contained by a Cara-
vaggesque concern with plasticity and stability.
After his return to Antwerp in 1608, his paintings
would have increasingly free and grand expression,
describing all reality in terms of physical move-
ment and temporal change. And yet, his early and
thorough assimilation of classical style meant
that this vision never overwhelmed the sense of
an underlying order and ethos.

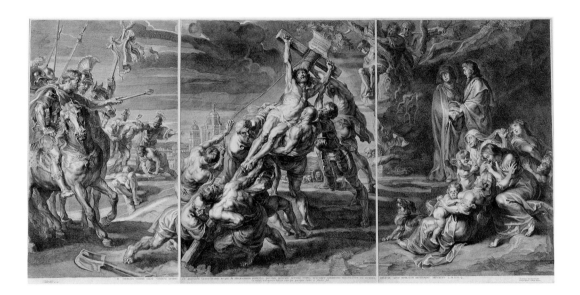

JAN WITDOECK

Antwerp, c. 1615–Antwerp (?), after 1642

The Raising of the Cross, 1638, after
Peter Paul Rubens

Engraving on three sheets, Dutuit 78, Bodart 307, Hollstein 5,
first state of five; (Left) Plate: 24½ × 14⅜ in. (62.2 × 36.5 cm);
Sheet: 24¾ × 14¹¹⁄₁₆ in. (62.7 × 37.3 cm); (Center) Plate: 24⁷⁄₁₆ ×
16¹⁵⁄₁₆ in. (62.1 × 43 cm); Sheet: 24⅞ × 17⁵⁄₁₆ in. (63.1 × 43.8 cm);
(Right) Plate: 24⁵⁄₁₆ × 18½ in. (61.8 × 47 cm); Sheet: 24⅞ ×
18¹³⁄₁₆ in. (63.2 × 47.8 cm.); The Leo Steinberg Collection, 2002;
2002.2584.1–3

THIS ENGRAVING REPRODUCES *The Elevation
of the Cross* in Antwerp Cathedral. Rubens's first
major commission after returning from Italy, the
altarpiece was executed in 1610 and 1611 for the
Jesuit church of Saint Walburga. Theatrical and
triumphal, it remains one of his most powerful
religious works. More than four feet across, the
engraving evokes not just the composition but the
scale, the triptych format, and even something of
the force of its prototype.

More than any artist, Rubens was concerned
with the dissemination of his work through prints.
Conscious of successful collaborations in the past,
principally that between Raphael and Marcantonio
Raimondi, he maintained a virtual team of engrav-
ers who worked in a collective style. Jan Witdoeck
was a later participant. Building upon the virtuoso
system of the Dutch Mannerists and contending
with the master's indomitable style, they brought
the translation of pictorial effects to a level and
coherence never surpassed. A century later French
printmakers would still cite their work as the
model for reproductive engraving. Their language
would endure until commercial photography made
such reproduction obsolete in the late nineteenth
century.

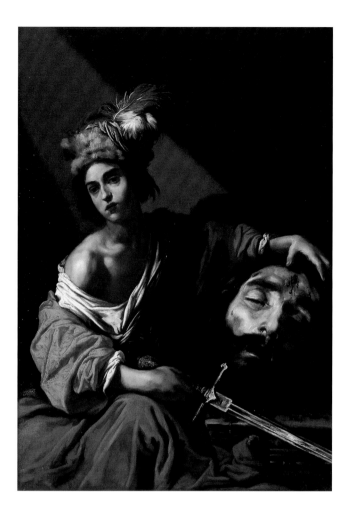

Claude Vignon

Tours, France, 1593–Paris, 1670

David with the Head of Goliath, c. 1620–1623

Oil on canvas; 52⅝ × 38⁹⁄₁₆ in. (133.7 × 98 cm); The Suida-Manning Collection, 1999; 593.1999

THIS IS THE MOST LITERALLY Caravaggesque painting in the oeuvre of Claude Vignon and perhaps of any Frenchman working in early seventeenth-century Rome. The subject had been established by Caravaggio and was expected of ambitious painters reaching the city. Here, however, the references to the master's style are compounded. The androgynous dandy in costume descends from Caravaggio's earliest paintings, while the formal devices—a palette stripped to earth tones, light entering as a diagonal shaft—quote from his paintings in the Contarelli Chapel. This embrace of Caravaggism occurred for a moment in Vignon's complicated development, shortly before his return to France in 1623.

Though simple in these elements, the painting is problematic in nature. By its date tenebrism had fallen from fashion in Rome. Vignon's seems an exaggeration of the style, almost a caricature. The viscous impasto of the draperies, the artist's trademark, tends to distract and dissociate. David's contemplative state leaves him so effete that he could be mistaken for a Judith. Perhaps Vignon imagined filling the void as other painters abandoned Caravaggism. In any event, his gift remained a realism of complex composition, scintillating surface, and odd feeling. As the future of this kind of realism lay back in northern Europe, it is surely no coincidence that Vignon returned to France immediately after such efforts.

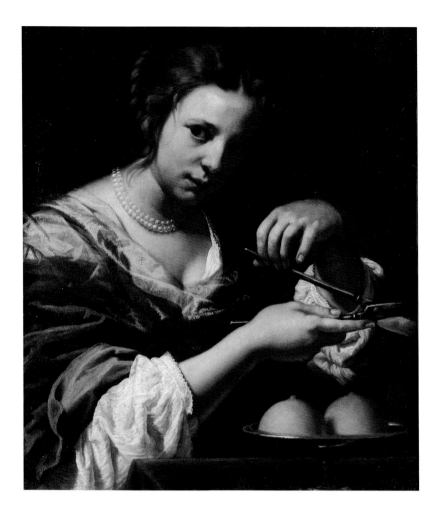

Orazio Riminaldi

Pisa, Italy, 1593–1630

Saint Agatha, mid-1620s

Oil on canvas; 29¹³⁄₁₆ × 25¼ in. (75.7 × 64.1 cm); The Suida-Manning Collection, 1999; 369.1999

THIS PAINTING RENDERS the early Christian martyr traditionally with the instrument of her torture and its result, her severed breasts. Half-length female figures of devotional or allegorical subject were common in mid-seventeenth-century Florence. Vague in substance and dreamy in mood, these subjects often hold a mild erotic charge and suggest the decadence of the city's culture. Here the saint's flesh is sharply drawn and carefully modeled. Her attributes are so vivid that the usual boundary between the symbolic and the actual breaks down. Transfixing the viewer with a glance that is at once vulnerable and provocative, she challenges the viewer to sort out devout sympathy from prurient curiosity. In this context the inherently beautiful material of the painting, its rare hues and thin glazing in the draperies, becomes ironic. The painting is a memorable combination of pungent realism and subtle transgression.

Although little known, Orazio Riminaldi was among the most progressive painters in early seventeenth-century Tuscany. In Rome between 1620 and 1626, he emerged as a convincing Caravaggesque with a formal restraint and elegance that affiliated him with his fellow Pisan Orazio Gentileschi and French interpreters like Simon Vouet. Inspired by Giovanni Lanfranco, his decoration of the cupola of the Duomo in Pisa is one of the first examples of full Baroque illusionism in the region.

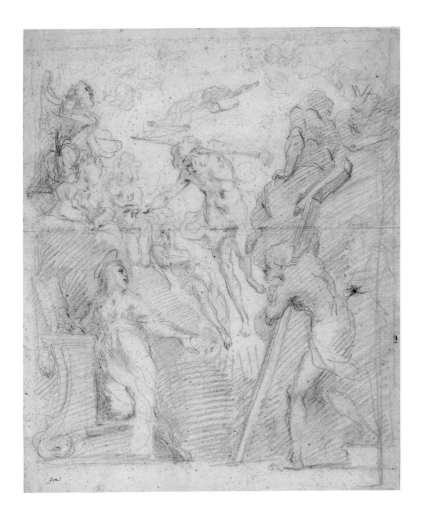

DOMENICO FETTI

Rome (?), c. 1588/1589–Venice, 1623

Christ Appearing to the Virgin, c. 1620–1621

Red chalk on cream antique laid paper, laid down; 15³/₁₆ × 12⅝ in. (38.6 × 32.1 cm); The Suida-Manning Collection, 1999; 254.1999

ONE OF THE GREAT PURE PAINTERS of the Baroque, Domenico Fetti transformed a basic naturalism through fluid movement, luminous color, and sinuous brushwork. This is the most elaborate of his few surviving drawings. With its symmetrical, dizzying collapse toward a central viewpoint, the composition derives from Rubens's early altarpieces, including the monumental *Adoration of the Trinity* for the Gonzaga family. Combining the insistent hatching of the late Roman Mannerists, the mobile light again of Rubens, and the animating contour of the

Venetians, its style is equivalent to that of Fetti's paintings. As a further distinction, it is the only signed drawing by the artist.

The rare subject is the appearance of the resurrected Christ to the Virgin according to the Apocryphal Gospel of Nicodemus. In his visionary staging of the scene, Fetti introduced Adam bearing the True Cross and a chorus of ancestors, prophets, and saints. Catherine de' Medici, Duchess of Mantua from 1617, was famously devoted to the Cross. Fetti had been a court artist since 1614, and their relationship is documented by numerous commissions. Because of its allusions to Gonzaga piety, to devout study of the Old and New Testament in the form of the Virgin at her prayer desk, and to the Cross itself, this drawing must pertain to a project, probably an altarpiece, for Catherine.

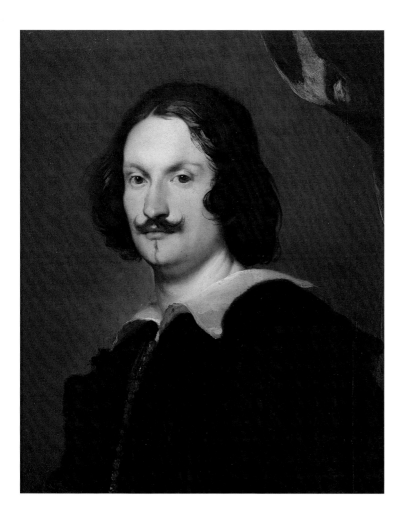

BERNARDO STROZZI

Genoa, Italy, 1581–Venice, 1644

Portrait of a Man, c. 1622–1623

Oil on canvas; 23¹¹⁄₁₆ × 19³⁄₁₆ in. (60.2 × 48.8 cm); The Suida-Manning Collection, 1999; 535.1999

THE MOST IMPORTANT NATIVE ARTIST in Genoa during the first quarter of the seventeenth century, Bernardo Strozzi was also one of the great pure painters of the Baroque. Of late-Mannerist formation, Strozzi tended toward rhythmic complication, exaggerated stylization, and audacious brushwork. Over the course of the second decade—and after a period as a Capuchin monk—he managed to integrate the narrative immediacy and dramatic chiaroscuro of Caravaggism. Later, he incorporated the dynamic form and mobile light of the great Flemish artists Rubens and Anthony van Dyck, who were active in Genoa. Finally, moving to Venice around

1630—ostensibly to avoid being recloistered—Strozzi would adjust again toward the grand compositions and warm palette of that school.

In his last decade in Genoa, Strozzi became a portraitist of the first order. Van Dyck, resident in the city in 1620 and 1621 and again in 1626 and 1627, produced innumerable portraits of members of the city's leading families. These clearly inspired Strozzi's efforts and determined their format, palette, and finish. At the same time, his individualism continued to assert itself in completely personal passages of paint—here, the fluid touch in the collar, and the daubed patches in the hair and left contour—and the suggestion of a subtle psychology. Restrained yet virtuoso, assertive yet sensitive, Strozzi's portraits are among the greatest of the period.

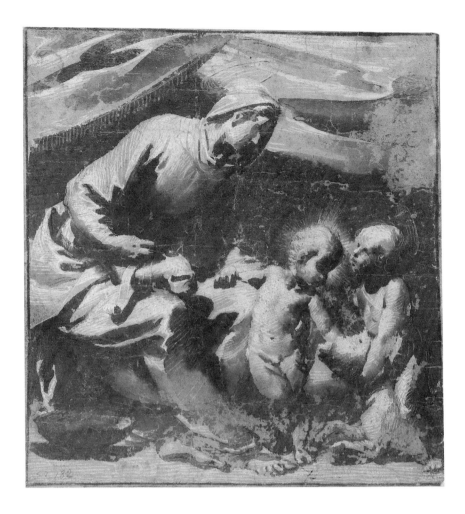

Pier Francesco Mazzuchelli, called **MORAZZONE**

Morazzone (Varese), Italy, 1573–1626

*Madonna and Child with the Young Saint
John the Baptist*, c. 1618–1620

Brush and brown wash with white heightening on gray-green
antique laid paper, laid down; 7¹³/₁₆ × 7³/₈ in. (19.8 × 18.7 cm);
The Suida-Manning Collection, 1999; 400.1999

THE ANGULAR PATTERN of composition and the
arbitrary alignment of form are Milanese habits
going back at least to Bramantino, made conven-
tional in the school of Gaudenzio Ferrari, and
anchored here by the elegant formulae of late-
century Rome. The description of form through
extensive wash and articulate heightening on
colored paper, with no use of pen, is equally char-
acteristic of the same tradition. In both regards
Morazzone is completely assured and distinctive
within seventeenth-century Milanese art. But his
is not just self-conscious reference or nativism.
Coherent, intense, and above all optical, the illumina-
tion derives from contemporary Rome. Disengaged
from naturalistic description, this Caravaggesque
contrast between light and shadow becomes abstract
and, if recognizable, suggests the action of moon-
light. The real expression of this drawing comes not
from subject matter nor even from rendered emo-
tion, which is generic and reticent. It arises from
the tension between compelling sensation and unfa-
miliar reality. Supernatural and expressionistic, this
style also evokes, and to some extent responded
to, the charged spirituality of Federico Borromeo's
Milan—a spirituality insisting upon authority to
the point of repressiveness, while exalting individual
sensibility to the point of mysticism. Resolute in
form and poetic in expression, this drawing is a
quintessential example of Morazzone's art.

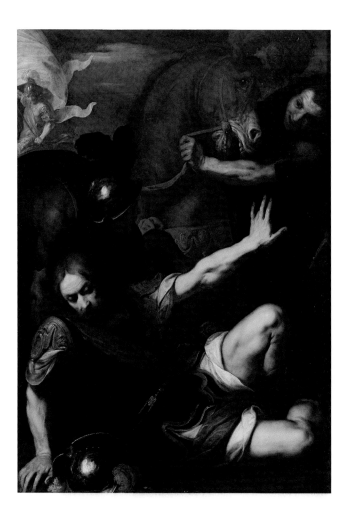

DANIELE CRESPI

Milan (?), 1597/1600–Milan, 1630

The Conversion of Saint Paul, c. 1621

Oil on wood panel; 46¾ × 33¼ in. (118.7 × 84.5 cm);
The Suida-Manning Collection, 1999; 197.1999

HAD DANIELE CRESPI ENJOYED a longer career, and were his works not largely confined to Lombardy, he would be widely known as a master of the first order. He was without doubt the finest painter of the second generation of Baroque painting in Milan. In his paintings the willful deformation and troubling intensity of the school's first generation have been subjected to a more disciplined sense of design and a more predictable language of expression, reflecting the lessons of recent Florentine painting as well as the emerging Bolognese academy. The resulting style is original in its staging but legible in its action and noble in its feeling.

This is one of Crespi's most important early pictures. The general composition and its compression of space into a single plane derive from a low-relief sculpture designed by Cerano for the façade of the church of San Paolo Converso in Milan. The intricate rhythms and the palette depend more on Giulio Cesare Procaccini, another major figure of the first generation who was Crespi's principal inspiration if not actual teacher. But the incisive drawing of Saint Paul, the exact modeling of his forms, and the memorable enunciation of the drama announce the fact and direction of a distinctive language.

The Suida-Manning Collection includes a second outstanding picture by Crespi, *Ecce Homo* of about two years later.

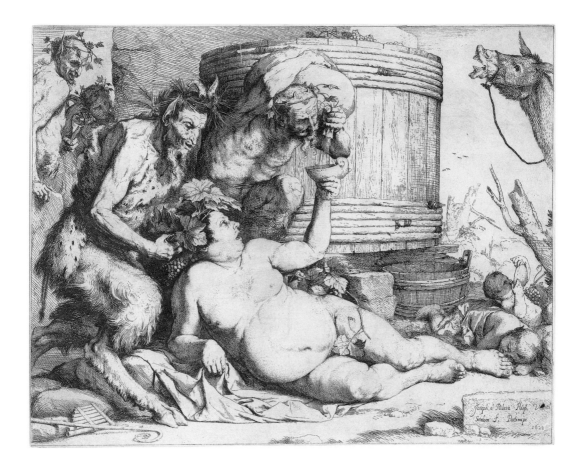

JUSEPE DE RIBERA

Játiva (Valencia), Spain, 1591–Naples, 1652

Drunken Silenus, 1628

Etching and engraving, Bartsch 13, Brown 14, first state of three; Sheet: 10¾ × 13¾ in. (27.3 × 35 cm); The 1989 Friends of the Archer M. Huntington Art Gallery Purchase, 1989; 1989.24

JUSEPE DE RIBERA was the most extraordinary realist of the Italian Baroque. His paintings are Caravaggesque in essence but given to unusual subjects, pungent interpretations, and an irregular stylization that owes something to his Spanish origins. His human content is so broad and unflinching that it approaches Rembrandt's. And his stunningly pure palette and singularly textured brushwork equal the painterliness of Italian virtuosi like Dominico Fetti and Bernardo Strozzi.

Etching was an occasional but very concentrated activity for Ribera. His earliest plates, made upon his arrival in Naples in 1616, are swift and energetic sketches of a fairly conventional sort. His major plates, all of the 1620s, rephrase subjects of paintings with exquisitely sensitive drawing, richly varied textures, and the same terribly moving expression. *Drunken Silenus* elaborates upon a painting of 1626 (Capodimonte, Naples). Its subject is the inebriation of the son of Pan, a Roman agricultural divinity who acted as guardian of the young Bacchus. A frequent pretext for showing the consequences of abandoning reason, the myth is pushed here toward a burlesque of bulging bellies and laughing asses. The etched version is his largest plate, the most similar to a painting, and the most carefully developed. Especially in this exceptionally early impression, Ribera is revealed as an absolute master of the technique.

The collection includes thirteen etchings by Ribera, most of his printed oeuvre.

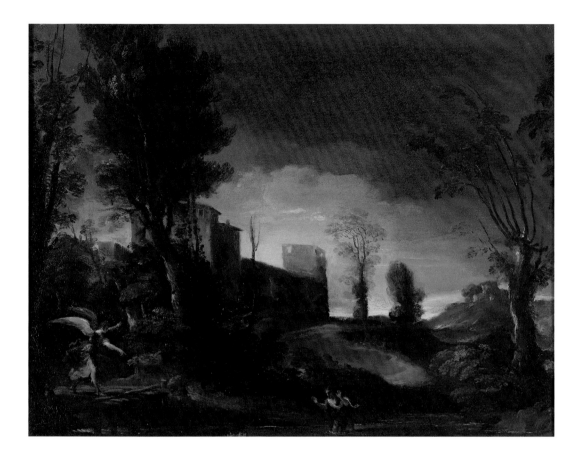

Giovanni Francesco Barbieri, called GUERCINO

Cento (Ferrara), Italy, 1591–Bologna, Italy, 1666

Landscape with Tobias and the Angel, c. 1616–1617

Oil on copper; 13¼ × 17½ in. (33.7 × 44.5 cm); The Suida-Manning
Collection, 1999; 323.1999

COMING TO THE TIGRIS RIVER, the angel Raphael
commanded the young Tobias to seize a great fish
and to save its entrails because these would cure
both the madness of his wife-to-be, Sarah, and the
blindness of his father, Tobit. Guercino has ren-
dered this popular subject from the Apocrypha in
the inherently attractive technique of oil on cop-
per, which was much favored around the time. The
tale of faith, revelation, and reward is translated
into a scene of mysterious nature, breaking day,
and exultant beauty. The pictorial elements of the
scene indicate the artist's eclectic and largely self-
taught formation: the landscape's structure derives
from sixteenth-century Venetian painting, the

saturated color from the tradition of Ferrara,
and the suffused, evocative light from the work of
Ludovico Carracci. But the fusion of these elements
into a conception of unprecedented sensory appeal
and stylization is his own considerable invention.
Although Guercino would soon temper and even-
tually retreat from the full implications of this
invention, others would pursue them toward the
full expression of Baroque style. As revelatory as
its subject, this painting is an enthralling overture
to that development.

The museum possesses two other paintings
by Guercino, a *Magdalene* of the mid-1620s and a
Personification of Astrology (see p. 58). In combi-
nation with eleven of his drawings and numerous
prints after the master's designs, they represent his
work at a level and across a range that is unsur-
passed in this country.

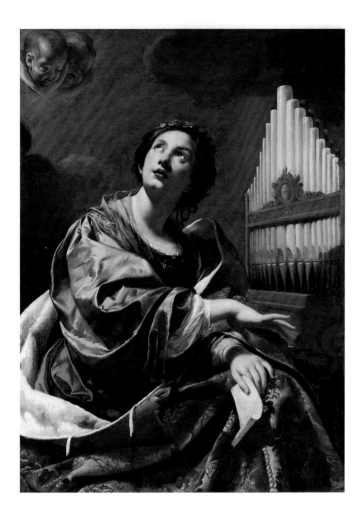

SIMON VOUET

Paris, 1590–1649

Saint Cecilia, c. 1626

Oil on canvas; 52¹³⁄₁₆ × 38¹¹⁄₁₆ in. (134.1 × 98.2 cm); The Suida-Manning Collection, 1999; 601.1999

A PROTEAN GENIUS, Simon Vouet participated in the major stages of the early Baroque in Rome, worked throughout Italy, then helped lay the foundation of French classicism. An underlying stylization of design betrayed his late-Mannerist formation. Reaching Rome in 1614, Vouet joined the followers of Caravaggio in their genre subjects and tenebrism. Influenced by both Giovanni Lanfranco and Guido Reni, his works of the 1620s became dynamic in composition, light in palette, and regular in expression. Brought back to Paris by Louis XIII in 1627, Vouet cultivated a brightly colored and increasingly ideal version of this style. It would dominate French painting through mid-century.

Saint Cecilia is a masterpiece from the moment before Vouet's departure from Rome. The cult of the third-century Roman martyr, the patron saint of music, had grown since the discovery of her purportedly uncorrupted remains in 1599. And rapturous, half-length female figures had become popular in Roman painting of the mid-1620s. Vouet's Cecilia is still Caravaggesque in her emphatic substance and finery, but transfigured by a rare palette and stylized ecstasy. A new monumentality and restlessness of form are owed to the example of Lanfranco's illusionism. Not least, the painting's delight in female beauty recalls Vouet's marriage to the young Roman painter Virginia da Vezzo in the same year.

Saint Cecilia is the centerpiece of the museum's seven paintings by the artist and his workshop.

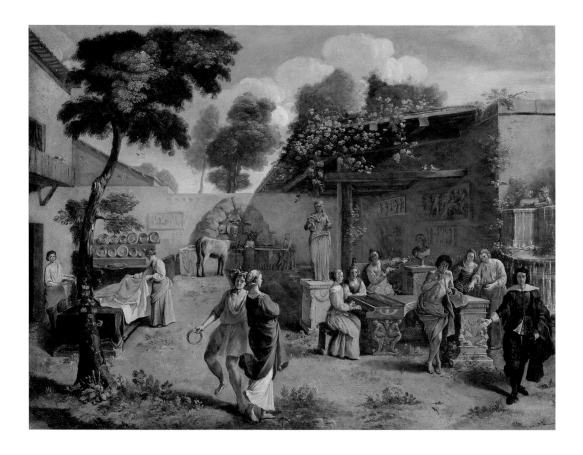

Giovanni Battista Passeri

Rome, 1610/1616–1679

Musical Party in a Garden, 1640s

Oil on canvas; 29 × 39 in. (73.7 × 99 cm); The Suida-Manning Collection, 1999; 438.1999

WITH ITS OPEN COURTYARD, Mediterranean light, and fragments of ancient sculpture, the setting here is typical of a garden on the outskirts of Rome. The gentleman at the right in contemporary attire addresses the viewer and presents several incidents. The woman in the blue mantle, the man in the orange tunic, and the semiclad piper seem engaged in a musical performance of classical inspiration. The group of women in modern costume accompanies them on a spinet. At the left two servants ready a table for dining. The precise meaning of the scene is obscure. Clearly, however, it expresses an ideal of the most elite intellectual circles in Rome: past and present

have been brought to simultaneous pictorial life, then transformed again by the ideal ordering of the classical tradition. Myth, idyll, genre, and probably even self-portrait—the proprietary gentleman— are compounded in this fascinating and poetical picture.

This work is close in subject and identical in style to Giovanni Battista Passeri's one signed painting (National Gallery of Ireland, Dublin). Its light palette, clear measure despite the ostensible revelry, and elaborate *concettismo*— self-conscious invention—reflect the artist's formation with the first generation of the classical Baroque, Domenichino in particular, and participation in the second alongside Nicolas Poussin. At the same time, the painting's apparently historical and literary spirit corresponds to Passeri's better-known endeavor as an important biographer of seventeenth-century Roman painters.

Claude Gellée, called CLAUDE LORRAIN

Champagne, France, 1604–Rome, 1682

Pastoral Landscape, c. 1628–1630

Oil on canvas; 24³⁄₁₆ × 34³⁄₄ in. (61.4 × 88.2 cm); The Suida-Manning Collection, 1999; 185.1999

CLASSICAL LANDSCAPE FOUND its highest and most enduring form in the work of Claude Lorrain. Active his entire career in Rome, Claude learned the rudiments from Agostino Tassi, integrated these with the distinct northern tradition of landscape, and dedicated himself exclusively to the genre. One of Claude's earliest known works, this picture presents a generic arcadian subject according to more established conventions for composition, color progression, and even paint handling, but it is overlaid by a softly textured and warm light. In the mature works, the formulae would recede, space would expand, and atmospheric light would fuse pictorial structure and pervade form. Evoking not just the glories of the Mediterranean past but the passage of time itself, this light became Claude's virtual subject. His style is like that of Rubens in asserting the priority of the transitory and temporal in representation. But his nature is more like that of vanitas paintings and idyllic poems in that these properties become metaphoric ends. In this sense his paintings express a tragic implication of Baroque style: the precariousness of meaning once individual sensation is made the measure of all things. For their incomparable beauty and perfect equation, but also for this metaphoric reach, Claude's landscapes would define the genre through the nineteenth century. The present painting stands at the very beginning of this fundamental tradition.

Claude Gellée, called **CLAUDE LORRAIN**

Champagne, France, 1604–Rome, 1682

Berger et bergère conversant [Shepherd and Shepherdess Conversing], c. 1651

Etching, Blum 37, Robert-Dumesnil 21, Mannocci 41, second state of seven; Plate: 7¹⁵⁄₁₆ × 10³⁄₈ in. (20 × 26.3 cm); Sheet: 7¹⁵⁄₁₆ × 10⁷⁄₁₆ in. (20.2 × 26.5 cm); The Leo Steinberg Collection, 2002; 2002.388

THE CREATOR of classical landscape painting, Claude Lorrain was an etcher of equivalent beauty and significance. Most of his prints were created in the 1630s. They evolved from the densely worked and animated style of Roman tradition to one approximating the subtlety of the artist's mature paintings. For nearly a decade after that, Claude did not return to etching. *Berger et bergère conversant* was one of the first plates after he resumed. As with many of Claude's etchings, the composition is related to that of a painting (Barnes Foundation, Merion, Pennsylvania). Much more than in early works, however, the conception was improvisatory, the initial handling broad, and the reworking of the plate pronounced. Claude had always made subtle changes to his plates in pursuing a desired effect. Now, the states test possibilities, vary mood as much as detail, and do not necessarily reach a conclusion. Here, the second state of the print involved extensive scraping and burnishing of the plate, eradicating entire passages, mottling the surface, and lightening the tone. No etcher in seventeenth-century Italy took greater advantage of the technique's opportunities for creative experiment.

The museum possesses sixteen etchings by Claude. The six in the Leo Steinberg Collection are all very early, fine, and today rare.

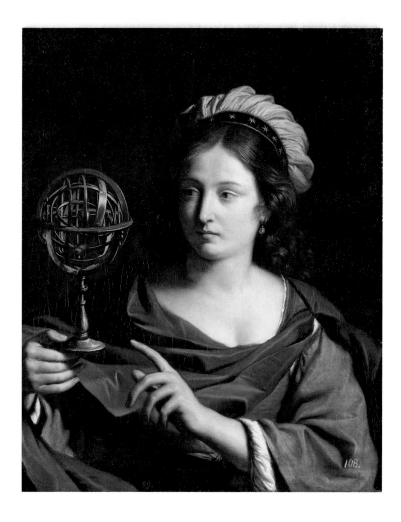

Giovanni Francesco Barbieri, called **GUERCINO**

Cento (Ferrara), Italy, 1591–Bologna, Italy, 1666

Personification of Astrology, c. 1650–1655

Oil on canvas; 31¾ × 25¾ in. (80.6 × 65.4 cm); Archer M. Huntington Museum Fund, 1984; 1984.57

AT THE ELECTION of Pope Gregory XV in 1621, Guercino had gone to Rome. There his deeply intuitive, sensuous style offered an alternative to the more schematic naturalism of Caravaggio's followers and the early classicism of Annibale Carracci. He was, however, affected by the classical tradition as well as by the emerging idealistic theory of art. Just as painters like Giovanni Lanfranco began to explore the possibilities of Guercino's style, he showed the first signs of disciplining it. For a while after his return to Cento in 1623, this retreat from the direction he had set could be reconciled with a stunning naturalism.

But around 1630, encouraged by the success of Guido Reni, there was a decided shift toward simplified composition, condensed light, and expression based upon shared rules. At Reni's death in 1642, Guercino moved to Bologna and took this style further, into the restrained and elegant classicism that had been Reni's domain. This painting is a splendid example of that latest style. Guercino's earlier identity as one of the first and greatest Baroque painters is still evident in the startling purity of color, optical behavior of light, and dissolved touch. But by now these qualities are subservient to an ideal conception of form, description of surface, and even characterization of personality. However much it may attract and please the eye, the picture transcends natural experience and attempts to engage the intellect.

JACQUES BLANCHARD

Paris, 1600–1638

Charity, 1634–1635

Oil on canvas; 43½ × 56¼ in. (110.5 × 142.9 cm); The Suida-Manning Collection, 1999; 50.1999

JACQUES BLANCHARD'S STYLE is a very attractive combination of a completely French, late-Mannerist formation and the influences from an Italian sojourn in 1624–1628, especially from Venetian painting. Traditionally called the "French Titian," although really more indebted to Paolo Veronese, Blanchard tended to infuse relatively simple, classicizing constructions and figure types with a soft luminosity, loose paint handling, and sensuous appeal. Although a bit formulaic and lacking in intellectual rigor, his works anticipate some basic concerns and conventions of later French academic painting, from Charles Le Brun through William-Adolphe Bouguereau.

The personification of Charity offered a high-minded pretext for rendering feminine beauty and physical allure. It was apparently a favorite of Blanchard and his patrons. This is one of several interpretations of the subject and one of six recorded versions of this particular composition. The primary version (Louvre, Paris) was one of the artist's most highly regarded works from the time it entered the royal collections in 1662. The present version, with its chiaroscuro less pronounced and its finish smoother, is a replica by the artist's own hand in excellent condition.

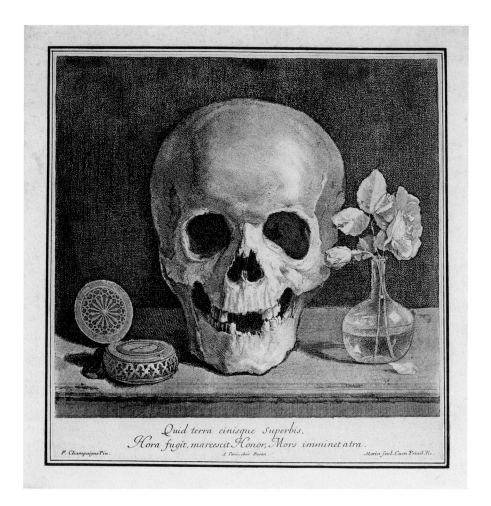

Quid terra cinisque Superbis,
Hora fugit, marcescit Honor, Mors imminet atra.

P. Champaigne Pin.　　　A Paris, chez Baron.　　　Morin fecil. Cum Priuil. Re.

JEAN MORIN

Paris, 1600–1650

Memento Mori, 1640s, after Philippe de Champaigne

Etching and engraving, Robert-Dumesnil 39, undescribed second
state of two; Sheet: 12⅝ × 12⁹⁄₁₆ in. (32.1 × 31.9 cm); The Karen G.
and Dr. Elgin W. Ware, Jr. Collection, 1996; 1996.110

IF LIMITED IN SUBJECT and even number of
plates, Jean Morin was the most subtle etcher in
seventeenth-century France. All of his work was
reproductive, mostly after paintings by the solemn
classicist Philippe de Champaigne. Morin inter-
preted these works in a mode inspired as much
by naturalistic painting as by printmaking, employ-
ing an extremely varied and flexible mark. His
rare landscapes and devotional works capture the
most fleeting and evocative qualities of light and
surface. Most of his work consists of portraits
of the size and bust format that was becoming
conventional in France.

The *Memento Mori* records a famous lost
composition by Champaigne. The motifs alone—
the skull set between an open timepiece and a vase
of roses—would symbolically express the transient
nature of existence. But their contrived arrange-
ment and exquisite rendering underscore the futil-
ity of attachment to the material world. As a
reminder of the ashes to which all persons will
return, it is also a somber retort to the ubiquitous
portrait prints of the day. This impression is laid
down on a heavy eighteenth-century sheet with
a severely drawn border. It was probably posted
as a funerary announcement. Because of such
adaptations, very few impressions have survived.

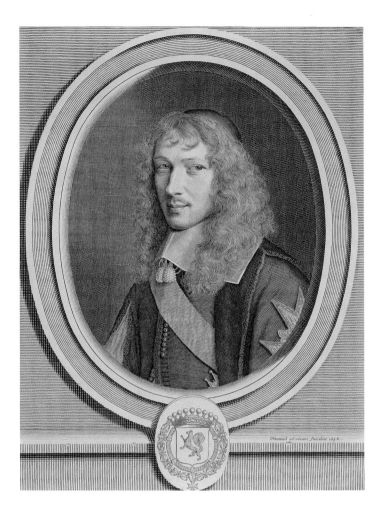

ROBERT NANTEUIL

Reims, France, 1623–Paris, 1678

Basile Fouquet, 1658

Engraving, Robert-Dumesnil 97, Petitjean & Wickert 75, second state of three; Sheet: 12⅝ × 9⅝ in. (32.1 × 24.4 cm); Anonymous gift in memory of Amy Cecelia Simkowitz-Rogers, 1996; 1996.316

MID-SEVENTEENTH-CENTURY France saw the emergence of an utterly coherent system of engraving that is among the major manifestations of the classical Baroque and among the great languages in the history of printmaking. Shortly after the foundation of the Royal Academy of Painting and Sculpture in 1648, engraving was elevated by royal edict from an industrial to a liberal art, incorporated as an academic discipline, and thus given equally systematic means for transmitting its skills and values.

The portraits of Robert Nanteuil were the first expression of this system. His work proceeds from an appropriation of Jean Morin's and Claude Mellan's modes, through a synthesis of their respective naturalism and idealism, to a moment in the late 1650s of extraordinary balance in the relation of one mark to another, sitter to frame, and form to ethos. Portraying a tenacious councillor of state who was later disgraced, this print is one of the artist's masterpieces. Much more than the conventions that Nanteuil established, it is his eminently rational conception and procedure, governing individual works and artistic development alike, that has been called "the constitution of French engraving." Nanteuil's achievement should be compared with that of Nicolas Poussin in painting, Pierre Corneille in tragedy, and René Descartes in philosophy.

The collection boasts 122 engravings by Nanteuil, more than half his oeuvre, with numerous prints in multiple states.

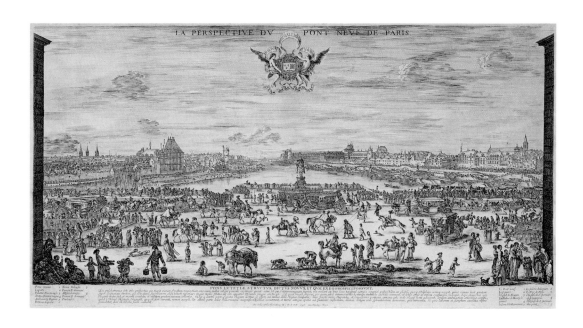

STEFANO DELLA BELLA

Florence, 1610–1664

La perspective du Pont Neuf de Paris [View of the Pont Neuf in Paris], 1646

Etching, DeVesme & Massar 850, first state of two; Plate: 14⅛ × 27⅛ in. (35.8 × 68.7 cm); Sheet: 14⁵⁄₁₆ × 27⁵⁄₁₆ in. (36.4 × 69.4 cm); Gift of Patricia Ross, by exchange, 2003; 2003.124

THE FINEST PROFESSIONAL etcher in seventeenth-century Italy, Stefano della Bella brought high Baroque style, rich invention, and subtle hand to the interpretation of contemporary and genre subjects. Jacques Callot inspired his interests and early service to the Medici. While working in Rome in the 1630s, he studied art broadly. In Paris in the 1640s, under the patronage of the Cardinal Mazarin and the Duc de Richelieu, he was further influenced by Dutch etching. His late series transcends their genre to achieve real painterliness and anticipate aspects of eighteenth-century etching.

This is the masterpiece of della Bella's period in Paris. The Pont Neuf was the city's first modern bridge and a popular meeting place. The near ground is a microcosm of French society, from royal carriages and strolling lovers to ruffians and stray animals. At the center of the bridge presides a statue of Henri IV, who had seen the structure completed in 1604. Beyond spreads a westward panorama of the heart of Paris, its monuments identified in the key below. Apparent only in such early impressions, the whole is pervaded by a heavy atmosphere and animated by a sparkling light. Combining genre scene, historical print, and topographic view, it is an extended metaphor of France itself.

The collection contains 111 etchings and three fine drawings by della Bella.

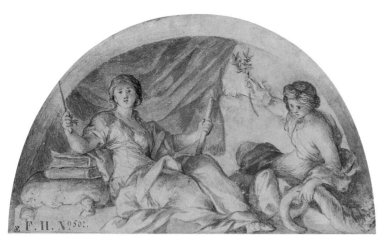

Giovanni Francesco Romanelli

Viterbo, Italy, 1610–1662

Justice and Abundance and *Prudence and Foresight*, 1655–1657

Watercolor over black and red chalks on cream antique laid paper; 4⅝ × 7¹⁵/₁₆ in. (11.7 × 20.1 cm) each; The Suida-Manning Collection, 1999; 503.1999a; 503.1999b

ADMIRED IN HIS OWN TIME as one of Europe's greatest painters, Giovanni Francesco Romanelli is today considered an elegant interpreter of his master, Pierto da Cortona, and an important exponent of Roman Baroque style. Romanelli was called to work in Paris twice. The principal project of his second sojourn was the decoration of the apartment of Anne of Austria, the queen mother, in the Louvre Palace. During these years the powerful chief minister, Cardinal Mazarin, was promoting contemporary Italian style. The frescoes epitomize his cultural program, which in turn influenced the course of French painting.

These drawings prepared the decoration of two of the six blind arches above windows in one of the apartment's rooms. Highly finished and extremely attractive, they were surely models submitted to Anne and her advisors for approval prior to the execution of the project. These and a few related studies for the apartment represent the height of Romanelli's draftsmanship. His drawings are generally simpler, prettier versions of Cortona's language, often phrased with a rich and inherently pictorial technique. The drawings for the apartment show an orderly design, disciplined form, and handsomely generalized effect that had been latent from his earliest training, with Domenichino, and emerged under the influence of Guido Reni in the preceding decade.

ESAIAS VAN DE VELDE

Amsterdam, 1587–The Hague, Netherlands, 1630

Landscape with a Lighthouse, c. 1624

Black chalk and brown wash on cream antique laid paper; 4¹⁵⁄₁₆ × 6⅝ in. (12.5 × 16.8 cm); Archer M. Huntington Museum Fund, 1980; 1980.55

ESAIAS VAN DE VELDE is the father of Dutch landscape painting. Cultivating an explicitly realistic representation of nature, he established the early conventions and set the stylistic direction in Holland. This new vision was based upon a rejection of both the imaginary subjects preferred by the late Mannerists and their extreme stylization even when treating less fantastic views or motifs. Van de Velde essayed familiar reality in a deliberately simplified and unpretentious fashion. Characteristic, this drawing is one of about a dozen that survive from a dismembered sketchbook.

The Mannerists' layered and interpenetrated composition has yielded to a single diagonal that leads steadily across the dunes like a path. Their complex color scheme has been replaced by a uniform tonality that evokes natural light and palpable atmosphere. Moreover, van de Velde's reality was not just familiar to the eye but specifically Dutch. Especially telling in this drawing, the low horizon, landmarks like the old lighthouse, and figures like the successful fishermen imply the sea comfortably nearby. Such drawings are among the first works to express the great pride of place in the recently independent Holland. In common with the work of Jan van Goyen and Pieter Molijn, this conception and these formal terms inaugurated the school's most original and influential tradition.

Secura reddamus tempora mensa
venit post multos una serena dies. Tibull.

Adriaen van Ostade

Haarlem, Netherlands, 1610–1685

The Breakfast (Le gourmet en campagnie),
c. 1647–1652

Etching, Bartsch, Hollstein, Godefroy 50, eighth state of twelve;
Plate: 8⁹⁄₁₆ × 10¼ in. (21.8 × 26 cm); Sheet: 8¹⁵⁄₁₆ × 10⅝ in.
(22.7 × 27 cm); The Leo Steinberg Collection, 2002; 2002.2422

Adriaen van Ostade was Holland's foremost artist of village life and its finest etcher after Rembrandt. In a Netherlandish tradition going back to Pieter Brueghel, his paintings show peasants in rural settings engaged in daily activities. The larger, more elaborate plates are variations on his own painted compositions. Most, inspired by Rembrandt, are smaller, briefer sketches of rustic types and their interactions. Fifty in all, they are characterized by very careful drawing, painstaking development of texture and color through successive

biting, and sympathetic observation. The collection counts eighteen, half in rare, early impressions.

The Breakfast is one of Ostade's largest and most painterly etchings. It renders the interior of a farmhouse with an assortment of types enjoying drink. However modest and cluttered the setting, the composition is definite in structure and subtle in balance. Similarly, the characters may be coarse in appearance and boisterous in gesture, but they are afforded kindness and dignity. Light reinforces the scene's coherence, adds further expressive warmth, and even imparts a sacramental sense. Ostade's etchings were tremendously successful. That their audience was urban and highly educated, with notions of a simpler time and place, is emphasized by the Latin inscription from the Roman poet Tibullus: "We spend time for an untroubled table—After a lengthy wait, a fair day comes."

REMBRANDT HARMENSZ. VAN RIJN

Leiden, Netherlands, 1606–Amsterdam, 1669

Self-Portrait Wearing a Soft Cap (The Three Mustaches), c. 1634

Etching, Bartsch 2, Hind 57, White & Boon 2, only state; Plate: 2 × 1¾ in. (5 × 4.3 cm); Sheet: 3⁷/₁₆ × 2¹³/₁₆ in. (8.7 × 7.1 cm); Blanton Ball Purchase, 2002; 2002.2839

SELF-PORTRAITURE was at the core of Rembrandt's art. His studies of his own appearance, unusual enough in number, in their play with guises, and in their variety of formats, transcend any convention in their visible probing of the self. In turn, they prepared a vocabulary to express the inner workings of other personalities and, more universally, the inclinations of the soul. Both the astonishing individuality and general humanity of Rembrandt's personages arise from, and were rehearsed through, this activity.

Rembrandt explored self-portraiture in sustained campaigns. The most intensive and experimental occurred among the late paintings and among the early etchings. Never formally published or reprinted, these prints were created for the artist's own satisfaction and are therefore among his rarest. Here he presents himself in a rakish cap, ever sensitive but quite confident. It is the most direct and emotionally mature of the first campaign.

The early self-portraits were no less experimental in technique. Their incredible spontaneity, economy, and of course size suggest the most intimate sketches. Along with some related portraits, these prints represent the most radical expression to date of the conceptual and procedural relation between etching and drawing. In this sense, they also predict Rembrandt's accomplishments as the greatest master of etching.

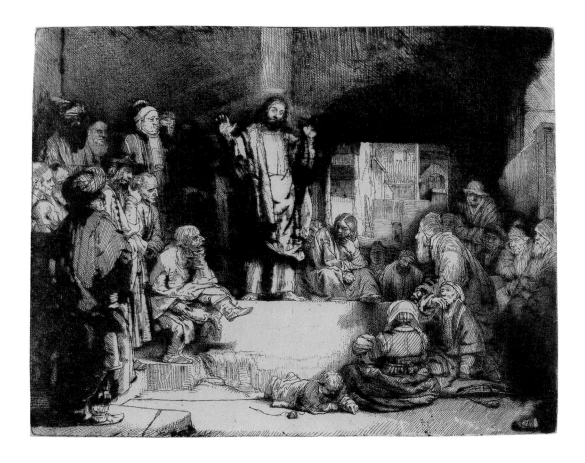

Rembrandt Harmensz. van Rijn

Leiden, Netherlands, 1606–Amsterdam, 1669

Christ Preaching (La Petite Tombe), c. 1652

Etching, drypoint, and burin on Japanese paper, Bartsch 67, Hind 256, White & Boon 67, only state; Sheet: 6⅛ × 8⅛ in. (15.5 × 20.6 cm); Purchase through the generosity of the Still Water Foundation, The Dean of the College of Fine Arts, and the Archer M. Huntington Museum Fund, 1995; 1995.46

Christ Preaching is one of Rembrandt's most famous and beautiful etchings. Its traditional title, *La Petite Tombe,* refers to the pedestal beneath Christ—a "little tomb"—but derives from a misunderstanding of an early reference to Pieter de la Tombe, for whom Rembrandt probably created the print. The scene conflates the events in Matthew 19, the culmination of Christ's ministry, in which he explains the sanctity of marriage, orders his disciples to "let the children come to me," and describes the virtue of poverty. The

composition, conceived in light of works by Raphael, is unusually explicit in structure. Christ's alignment with its axes and his gesture, arms upraised, hands oversized, effectively prefigure the Crucifixion. At the same time, this rigor and this content are relieved by wonderfully observed human incidents, from the unmoved Pharisees to the children, one dumb and led by the hand, another oblivious as he draws with a finger. All are subjected to a mysterious shadow that fuses the theological and human meanings of the scene. These meanings emerge in any impression, but no more than a handful so thoroughly express the artist's aesthetic intention. With the work in drypoint vivid, a veil of ink tone unifying the surface, and a slightly translucent Japanese paper imparting a faint glow, this would have been among the very first printed by Rembrandt himself.

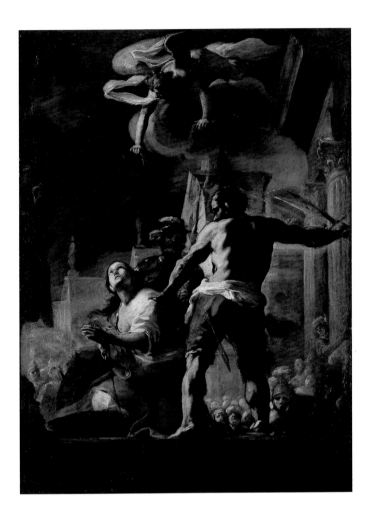

MATTIA PRETI

Taverna (Calabria), Italy, 1613–Valletta, Malta, 1699

The Martyrdom of Saint Catherine,
c. 1657–1659

Oil on canvas; 39 9/16 × 29 1/2 in. (100.5 × 75 cm); The Suida-
Manning Collection, 1999; 484.1999

MATTIA PRETI'S ARTISTIC FORMATION was
principally Roman, with a foundation in late Cara-
vaggesque naturalism, then attraction to the more
summary and dynamic styles of the later Emilian
painters Guercino and Giovanni Lanfranco. He
worked mostly in Rome until the early 1650s, then
alternately between that city and Naples, with
some trips north, before settling in Malta in the
early 1660s. In their recapitulation of early Baroque
styles and their extension into a decorative man-
ner of bold shapes, mobile light, and impetuous
handling, his mature work prepared the way for
important aspects of eighteenth-century painting.

Specifically, his style determined the later school
of Naples.

This painting captures not only Preti's extra-
ordinary vitality but the essence of his innova-
tions in decoration. It is a sketch for one of the
ten canvases executed from 1657 to 1659 and set
into the carved and gilt ceiling of the church of
San Pietro a Maiella in Naples. The foreshorten-
ing of the composition, the abbreviation of its
description, the violence of its gestures, and the
starkness of its illumination are all tendencies of
Preti's mature style. Here, however, they are exag-
gerated in preparation for the eventual painting's
monumental scale and high position. The paint-
ings in San Pietro constitute Preti's most important
project in the city. This sketch is his only known
study for the project.

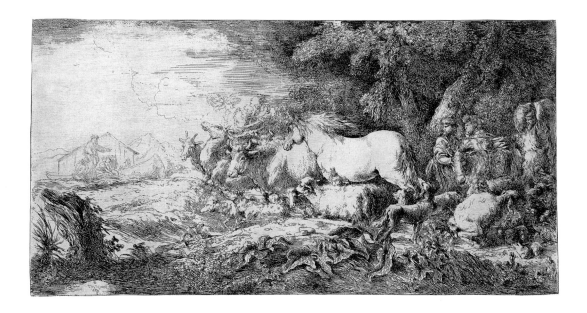

GIOVANNI BENEDETTO CASTIGLIONE

Genoa, Italy, 1609–Mantua, Italy, 1664

Noah and the Animals Entering the Ark, c. 1650

Etching, Bartsch 1, Percy 24, Bellini 61, only state; Sheet:
8 × 15¹¹⁄₁₆ in. (20.3 × 39.9 cm); The Leo Steinberg Collection,
2002; 2002.1768

BY ORIGIN AND PERIODIC association, Giovanni
Benedetto Castiglione was Genoese. His style
thoroughly reconciles the school's residual Man-
nerism with its naturalism of Netherlandish cast.
At the same time, spending much of the 1630s
and 1640s in Rome, he assimilated Nicolas Poussin
and Pietro Testa's highly intellectual and idealized
Baroque. Castiglione's curiosity and openness
are confirmed by his ceaseless exploration of the
graphic arts and by his late activity across northern
Italy. More than any other figure, he transcended
conventional Baroque categories and predicted the
dominant tendencies of eighteenth-century style.

Combining noble theme with a pretext for
genre, the journeys of the patriarchs in the Book
of Genesis were a constant subject in Castiglione's
art. With the added appeal of a menagerie, Noah
and the loading of the Ark was a particular favor-
ite. The many versions include an early oil on
paper in the Suida-Manning Collection. Here,
the procession is organized with the simple struc-
ture and slow cadence of an ancient relief, but
brought to life by the busy hand, textured light,
and even bawdy accent of Rembrandt's early
etchings.

Castiglione's etchings are the finest of the
period in Italy. This is perhaps his most pictorial
and coherent. Characterized by great clarity, a
silvery tone, and dense polishing scratches, this
is an especially early impression. The museum
possesses forty etchings by the artist.

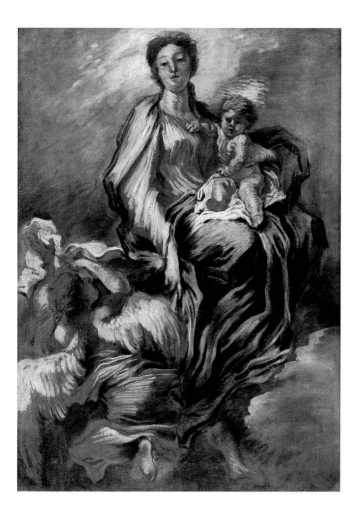

GIOVANNI BENEDETTO CASTIGLIONE

Genoa, Italy, 1609–Mantua, Italy, 1664

Madonna and Child in Glory with an Angel, c. 1654–1655

Brush and colored oil paint on cream antique laid paper, glued down on canvas; 21 1/16 × 15 7/16 in. (53.5 × 39.2 cm); The Suida-Manning Collection, 1999; 162.1999

MONUMENTAL IN CONCEPTION and pictorial in development, this work dramatizes the interrelation of media and character of research in Giovanni Benedetto Castiglione's art. Brush with oil paint on paper was his preferred graphic technique after around 1650. Although the motif recalls several altarpieces, and its loaded pigment and close brushwork resemble those of a preparatory *bozzetto*, this study was apparently conceived as an autonomous work. Such studies were the most focused and sustained of Castiglione's innumerable variations upon motifs established in his paintings.

This sketch is also an outstanding example of the complex sources of Castiglione's mature style. The inspiration of Rubens and Anthony van Dyck is still palpable in the technique, rhythmic articulation, and modulated light. The lyrical touch recalls another early influence, the Genoese works of Giulio Cesare Procaccini. These accommodate, however, later Roman examples: the luminous color of Giovanni Lanfranco and the extravagant form of Gianlorenzo Bernini. Specifically, the haughty Virgin and convulsed angel paraphrase the composition and invert the relationship in the sculptor's famous *Saint Theresa in Ecstasy*. Not only was Castiglione in contact with Bernini during his second Roman sojourn, but the Cornaro Chapel was the sculptor's principal project at the time.

The Suida-Manning Collection includes ten works on paper by the artist.

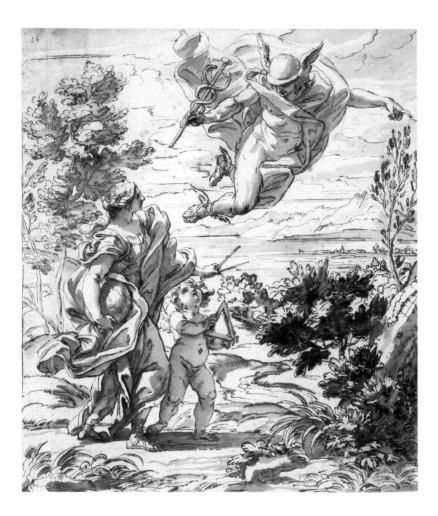

Giovanni Battista Gaulli, called BACICCIO

Genoa, Italy, 1639–Rome, 1709

Mercury Leading Geography, c. 1690

Pen and iron gall ink with brush and brown and gray washes over black chalk on cream antique laid paper, laid down; 11⅝ × 10¼ in. (29.6 × 26.1 cm); The Suida-Manning Collection, 1999; 13.1999

ROOTED IN THE GENOESE SCHOOL, shaped by a long collaboration with Gianlorenzo Bernini, and inspired specially by Correggio, Baciccio's style is the most complete expression of the High Baroque in painting. Overwhelming in their illusionism and ecstatic in their spirituality, his frescoes, above all in the Gesù (1672–1683), represent the culmination of Roman ceiling painting. Similarly, his altarpieces, mythological works, and portraits are incomparable in their robust sensuousness and vibrant color.

This is a study for an engraved frontispiece in the most important atlas of the period in Rome. Although less known for such projects, Baciccio was a successful designer of book illustration. Surprising on this scale, the undulating rhythm and the intertwined form evoke his monumental decoration. At the same time, the composition is conditioned by the diagonal scheme of the conventional late Baroque. The space is more measured in construction, like that of classical landscape. The attitudes and behavior too seem more systematically conceived and carefully staged. This tempering of Baciccio's characteristic exuberance would have facilitated the design's translation into engraving. But it is also symptomatic of his late concessions to academic style.

Baciccio's work is represented in the museum by a portrait painting, two oil sketches, and three other drawings.

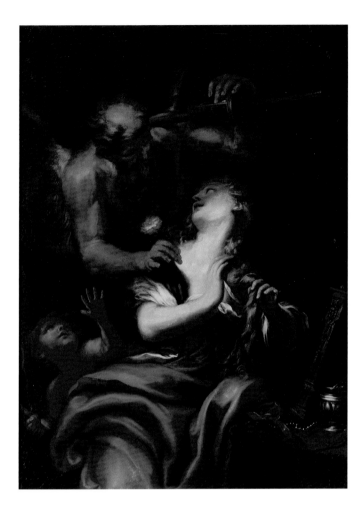

DOMENICO PIOLA

Genoa, Italy, 1627–1703

Allegory of Youth, c. 1680

Oil on canvas; 60¹¹⁄₁₆ × 44¾ in. (154.1 × 113.6 cm); The Suida-Manning Collection, 1999; 467.1999

DOMENICO PIOLA and his pupil Gregorio de Ferrari were the leading painters in Genoa during the second half of the seventeenth century. With the catalyst of Pietro da Cortona's High Baroque cycles, in a manner so fluent as to seem automatic, Piola managed to generalize the lessons of Rubens's and Anthony van Dyck's dynamic naturalism and translate them into the grand-scale decoration of the native Genoese tradition. Few palaces in Genoa and scarcely a church in Liguria lack a work with the undulating rhythms, and softly modulated light that are his trademarks. Piola's works may not be the most varied in solution or deep in characterization, but they convey an

ease, even a joy, that is estimable and historically significant.

Here a beautiful young woman is interrupted by an aged, winged male who holds an hourglass and scythe in one hand and presents a flower with the other. The subject is related in basic elements and composition to a common Baroque allegory, Time revealing Truth. In fact, the explicit vanity of plaiting hair, the implicit one of a mirror, the futile gesture of the little boy, and the flower shift the meaning to the short duration and precariousness of physical beauty. In its suave rhythms and decorative amplitude, the painting exemplifies Piola's mature style.

The Suida-Manning Collection's four pictures, Piola's only works in an American museum, span his entire career.

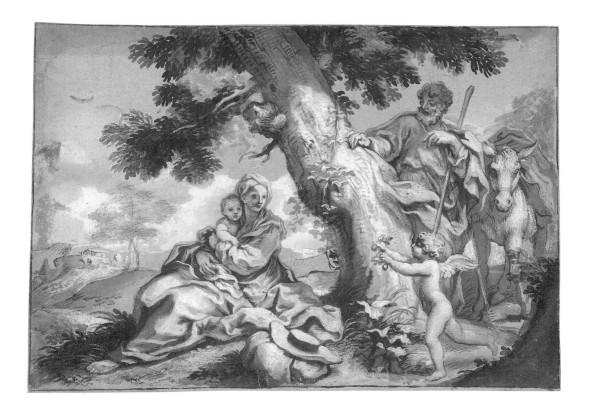

PAOLO GEROLAMO PIOLA

Genoa, Italy, 1666–1724

The Rest on the Flight into Egypt, c. 1690–1694

Brush and brown ink with brown and gray washes and white heightening (partly oxidized) over black chalk on gray-green antique laid paper, laid down; 10⁵⁄₁₆ × 15¼ in. (26.2 × 38.7 cm); The Suida-Manning Collection, 1999; 463.1999

THIS DRAWING REPRESENTS a culmination of numerous currents in Genoese draftsmanship. Of extremely high finish and inherent attractiveness, it is manifestly an autonomous work in the tradition that began with Luca Cambiaso. In its painterly conception and handling, such a drawing descends more specifically from Giovanni Benedetto Castiglione's exploration of the boundary between the media. Formally, the composition is an especially fine example of the translation of the habits of monumental decoration—broad distribution of motif, balanced structure of values, steady pulse of rhythm—into the intimate scale and materials of drawing.

Although this is one of the best-known Genoese drawings in the Suida-Manning Collection, its attribution has alternated. Most often, because of its repertory relationship to works by Domenico Piola and no doubt its sheer quality, it has been assigned to the elder Piola. The more agitated surface of draperies, the more eccentric drawing in profiles, and the sharper modulation of tone reflect the formative influence of Gregorio de Ferrari. That these tendencies have been disciplined according to academic principle reflects the younger Piola's long study with Carlo Maratta in Rome and then his collaboration with various sculptors. Purely Genoese, entirely within the seicento, the style of Domenico is different in both appearance and essence.

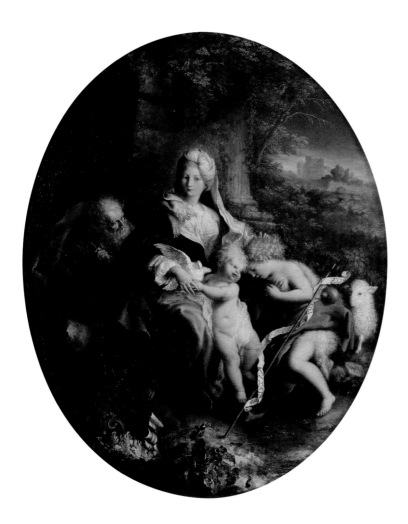

BARTOLOMEO GUIDOBONO

Savona, Italy, 1654–Turin, 1709

Holy Family with the Young Saint John the Baptist, c. 1680–1685

Oil on canvas; 28⁷⁄₁₆ × 22¹⁵⁄₁₆ in. (72.3 × 58.2 cm); The Suida-Manning Collection, 1999; 326.1999

LOVELY IN DESCRIPTION, sweet in disposition, and careful in craft, Bartolomeo Guidobono's work is a distinctive variation upon the grand manner of late seventeenth-century Genoese painting. His style arose from his first training and lifelong collaboration in the family business of fine porcelain painting. Its larger context is the Genoese taste for Netherlandish painting that goes back to the fifteenth century. After a series of trips to Emilia, Guidobono shifted this already delicate style toward the soft contour, luminous color, and gentleness of Correggio. Later he would reconcile it with the large rhythms and efficient manufacture of Domenico Piola.

This *Holy Family* is a beautiful compendium of Guidobono's early style. Its matrix is surely Genoese, with the figural group suggested by Piola and the pure hues reminiscent of Baciccio. Instead, the grain of light, amplitude of the figures, and tenderness reveal the recent debt to Correggio. Most impressive, however, are the refined drawing and meticulous finish, practically those of a miniature painting. In few other works of Guidobono is the craft more sustained or the reflection of his first activity more apparent. This unorthodox *petite manière* also anticipates the prettiness of the Rococo and the developing relation of the Genoese school to the French. In fact, the painting was at one time attributed to the eighteenth-century French painter Jean-Baptiste Le Prince.

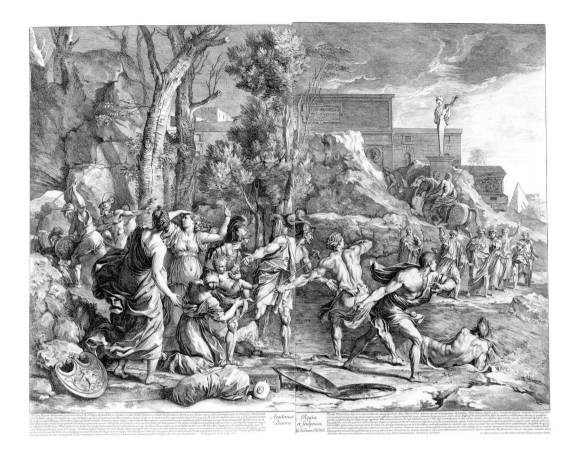

GÉRARD AUDRAN

Lyon, 1640–Paris, 1703

The Saving of the Infant Pyrrhus, 1674,
after Nicolas Poussin

Etching and engraving on two sheets, Robert-Dumesnil 54, Inventaire 62, Johnson 12, third state of three; Outer dimension of combined sheets: 28⁹⁄₁₆ × 37⅛ in. (72.5 × 94.3 cm); Purchase through the generosity of the Print Study Group, 1990; 1990.194

GÉRARD AUDRAN'S INNOVATION and ambition established his family's reputation as the most celebrated workshop of engravers in France. He learned his art from his father and perfected his skills in Rome. Upon his return to Paris, he came to the attention of Charles Le Brun, the most important artist in Louis XIV's court, who recognized Audran's talent and remarked that his reproductions of paintings were often better drawn than the originals he copied. Another critic said that

the artist "paints with the needle and burin, and in his hands these two instruments take on the facility of a brush."

They were responding to Audran's unconventional combination of etching and engraving that allowed each technique to retain its distinctive character, rather than layering or compounding them so that they become indissoluble. This method lent his plates a dynamism and animation not seen in other artists' work. He worked, too, on a scale that won him the admiration of his peers and collectors. Here, he reproduced Nicolas Poussin's The Saving of the Infant Pyrrhus (Louvre, Paris) on two sheets joined together and presented it to the Académie Royale in gratitude for accepting him into its ranks earlier in the year.

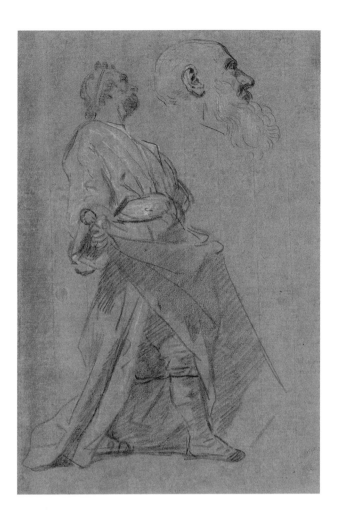

JEAN-BAPTISTE JOUVENET

Rouen, France, 1644–Paris, 1717

Studies of a Standing Man, c. 1700

Black and white chalks on gray paper, laid down, Schnapper 167; Sheet: 14¹³/₁₆ × 9¹⁵/₁₆ in. (37.7 × 25.3 cm); The Suida-Manning Collection, 1999; 343.1999

JEAN-BAPTISTE JOUVENET is counted among the masters of French Baroque painting. He hailed from a family of artists in Rouen and worked with Charles Le Brun on the decorative programs for a number of royal palaces, including Versailles. A member of the Académie Royale, he excelled at history paintings typically seen in municipal buildings, churches, and aristocratic residences. Jouvenet's fame lasted well into the eighteenth century, when his draftsmanship in particular was admired. Denis Diderot used Jouvenet's study of two male nudes to illustrate his essay on drawing in the *Encyclopédie*.

Once attributed to Simon Vouet, this study has since been recognized as an example of Jouvenet's mature work—one of the few drawings by this artist in the United States. Jouvenet's drawing here is "hardy and correct," as one eighteenth-century commentator remarked. His treatment of drapery as a network of sharp angles created with strong, closely spaced hash marks and his sure handling of the figure's contours convey a sense of clarity, solidity, and volume that is characteristic of French drawings of this period. Though not definitively related to a painting, this study is similar to a figure in the artist's *Descent from the Cross* of 1697 (Louvre, Paris).

NICOLAS DE LARGILLIERE

Paris, 1656–1746

Portrait of a Man, c. 1715

Oil on canvas; 36⁵/₁₆ × 29¹¹/₁₆ in. (92.2 × 75.4 cm); The Suida-Manning Collection, 1999; 359.1999

WITH MORE THAN 1,500 PORTRAITS to his credit, Nicolas de Largilliere was one of the most prolific portraitists of his time. He enjoyed the patronage of the royal families in England and France and members of the aristocracy, who frequently had their painted portraits reproduced as engravings in order to distribute them more widely. Arguing that portraiture was the preroga-tive of the aristocracy alone, one commentator wrote in 1787, "This custom [of having one's portrait made] is nevertheless to be recommended among noblemen in order to stimulate them to uphold the glory of their honorable names and prevent them from doing anything to tarnish it . . . whereas it is only stupid conceit for the ordinary individual to seek to preserve his likeness with the aid of art." But with the rise of the middle class in the seventeenth and eighteenth centuries, the bourgeoisie increasingly commissioned portraits of themselves, although they rarely went to the expense of having engravings made after them. Largilliere preferred his bourgeois patrons to those at court because they paid better and on time, and were less demanding. Especially casual in garb and amiable in attitude, this sitter may well have been a fellow artist.

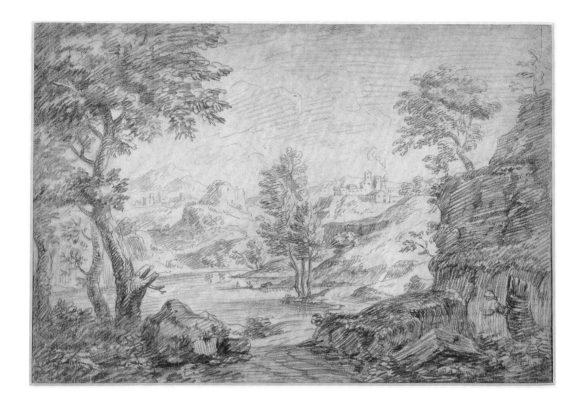

JEAN-ANTOINE WATTEAU

Valenciennes, France, 1684–Paris, 1721

Landscape in a Venetian Manner, c. 1715–1716

Red chalk on cream antique laid paper; Sheet: 11 9/16 × 17 5/16 in. (29.3 × 44 cm); Archer M. Huntington Museum Fund, 1982; 1982.725

JEAN-ANTOINE WATTEAU is best known for his *fêtes galantes*, a term invented by the Académie de France in 1717 especially to describe the artist's variation on the traditional theme of outdoor feasts. In these pictures elegant young couples frolic in pastoral settings. Watteau kept bound albums of his own landscape drawings—some made from nature and others copied from earlier artists—which he later incorporated into his painted compositions. Although Watteau never had the good fortune to travel to Italy, he had access to a substantial collection of Venetian drawings owned by

Pierre Crozat, his patron and benefactor. He copied the works of Titian, Domenico Campagnola, and the Bassano family from this collection.

No model has yet been identified for this drawing within that Venetian collection, but it is characteristic of others more securely attributed to this period. The mountainous background and the medieval hilltop town crowned with asymmetrical towers signal Italian inspiration. The tree in the left foreground, used as a framing device for the composition, is a familiar refrain in Watteau's Venetian copies. The artist's interpretations of his Venetian predecessors are unique, however, in their featherlike touch and a delicacy that suggests life's fragility and transience.

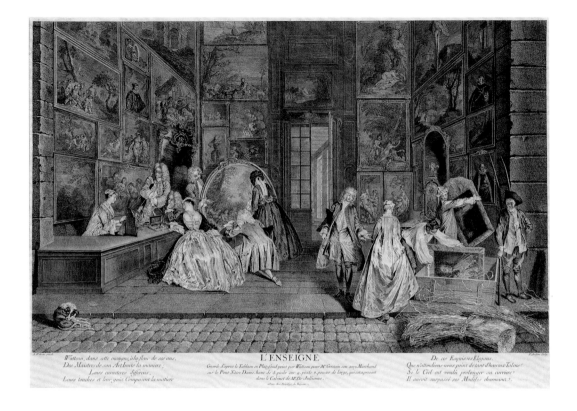

PIERRE-ALEXANDRE AVELINE

Paris, 1702–1760

L'enseigne de Gersaint [Gersaint's Shop Sign],
c. 1732, after Jean-Antoine Watteau

Etching and engraving, Dacier & Vuaflart 115, third state of three;
Plate: 22¹³⁄₁₆ × 33⁹⁄₁₆ in. (58 × 85.3 cm); Sheet: 23⅜ × 34 in. (59.4 ×
86.3 cm); Archer M. Huntington Museum Fund, 1997; 1997.133

FINE AND SPARKLING, this impression of Pierre-Alexandre Aveline's reproduction of Jean-Antoine Watteau's *L'enseigne de Gersaint* of 1721 (Palais Charlottenburg, Berlin) is the centerpiece of the museum's early eighteenth-century French prints.

In 1721 the art dealer Gersaint commissioned Watteau to make a shop sign for his gallery. Casually arranged in the artist's trademark lyrical style, the wealthy clientele visiting the shop are as much on display as are the paintings that they study. Cleverly marking the new political era, Watteau included a vignette of handlers packing away a portrait of Louis XIV, who had died seven years earlier.

By combining the techniques of engraving and etching in this reproduction, Aveline achieved an impressive range of tones and details—for example, in the reflections in the mirror and in the windowpanes of the door that leads into an interior room at the center. What Watteau was able to do in paint with the shimmering fabric of the costumes, Aveline successfully translated into black and white using the burin and etching needle. Although Watteau died at thirty-seven, his art continued to have an impact until the end of the century, in part through reproductions such as this.

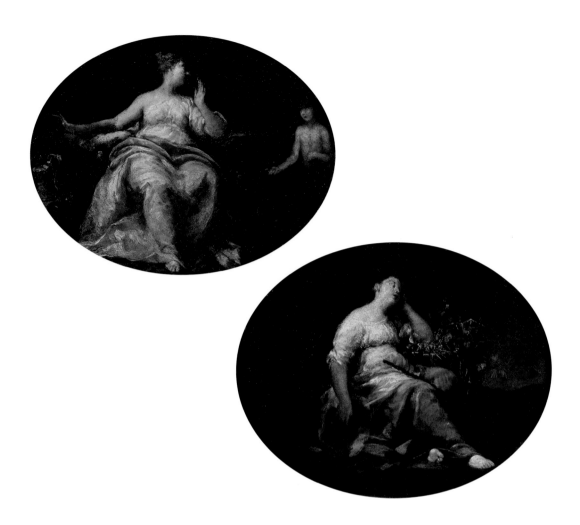

Giuseppe Maria Crespi

Bologna, Italy, 1665–1747

Woman Surprised by a Boy (Spring) and
Sleeping Shepherdess (Fall), 1698

Oil on copper; 6¼ × 9 in. (15.9 × 22.9 cm) each; The Suida-Manning Collection, 1999; 202.1999 and 199.1999

IN SCALE AND INCIDENT, these paintings on copper reveal Giuseppe Maria Crespi at his most intimate and charming. Traditionally their subjects were described as allegories of spring and fall. Without excluding such associations, they are better described as bucolic reveries, the one involving a feigned drama, the other a quiet grace. Their meaning, like much of Jean-Antoine Watteau's work, is deliberately imprecise and therefore broadly poetic.

Crespi was a great individualist of the late Baroque and in turn one of the most striking realists in European painting. In one sense, his style is proto-Romantic, based upon a rejection of academic training and the predictable style it was engendering. In another, it represents a conscious return to the naturalistic light, sincere feeling, and personalized touch of early seventeenth-century Bolognese painters like Guercino. Crespi's interpretation of religious and mythological subjects is idiosyncratic, seemingly ingenuous, and reinforced by the delicate matter of his pearlescent light and scumbled surface. And unique are his choice, psychological exploration, and dignifying of genre subjects. Crespi's realism reflects the taste of both a fading nobility and an emergent bourgeoisie for emblems of a simpler, unaffected existence. But these works are so unexpected and acute in observation that they predict significant aspects of nineteenth-century painting.

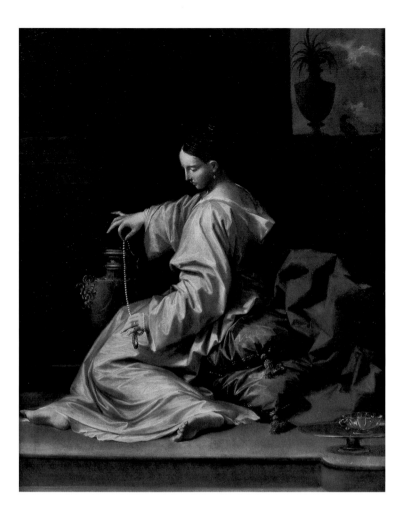

DONATO CRETI

Cremona, Italy, 1671–Bologna, Italy, 1749

Cleopatra, 1710s

Oil on canvas; 29⁹⁄₁₆ × 24⅛ in. (75.1 × 61.3 cm); The Suida-Manning Collection, 1999; 208.1999

DONATO CRETI'S STYLE represents the most self-conscious and rarefied classicism in late Baroque painting. Trained in the Bolognese academy, he reacted against its increasingly stale and unfelt formulae by attempting to return to its first principles, or at least early manifestation, in the art of Guido Reni. The result of this deliberate archaism is an extreme refinement of form and color, a complete suppression of affect, and an unearthly beauty. In character and appearance, Creti's works recall Mannerism created in the region of Emilia and equally anticipate the true Neoclassicism of several generations later.

Cleopatra is a perfect demonstration of this ideal style. The attitude could scarcely be more contrived, the drawing more elegant, the palette more artificial, and the psychology more remote. Intellectual appeal overwhelms plausibility and empathy. Light, space, and sentiment—reasoned and shaped but still accessible in the period's conventional classicism—here become near abstractions. Creti would often create replicas of individual motifs from larger compositions. This figure corresponds to one that appears in the painting *Achilles Dipped in the Styx* (Pinacoteca Nazionale, Bologna). Here, however, the motif is more logical and better resolved, suggesting that it preceded the larger composition. Patrons, it seems, requested not just replication but incorporation of favorite motifs, which Creti's conceptual and systematic style could readily accommodate.

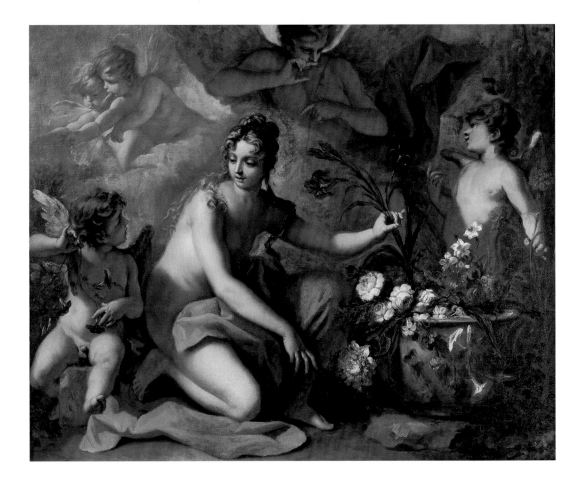

SEBASTIANO RICCI

Belluno, Italy, 1659–Venice, 1734

Flora, c. 1712–1716

Oil on canvas; 49⁵⁄₁₆ × 60½ in. (125.3 × 153.7 cm); The Suida-Manning Collection, 1999; 494.1999

IN OVID'S *FASTI*, the nymph Chloris is seduced by the West Wind, Zephirus, and renamed Flora, goddess of flowers and the spring. This painting renders the moment before her seduction. At the right, a vessel spills over with the product of this union, the inspiration of the nymph's new name. The composition is so balanced, its rhythm so elegant, and its material so rich that a quotation from antique statuary—the Crouching Venus—appears seamless. The painting evokes the great mythological works of sixteenth-century Venice.

Sebastiano Ricci inaugurated the second great age of the Venetian school. Trained in Bologna,

Parma, and Rome, he absorbed the full range of the late academic Baroque. Back in Venice by 1700, he consulted Luca Giordano's more vital, eclectic style, and above all referred to Paolo Veronese's grand reconciliation of painterly values and systematic decoration. The resulting style is synthetic, but with the classical component deeply assimilated, the optical component enhanced through stunning color, and the paint handling personalized with sensuous brushwork. This style also played a critical historical role: Ricci worked in London and Paris in 1712–1716, influenced Central European painting, and trained many of the next generation in Venice.

The Suida-Manning Collection features four fine pictures by Ricci and a fifth, a landscape by his nephew Marco, to which he contributed the figures.

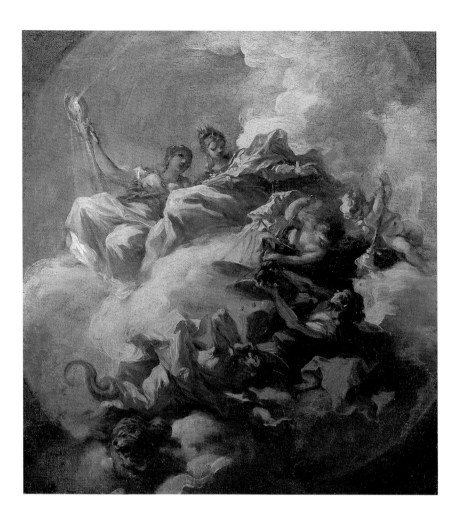

GIOVANNI ANTONIO PELLEGRINI

Venice, 1675–1741

Justice Fulminating the Vices, 1717

Oil on canvas; 13⅝ × 12¹¹/₁₆ in. (34.6 × 32.3 cm); The Suida-Manning Collection, 1999; 443.1999

GIOVANNI ANTONIO PELLEGRINI represents eighteenth-century Venetian painting at its most exuberant. He was first trained in Milan with the idiosyncratic Paolo Pagani, but his style depends more on the sensuous and decorative aspects of Sebastiano Ricci. Pellegrini's drawing is broad and soft, his palette warm and pastel, and his paint handling dense and fluid. Defying gravity, bordering on the caricatural, this painterly virtuosity was a tremendous success across Europe, with the artist called to execute significant fresco cycles and numerous canvases in England, France, and Germany.

During a year-long sojourn in Antwerp, Pellegrini carried out three major decorative projects. This painting is an unpublished oil sketch for one of these, a much-admired canvas for the ceiling of the Salle du Petit Collège in the city's town hall. Appropriate to that setting, it represents the figures of Justice and Prudence crushing two male figures identifiable as Avarice and Deceit. Phosphorescent in color, practically sculpted in paint, this sketch dramatizes the material properties for which Pellegrini was so highly regarded. These properties are conspicuous in the wake of a recent cleaning and relining of the canvas.

The Suida-Manning Collection includes two other paintings by Pellegrini: a comparably rich, half-length figure of *Bellona* from around 1713–1714, and a more summary *Venus and Cupid*, which may have come from a decorative ensemble.

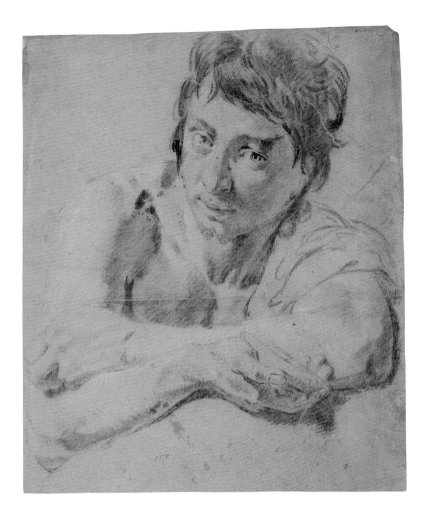

GIOVANNI BATTISTA PIAZZETTA

Venice, 1682–1754

Saint John the Baptist, c. 1720

Black and white chalks on blue antique laid paper faded
to gray-green, laid down; 18⁹/₁₆ × 15¹⁵/₁₆ in. (47.1 × 40.5 cm);
The Suida-Manning Collection, 1999; 452.1999

ALONG WITH SEBASTIANO RICCI, Giovanni
Battista Piazzetta was responsible for revitalizing
Venetian painting and inaugurating its second great
age. Schooled in Bologna, Piazzetta learned a natu-
ralism based upon systematic drawing, featuring
intense chiaroscuro, and dedicated to dramatic
expression. Reconciling this conception with the
flickering light and personalized brushwork of his
native tradition, while rejecting its bright palette
and decorativeness, Piazzetta brought new life to
the school's tired formulae. Unlike many compa-
triots, he would rarely pursue monumental deco-
ration and never work outside Venice. He did,
however, bring to religious and genre subjects a
force of visual sensation and human characteri-
zation equal to that of the early Baroque.

This is a preparatory study for a painting
of *Saint John the Baptist* at Rovigo. Drawn from
a model, it demonstrates Piazzetta's foundation
in academic practice but inclination toward more
selective description, varied touch, and sincere
feeling. Indeed, this figure is especially present
and powerful even for Piazzetta. It reveals at how
early a stage the artist determined the eventual
pose, chiaroscuro, and expression of the painting.
Not least, this drawing predicts Piazzetta's life-size
chalk "heads of characters," which would become
the most celebrated and reproduced drawings in
eighteenth-century Venice.

The museum possesses two other drawings
and two fine paintings by Piazzetta as well as
numerous prints by his best interpreters.

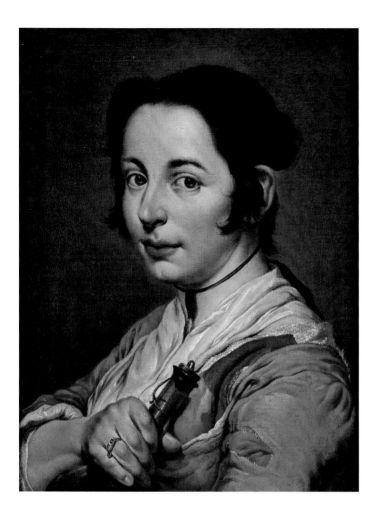

Giacomo Ceruti

Milan, 1698–1767

Young Peasant Woman Holding a Wine Flask,
c. 1737–1738

Oil on canvas; 19⁵⁄₁₆ × 15⁹⁄₁₆ in. (49 × 39.5 cm); The Suida-Manning Collection, 1999; 174.1999

IN AN AGE CHARACTERIZED by the quantity and originality of genre painting, Giacomo Ceruti holds a special place, not unlike that of Jean-Baptiste-Siméon Chardin. The specific origins of his style remain obscure, but they clearly lie in the Brescian school's long tradition of realism. Ceruti managed the occasional altarpiece and decorative project, but specialized in portraiture of both conventional sitters and anonymous subjects from the bottom and periphery of society. His works' great distinction is the unflinching record of appearance and the sympathetic response to personality. Initially, these essays in the human condition tended toward a hard edge, monochrome, and dry touch. After sustained exposure to Venetian painting in the late 1730s, his conception broadened, his palette admitted subtle color, and his handling loosened. Ceruti's works enjoyed great popularity with the noble families of Brescia and are rare today outside of Lombardy.

This is a characteristic work from the time of Ceruti's activity in Padua. Presented according to the conventions of high portraiture, this peasant girl, her simple garments, and her heavy hands are bestowed a real dignity. At the same time, rendered without prejudice or condescension, her being seems thoroughly individual and unaffected. The remarkable daylight, modest hues, and generous application of paint then also become metaphoric. The painting anticipates not just the realism but the egalitarian political spirit of the next century.

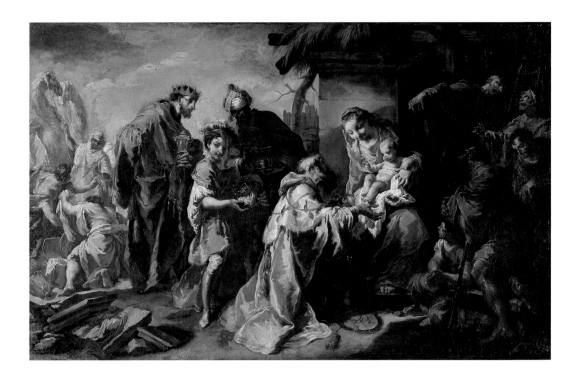

ANTON KERN

Tetschen, Bohemia, 1710–Dresden, Germany, 1747

The Adoration of the Magi, 1730

Oil on canvas; 17¹¹⁄₁₆ × 28¹³⁄₁₆ in. (45 × 73.2 cm); The Suida-
Manning Collection, 1999; 345.1999

ANTON KERN was the leading painter of the
mid-eighteenth century in Prague and Dresden.
Determined by training and a long collabora-
tion with Giovanni Battista Pittoni in Venice, his
style combines the fluid composition and extreme
grace of the Central European Baroque with the
vibrant palette of Sebastiano Ricci and his follow-
ers. Called to Dresden in 1738, he would spend the
rest of his short career at the court of Augustus III.
While capable of grand decoration and an occa-
sional altarpiece, his specialty was cabinet pictures
with the loose handling of oil sketches.

This delightful picture is an important
example of Kern's earliest style. Its color and
handling are so purely Venetian, the slightly
angular construction and pointing types so
indebted to Pittoni, that it could be confused
with his work. The drawing, however, is slacker,
the impasto gratuitous, and the sentiment a bit
saccharine. An early biographer of Bohemian
painters, Johann Quirin Jahn, mentions at least
six paintings by Kern in the residences of the
Counts Czernin at Prague. Apparently forming
a series, four represent scenes from the youth of
Christ. The Suida-Manning picture has been
recently identified as one of those pictures and
dated 1730, the date that appears on another
picture from the series in a private collection in
Bologna.

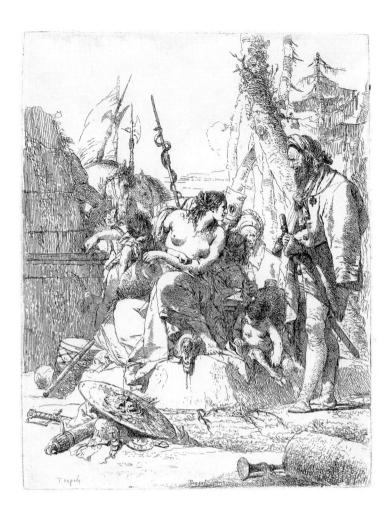

GIOVANNI BATTISTA TIEPOLO

Venice, 1696–Madrid, 1770

Seated Woman and Standing Man Surrounded by Other Figures, from the *Scherzi di fantasia,* c. 1750s

Etching, De Vesme 15, Rizzi 6, first state of two; Plate: 8 11/16 × 6 7/8 in. (22.1 × 17.5 cm); Sheet: 9 13/16 × 7 15/16 in. (25 × 20.1 cm); Purchase through the generosity of the Still Water Foundation, 1997; 1997.97

WITH A STYLE of incomparable amplitude, rhythm, and color, Giovanni Battista Tiepolo was the protagonist of the second great age of the Venetian school and a fundamental figure in European painting before the rise of Neoclassicism. Extraordinarily prolific and convincing in all genres, he was brilliant above all in decorative ensembles for palaces and villas in the Veneto, across northern Italy, and notably at Würzburg, Germany, and Madrid. Endlessly inventive in composition, utterly personal in vocabulary, and seemingly spontaneous in touch, Tiepolo's drawings and etchings count among the finest achievements in their respective media. In many senses, Tiepolo is the last great Old Master.

Tiepolo created the twenty-three plates of *Scherzi di fantasia* probably in the 1750s. The most complicated and accomplished of his etchings, they involve very free and iconographically imprecise variations upon a range of Baroque themes. They draw upon a repertory of exotic figures, architectural fragments, and objects with at least a double sense. More or less allegorical, all refer to the passage of time, the stages of life, and the nature of knowledge. This subject is typical. Its composition, however, is one of the best resolved of the series, and this impression is unusually fine.

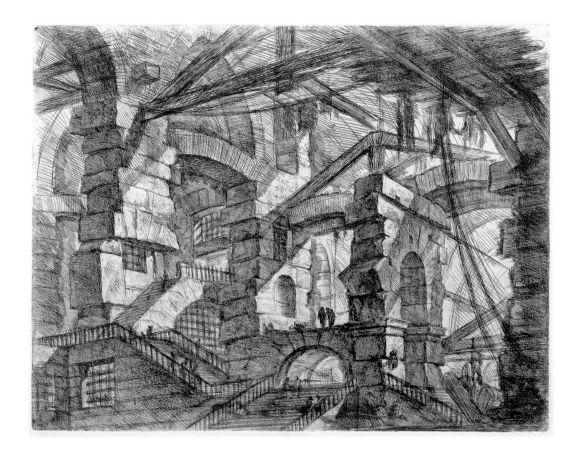

Giovanni Battista Piranesi

Mogliano (Treviso), Italy, 1720–Rome, 1778

The Gothic Arch, plate XIV from the *Carceri d'invenzione [Imaginary Prisons]*, 1749–1750
Etching, engraving, and sulfur tint with burnishing, Hind 14, Robison 40, first state of six, first edition, first or second issue; Plate: 16⁵⁄₁₆ × 21½ in. (41.4 × 54.5 cm); Sheet: 20⅛ × 28⅛ in. (51.2 × 71.4 cm); Purchase through the generosity of the Still Water Foundation, 1992; 1992.282

THE *CARCERI* are Giovanni Battista Piranesi's most inventive and famous series of architectural fantasies. The fourteen plates present sweeping views within vast interiors of massive masonry construction. Certain architectural motifs, various accoutrements of prisons and torture, and above all the suggestion of overpowering weight signal the theme. The *Carceri* conflate the visionary reconstruction of ancient Roman architecture in one earlier series, the *Prima Parte*, and the fanciful variations upon archaeological remains in another, the *Grotteschi*. Meanwhile their superimposition of rigorous perspective over frequently illogical structure recalls Piranesi's training in scenographic decoration.

As they were fully articulated in later states with extensive re-biting and burin work, the *Carceri* are dark, menacing prefigurations of the awesome beauty of Edmund Burke's "sublime." But each plate began with a preparation in practically pure etching, which was issued in a small edition for connoisseurs. On the one hand, their fluent gesture and animated surface hark back to the earliest Italian etching. On the other, their ambiguous subject and summary rendering prefigure the preoccupation with surface and the self-referential technique of modernism.

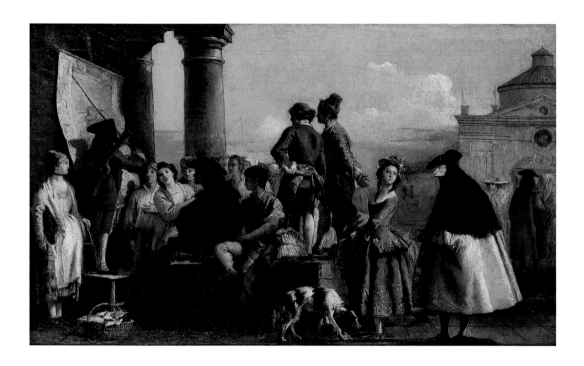

GIOVANNI DOMENICO TIEPOLO

Venice, 1727–1804

The Storyteller, mid-1770s

Oil on canvas; 13⁵⁄₁₆ × 22½ in. (33.8 × 57.1 cm); The Suida-
Manning Collection, 1999; 554.1999

ON THE EDGE of a Venetian piazza, a *cantastorie*
—a popular storyteller and balladeer—entertains
a group that seems a microcosm of society. The
scene appears at first a slice of contemporary life.
Underpinning it, however, are the basic conven-
tions of Venetian decoration from Paolo Veronese
through Sebastiano Ricci: horizontal proportions,
a low viewpoint that translates the group into a
procession, and a distribution of light and color
that give it structure. Any simple realism is put to
further question by the loose brushwork, by the
traces of underdrawing in black, and in general
by a display of process that underscores artifice.

Ultimately the picture insists upon its own ex-
quisite fiction, echoing the performance of the
cantastorie, enchanting the viewer as he does
his listeners.

Another version of *The Storyteller,* larger
and more even in finish, belongs to a famous
series of genre pictures painted by Giovanni
Domenico Tiepolo just after going to Madrid
with his father, Giovanni Battista, in 1762. Some
time later Giovanni Domenico revisited the sub-
jects with a cooler palette, more nervous touch,
and greater whimsy. This picture is one of those
re-creations. That it was conceived thus, as part
of a personal repertory performance, only multi-
plies and deepens the ways in which the work
is reflexive. Contemporary and nostalgic, real
and artificial, the painting is emblematic of the
Venetian school in its waning moments.

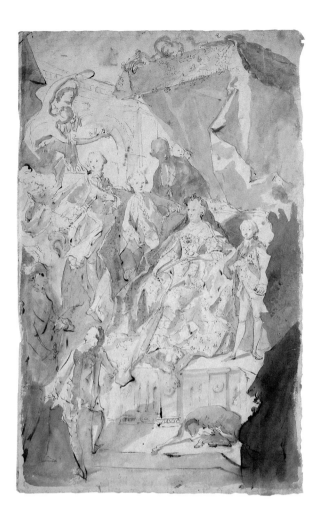

Franz Anton Maulbertsch

Langenargen, Austria, 1724–Vienna, 1796

*Empress Maria Theresa with Her Sons Joseph II,
Leopold II, Ferdinand, and Maximilian Francis,*
1765

Pen and brown and black inks with brush and brown and gray
washes over traces of black chalk on cream antique laid paper;
15½ × 9¹⁵⁄₁₆ in. (39.4 × 25.2 cm); The Suida-Manning Collection,
1999; 389.1999

THE EMPRESS MARIA THERESA (1717–1780),
queen of Hungary and Bohemia from 1740, is con-
sidered the greatest Hapsburg ruler for her numer-
ous reforms, tenacious struggle against Prussian
secession, and sagacity. Here she is enthroned at
the center of the composition. At the upper left,
an allegorical figure places a halo upon a portrait
bust and holds a crown above a young man with a
staff that rhymes with the scepter of the empress.
The scene commemorates both the death of her
husband, Francis I, and the naming of her eldest
son, twenty-four-year-old Joseph II, as coregent
and emperor in 1765.

Franz Anton Maulbertsch was the greatest
painter of his time in Vienna and south Austria.
In 1765 he was at the height of his powers and
success. The iconography and the formal character
of this drawing—its amorphous space, undulating
surface, and flickering light—are closely related to
his major projects of the period, complex allegori-
cal ceiling paintings in the bishop's summer resi-
dence at Kromeríz, in the Castle of Halbturn, his
first imperial commission, and in what became the
Hungarian Embassy in Vienna. Characteristic of
Maulbertsch's mature graphic style are the darting
line, extravagant washes, and unstable hues. With
its autograph notations about color on the verso,
this must have been a preparatory study for
another imperial commission.

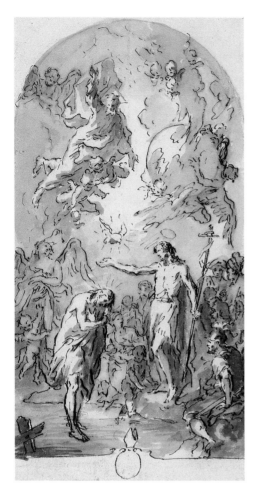
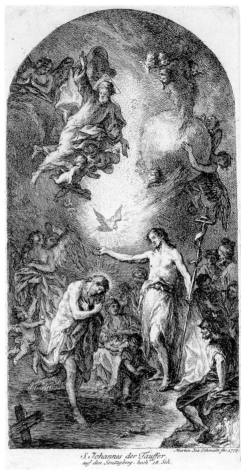

S. Johannes der Tauffer.
auf den Sonntagberg. hoch 18. Sch.

Martin Joh: Schmidt fec: 1773

Martin Johann Schmidt, called KREMSER-SCHMIDT

Grafenwörth, Austria, 1718–Stein, Austria, 1801

The Baptism of Christ, 1773

Recto and verso: Pen and brown ink with brush and brown and
gray washes over traces of graphite and a stylus on cream antique
laid paper; 9½ × 4¹⁵/₁₆ in. (24.1 × 12.6 cm); The Suida-Manning
Collection, 1999; 349.1999

The Baptism of Christ, 1773

Etching, Le Blanc 1, only state; Plate: 9³/₁₆ × 4¹³/₁₆ in. (23.3 ×
12.1 cm); Sheet: 9⁵/₁₆ × 4⅞ in. (23.6 × 12.4 cm); Jack S. Blanton
Curatorial Endowment, 2003; 2003.10

KREMSER-SCHMIDT was an important painter
principally of religious subjects in lower Austria.
His style depends upon the Venetians of the early
eighteenth century, particularly Sebastiano Ricci
and Gaspare Diziani. In 1773 he was commissioned
an altarpiece of *The Baptism of Christ* for the
popular pilgrimage church at Sonntagberg. One of
the most capable and prolific etchers in Central
Europe, he created an etching of the composition
before the altarpiece was even completed. This
print may have been part of an effort to raise
funds for the project.

It was with this extraordinarily fresh, double-
sided sheet that Kremser-Schmidt prepared the
etching. He began by copying his painting on the
recto (reproduced, left), then traced this drawing
on the verso, and finally transferred this second,
reversed version to the copper plate. This process
facilitated any correction of the work on the plate
and restored the eventual print to the proper orien-
tation of the painting. Most striking, despite its
technical role and necessarily restrained handling,
the drawing possesses wonderfully varied color,
sparkling light, and sheer vibrancy.

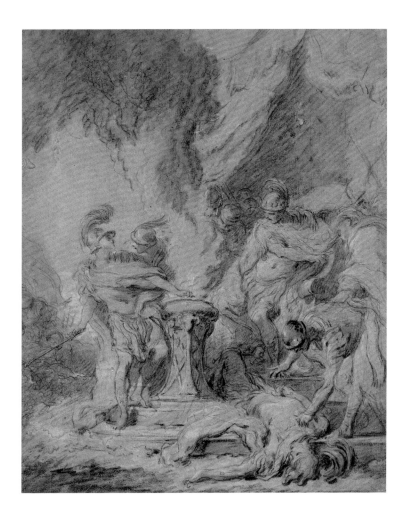

FRANÇOIS BOUCHER

Paris, 1703–1770

Mucius Scaevola Putting His Hand in the Fire,
c. 1726–1728

Black and white chalks on blue antique laid paper, laid down;
Sheet: 18 3/8 × 14 15/16 in. (46.6 × 38 cm); The Suida-Manning
Collection, 1999; 60.1999

THIS DRAWING ILLUSTRATES the story Plutarch
and Livy tell of the ancient Roman hero Mucius
Scaevola. Captured and brought before the Etrus-
can king laying siege to Rome, Mucius put his
right hand into a fire to show his indifference to
physical pain, thereby earning the admiration of
his captors, winning his freedom, and ensuring
peace with the Etruscans.

This drawing is an important early work
by François Boucher. Its dynamic composition,
rhythm, and dramatic action perpetuate and
amplify the graphic power learned from his teacher
François Lemoyne. At the time of this drawing,
Boucher was the principal reproductive etcher for
Jean de Jullienne's collection of prints after Jean-
Antoine Watteau's drawings. His original design
for the frontispiece to the third volume of the col-
lection is in fact very close in structure and move-
ment to this work. Boucher's deep involvement
with printmaking at around this time, the draw-
ing's uniform development and sure handling, the
sheet's large size, and Mucius's offering of his left
hand (which would have been correctly reversed in
a print) all suggest that this drawing was not just
a compositional study but the working model for
an engraving that was apparently never executed.

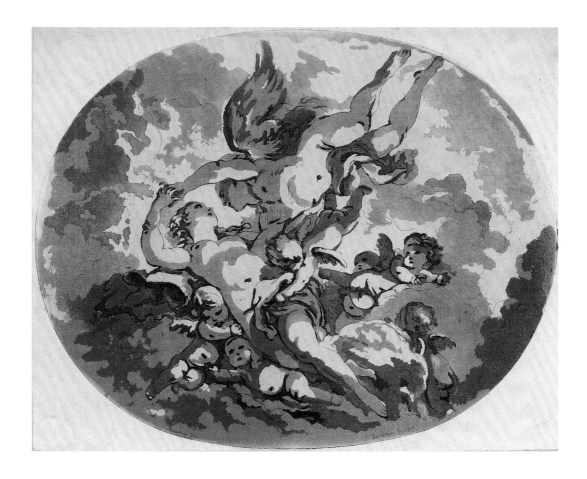

JEAN-CLAUDE-RICHARD DE SAINT-NON

Paris, 1727–1791

Cupid and Psyche, 1766, after François Boucher

Etching and aquatint, Jean-Richard, p. 377, only state; Plate: 9⅞ × 12¹¹⁄₁₆ in. (25.1 × 32.3 cm); Sheet: 11⅜ × 14⁷⁄₁₆ in. (28.9 × 36.6 cm); Archer M. Huntington Museum Fund, 1995; 1995.21

JEAN-CLAUDE-RICHARD de Saint-Non's innovations in the field of printmaking rank him as one of the most important amateurs of the eighteenth century. In 1765 he worked with professional printmaker Jean-Baptiste Delafosse to devise the new method of aquatint, which could reproduce the broad tones of wash drawings with a consistency that had eluded engraving and other experiments to that point. This sheet is one of only four known impressions of his earliest attempts in the new medium. It faithfully reproduces François Boucher's sensuous pen-and-wash technique.

Saint-Non produced four other aquatints after Boucher in 1766, but it is believed that Boucher discouraged their publication and distribution, which accounts for their rarity.

A younger son in a wealthy family, Saint-Non was destined for the priesthood, but his avid interest in art led him to take only minor orders. He traveled extensively throughout Europe, meeting Jean-Honoré Fragonard at the Académie de France in Rome. Saint-Non used his friend's drawings made after the Italian masters as the source for his volume of engravings of selected masterpieces in Italy. On the basis of his substantial collection, his patronage of contemporary artists, and his important innovations in printmaking, the Académie Royale de Peinture et de la Sculpture elected Saint-Non an honorary member.

L'ARMOIRE

JEAN-HONORÉ FRAGONARD

Grasse, France, 1732–Paris, 1806

L'armoire [The Cupboard], 1778

Etching, Portalis & Beraldi, Inventaire 22, Wildenstein 23,
second state of four; Plate: 13⁷⁄16 × 18¼ in. (34.2 × 46.3 cm);
Sheet: 16³⁄8 × 21⁹⁄16 in. (41.6 × 54.8 cm); The Teaching Collection
of Marvin Vexler, '48, 1995; 1995.60

WITH JEAN-ANTOINE WATTEAU and François
Boucher, Jean-Honoré Fragonard completes the
triumvirate of artists who defined the French
Rococo style. As shown in *The Swing, The Bolt,*
and *The Stolen Kiss,* Fragonard excelled at images
of illicit love. Witty, charming, and lighthearted,
the artist's approach was comic rather than moral-
izing. In *L'armoire* a young man shamefacedly
steps out from his hiding spot with his hat sug-
gestively held in front of him as he is threatened
with a stick by the irate parents of his lover. The
daughter, partly in embarrassment and partly in
despair, covers her face with her apron. The paint-
ing became famous and increased in popularity
after Fragonard etched the image here.

The museum etching is an early impression of
the second state on eighteenth-century paper that
has never been washed. Other works by Fragonard
in the Blanton's collection include the even rarer
impression of a portrait of his son, Fan-Fan, made
in collaboration with Marguerite Gérard, as well
as an important, if somewhat compromised, draw-
ing from the Suida-Manning Collection.

Jean-Jacques de Boissieu

Lyon, France, 1736–1810

Self-Portrait, 1796

Etching, drypoint, engraving, and roulette, Perez 102, fourth
state of eight; Plate: 14¹¹⁄₁₆ × 11⅝ in. (37.3 × 29.5 cm); Sheet:
15⁷⁄₁₆ × 12⅜ in. (39.2 × 31.5 cm); Jack S. Blanton Curatorial
Endowment, 2003; 2003.6

KNOWN FOR HIS EXQUISITE LANDSCAPES and
genre scenes, Jean-Jacques de Boissieu also made
a number of portraits. This late self-portrait shows
his debt to the seventeenth-century Dutch masters,
notably Rembrandt and Adriaen van Ostade.
Posed casually in a compressed space, the instru-
ments of his trade arrayed in the foreground, the
artist appears with his elbow resting on a closed
book as he holds up a copperplate with a portrait
of his wife. In a later state, after her death, this
portrait was replaced with a landscape.

In postrevolutionary France Boissieu was
a paragon of the bourgeois amateur artist.
By the time he made this self-portrait, he had
established himself as one of the best repro-
ductive printmakers in the country. Collectors
prized his original etchings for their sensitive
handling of light and their rich textures, as
did the artists engaged in the Etching Revival
in the mid-nineteenth century, such as Charles
Meryon and Félix Braquemond. This is one of
nine Boissieu prints in the museum's collection,
part of a distinguished group of etchings by
late eighteenth-century amateurs, such as
Jean-Pierre Norblin and Marcenay de Guy,
who pursued pure, personal etching at a time
when engraving and other complex reproduc-
tive techniques dominated.

JOHN BELL

England, active c. 1750

Cruelty in Perfection, 1750–1751, after
William Hogarth

Woodcut, second state of two; Sheet: 22⅞ × 17¹¹⁄₁₆ in. (58.1 ×
45 cm); Archer M. Huntington Museum Fund, 1991; 1991.95

WILLIAM HOGARTH

London, 1697–1764

Cruelty in Perfection, 1750–1751

Etching with engraving; Paulson 189; Plate: 15³⁄₁₆ × 12⅝ in.
(38.6 × 32 cm); Sheet: 23¹⁄₁₆ × 17⅝ in. (58.5 × 44.8 cm); Archer M.
Huntington Museum Fund, 1991; 1991.155

WILLIAM HOGARTH'S REPUTATION as a brilliant
satirist and moralist is much in evidence in *Cruelty
in Perfection*, the third vignette from his series *The
Four Stages of Cruelty*. The first two stages show
the main character abusing animals. In the third
stage, shown here, the protagonist—who has
murdered his mistress with whom he had plotted
a burglary—is forced to confront his crime. The
final stage features doctors dissecting his corpse,
the noose of his execution still hanging around
his neck.

Hogarth directed the message of cruelty's
retribution squarely at members of the working
class, whom he hoped to scare into more civil be-
havior. To reduce the cost and heighten the appeal
for his target audience (who were familiar with the
woodcut aesthetic), he employed John Bell to re-
produce the series in woodcut. But Bell cut only
two of the scenes before the project became too
costly for Hogarth to continue. He economized by
etching the series himself, printing it on two quali-
ties of paper, one more affordable than the other.

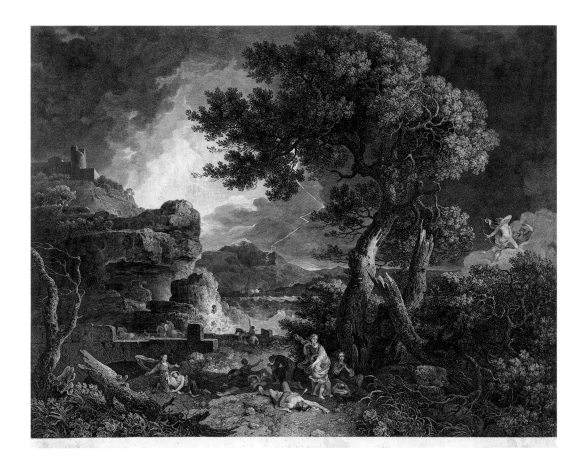

WILLIAM WOOLLETT

Maidstone, England, 1735–London, 1785

The Destruction of Niobe's Children, 1761,
after Richard Wilson

Etching and engraving, Fagan 42, second state of five; Sheet:
17¹¹/₁₆ × 22¹³/₁₆ in. (45 × 58 cm); The Leo Steinberg Collection,
2002; 2002.1663

THIS PRINT REPRODUCES Richard Wilson's
celebrated painting *The Destruction of Niobe's
Children* of 1759–1760 (Yale Center for British
Art, New Haven, Connecticut). It established
Woollett's reputation as the finest line engraver in
eighteenth-century England, earning his publisher,
John Boydell, a significant income. The museum
possesses forty-four engravings by Woollett, most
from a collection formed by a direct descendent,
David Woollett.

The scene, taken from Greek mythology,
shows the Theban queen, Niobe, punished for her
excessive pride by Apollo and Diana, who are in
the process of slaying her seven sons and daughters.
Woollett achieved the range of tones and textures
that contributes to the sense of violence in this
scene by first etching parts of the plate to various
depths, then engraving the rest of the image. So
effective was this technique in depicting the stormy
setting that a contemporary of Woollett dubbed
him "the first Landscape Engraver in the World."
King George III later appointed him Engraver in
Ordinary, and Benjamin West gave him the com-
mission to reproduce his own masterpiece, *The
Death of General Wolfe* of 1770 (National Gallery,
Ottawa).

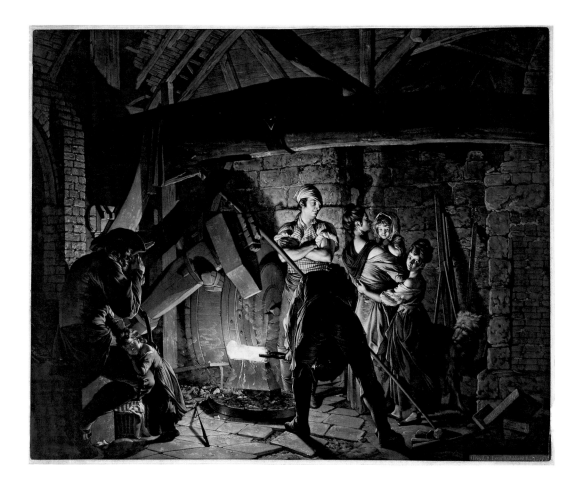

RICHARD EARLOM

London, 1743–1822

An Iron Forge, 1773, after Joseph Wright of Derby

Mezzotint, Chaloner-Smith 48, Clayton 12, first state of two;
Plate: 18¹⁵/₁₆ × 23⅜ in. (47.9 × 59.3 cm); Sheet: 19¼ × 23¾ in.
(48.9 × 60.2 cm); The Leo Steinberg Collection and Archer M.
Huntington Museum Fund, by exchange, 2005; 2004.188

DEVELOPED IN LATE seventeenth-century
Holland, but perfected in eighteenth-century
Britain, mezzotint was better than engraving
and etching at simulating the tonal qualities of
the paintings it reproduced. In mezzotint the
artist painstakingly roughens the entire surface
of the plate, creating a uniform black texture
were the plate to be printed at this point. He
then uses scrapers to remove and polish the
roughened areas to be illuminated. Varying the
degree of polishing, he works from dark to light

and achieves a wide range of mid tones, or
mezzotinto in the original Italian.

Richard Earlom, whose work is well repre-
sented at the museum, used mezzotint to its
greatest advantage in reproducing paintings
such as Joseph Wright of Derby's *Iron Forge*, in
which dramatic light is central to its meaning.
Fascinated with advances in science and industry,
Wright romanticized the early years of the Indus-
trial Revolution. The artist's use of light here
was compared to the illumination that emanates
from the Christ Child in medieval and Renaissance
nativities. By analogy, the forge and other new
technologies were posited as Britain's salvation
in the modern world.

Early and with its surface immaculate, this
impression reveals the technique's tremendous
subtlety and inherent beauty.

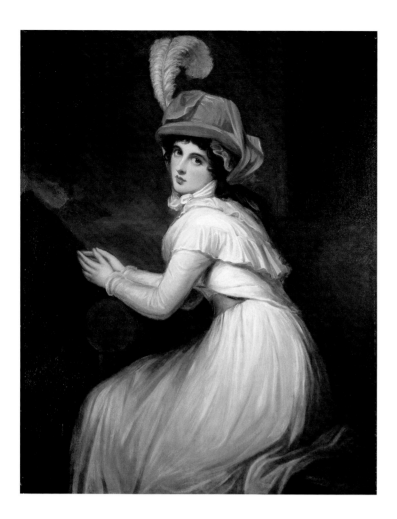

GEORGE ROMNEY

Dalton-in-Furness, Lancashire, England, 1734–Kendal,
Cumbria, England, 1802

Lady Hamilton as Ambassadress, 1791

Oil on canvas; 62⅝ × 52⅜ in. (159.1 × 133.1 cm); Bequest of
Jack G. Taylor, 1991; 1991.108

ALONG WITH Thomas Gainsborough, Sir Henry
Raeburn, and Sir Thomas Lawrence, whose work
is also in the Blanton Museum, George Romney
was one of the best British portraitists of the
eighteenth century. *Lady Hamilton as Ambassa-
dress* is among his finest works. Its sweeping com-
position, bold drawing, and judicious use of color
indicate why he was considered a serious rival to
Sir Joshua Reynolds.

Romney painted many portraits of Lady
Hamilton, a woman who rose from obscurity and
poverty through the rigid ranks of British society
to become the wife of an ambassador and the
mistress of Lord Horatio Nelson, the storied
admiral of the British fleet. He began painting her
shortly after they were introduced in 1782, titling
one of his earliest depictions of that year *Lady
Hamilton as Nature* (Frick Collection, New York).
This is the last portrait of his famous muse, which
he made from life in 1791 when she returned to
London to marry Sir William Hamilton, ambas-
sador to Naples. That is the locale signaled by
an erupting Mount Vesuvius in the background.
Romney kept this portrait until 1800, when he
finally gave it to Lady Hamilton's mother.

The museum also possesses three drawings by
Romney: two sheets of studies inspired by Dante's
Inferno and a more finished portrait study of two
children.

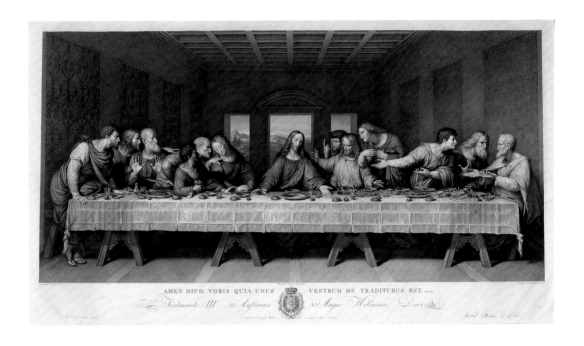

AMEN DICO VOBIS QUIA UNUS VESTRUM ME TRADITURUS EST.

RAPHAEL MORGHEN

Naples, 1758–Florence, 1833

The Last Supper, 1800, after Leonardo da Vinci

Etching and engraving; Plate: 20½ × 36¾ in. (52 × 93.3 cm); Sheet: 25¹³/₁₆ × 40¹¹/₁₆ in. (65.6 × 103.3 cm); The Leo Steinberg Collection, 2002; 2002.2757

PROFESSOR AT FLORENCE'S Accademia di Belle Arti and a member of the Institut de France, Raphael Morghen was the most celebrated reproductive engraver of his era. He made some 254 prints, exclusively after the Old Masters. With the exactness of his drawing and the variety of his hatching, he achieved tonal gradations so subtle as to verge on the photographic. His skill earned him the praise of connoisseurs and colleagues throughout Europe.

This reproduction of *The Last Supper* was his most celebrated and influential achievement.

As distinguished art historian Leo Steinberg describes in his recent, searching study of the fresco, no good home in the nineteenth century lacked an impression. Morghen's engraving, which was the basis for many more reproductions made well into the nineteenth century, helped shape the understanding and determine the popularity of Leonardo da Vinci's masterpiece through successive generations.

Since the rise of photography and the triumph of modernism, the aesthetic interest of this and all such engravings has usually been dismissed. But Steinberg insists, "Morghen's print in its proper context is a masterpiece."

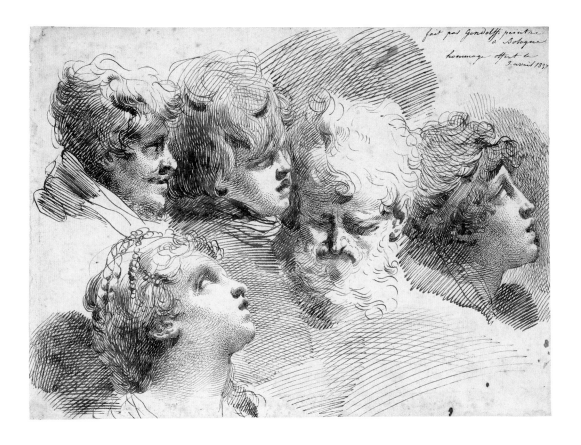

Mauro Gandolfi

Bologna, Italy, 1764–1834

Studies of Five Heads

Pen and brown ink on cream antique laid paper, laid down;
8⁵⁄₁₆ × 11⁷⁄₁₆ in. (21.1 × 29.1 cm); The Suida-Manning Collection,
1999; 283.1999

STUDIES OF IMAGINARY physiognomy are as old
as Italian drawing. Leonardo da Vinci's famous
grotesque heads are the most conspicuous early
examples. For Parmigianino such studies were
a pretext for exploring stylized appearance and
sheer graphic beauty. They also established a dis-
tinct tradition in Emilian drawing. The reaction
against Mannerism in the late sixteenth century
brought a new concern with natural appearance
and psychological states. The artistic reform of
the Carracci featured their systematic pursuit and
conventional expression through life study. By the

later seventeenth century, this had become a staple
of academic training. The rendering of physiog-
nomic expression was now an explicit artistic
research, while imaginary studies were generally
relegated to the new realm of caricature. Bolognese
artists, however, upheld their early tradition. The
school's principal academic painter of the late
eighteenth century, Gaetano Gandolfi, and his son
Mauro made a specialty of the genre, transform-
ing it into virtuoso performance for collectors.
Gaetano's studies of the kind are more dense in
pattern, coherent in emotion, and regular in artic-
ulation. Mauro's are distinguished by a greater
detachment of one motif from another, flourishes
about the perimeter, and prominent stipple in the
modeling. This is a very fine example, inscribed in
French as a gift and thus underscoring its intended
function.

Las rinde el Sueño.

FRANCISCO JOSÉ DE GOYA Y LUCIENTES

Fuendetodos, Spain, 1746–Bordeaux, France, 1828

Las rinde el sueño [Sleep Overcomes Them], plate 34 from *Los Caprichos,* 1799

Etching and burnished aquatint, Delteil 71, Harris 69, second state of three, trial proof with corrections; Plate: 8⁷⁄₁₆ × 5¹⁵⁄₁₆ in. (21.5 × 15.1 cm); Sheet: 12½ × 8⅜ in. (31.7 × 21.2 cm); The Teaching Collection of Marvin Vexler, '48, 1989; 1989.8

FRANCISCO DE GOYA's etchings are a monument in the history of printmaking. It was in the more private world of these prints that the artist's personality was given free rein, the comment upon his own time was most acerbic, and the indifference to artistic convention was most striking. Goya's four major series—the fantastically ironic *Caprichos,* the fiercely candid *Desastres de la Guerra,* the formally and morally ambiguous *Tauromaquia,* and the surreal *Disparates*—are fundamental works of modern art.

The *Caprichos* is the earliest and best-known series. Its eighty plates weave popular imagery, folklore, and the residue of Baroque allegory into fanciful images that mock society's beliefs and habits. Their captions, also devised by the artist, are equally personal and usually sarcastic. With no appreciable tradition of printmaking in Spain, Goya drew inspiration from both British satire and Giambattista Tiepolo's allegories. But the imagination and subversiveness of the *Caprichos,* their privileging of individual sensibility over any other artistic consideration, was his own genius. Showing four figures submerged in darkness, perhaps that of a prison, this plate is one of the few unleavened by humor and undirected toward specific comment. Redolent of the iconography of Christ on the Mount of Olives, but with no angel to comfort, the scene becomes thoroughly existential.

FERNAND-VICTOR-EUGÈNE DELACROIX

Saint-Maurice (Paris), 1798–1863

Cheval sauvage terrassé par un tigre [Wild Horse Felled by a Tiger], 1828

Lithograph on chine collé, Delteil 77, first state of four; Sheet: 9¹/₁₆ × 11¹/₈ in. (23 × 28.3 cm); The Teaching Collection of Marvin Vexler, '48, 1999; 1999.85

EUGÈNE DELACROIX's *Wild Horse Felled by a Tiger* is the quintessential Romantic print. This lithograph conveys a violence so raw and instinctive as to be repulsive. Wild animals in combat were a favorite theme of Romantic artists, who sought to venture well beyond the realm of reason and exercise emotions that could tap into the innermost reaches of the human soul, achieving a state of transcendence.

One of the qualities of lithography that appealed to the French Romantics was its ability to communicate both the artist's unique vision and the dramatic movement within the composition. Here Delacroix barely sketched in the setting, using bold strokes to suggest a harsh, rocky environment, and instead focused our attention on the action in the center, a swirling mass of horseflesh writhing in the throes of death.

This is one of only seven known impressions of the first state of the print. Generally strong, the museum's holdings of early French lithography include five other prints by Delacroix, 23 by Théodore Géricault, 13 by the brothers Vernet, ten by Louis-Léopold Boilly, and 41 by Achille Devéria.

DAS SCHLOSS PREDIAM*. IN CREIN XII STUND: VON TRIEST.

KARL FRIEDRICH SCHINKEL

Neuruppin, Mark Brandenburg, Germany, 1781–Berlin, 1841

Das Schloß Prediama in Crein XII Stund: von Triest [Predjama Castle in Carniola, Twelve Hours from Trieste], 1816

Pen lithograph and yellow tone-plate with retouching in ink, Winkler 13, only state; Sheet: 15½ × 12⅜ in. (39.3 × 31.3 cm); Jack S. Blanton Curatorial Endowment, 2005

KARL SCHINKEL is best known for his Greek Revival and Gothic Revival architecture, but he was also a painter, a set designer, and an early proponent of lithography. It was during his trip to Italy from 1803 to 1805 that he visited Predjama Castle and drew this scene. What impressed the young architect most was the castle's location on a rocky precipice. He was in awe of "the wildest courage that people can command to settle in such a position." The drawing lay in Schinkel's sketchbooks until 1816, when he met the brilliant poet and playwright Johann Wolfgang von Goethe, whose theory that mountains were crystalline in structure may have inspired the artist to return to the motif. The juxtaposition of man-made structures and natural elements was particularly appealing to the architect, more generally to the Romantic sensibility. The rustic wooden buildings nestled into the forest in the foreground were an addition to the original drawing and echo the theme of the castle tucked into the mountainside, suggesting the work's evolutionary process. Like Eugen Neureuther's *Sleeping Beauty* (1836), opposite, Schinkel's *Predjama Castle* is characteristic of German Romanticism with its focus on the intersection of nature and the human spirit and its remove from the classical tradition.

EUGEN NAPOLEON NEUREUTHER

Munich, 1806–1882

Dornröschen [Sleeping Beauty], 1836

Engraving, Schubert 9; Plate: 27 × 20⁷⁄₁₆ in. (68.6 × 51.8 cm); Sheet: 31⅛ × 23¼ in. (79.1 × 59 cm); Jack S. Blanton Curatorial Endowment, 2002; 2002.2876

ALTHOUGH EUGEN NEUREUTHER worked as a muralist, he was renowned for his book illustrations, especially the lithographs he made for *Vignettes for Goethe's Ballads and Romances* (1829–1839). This illustration of the Brothers Grimm's *Sleeping Beauty* is similarly a tour de force of German Romanticism, with an intricacy and sheer technique that are dizzying. The scene functions like a visual synopsis of the text, printed so small as to be almost illegible. He placed the climax of the tale in the center of the composition and arranged the princess's sleeping court, her parents, and the instrument of her demise, the old woman spinning in the garret, in a circular pattern around her. Weaving them together is the heavy foliage that the Brothers Grimm described as growing over the castle. The morals the writers provide at the conclusion of their stories find a corollary here in the classical allegory at the bottom. By appealing to the viewer's imagination and emotion through local folk literature, regarded by the Romantics as an authentic and pure source of the Truth, Neureuther has left us with a remarkably rich and telling document of the collective German psyche.

THOMAS GIRTIN

London, 1775–1802

Part of the Tuileries, 1801

Graphite and watercolor on off-white antique laid paper; Sheet: 14¹³/₁₆ × 12⅝ in. (37.7 × 32 cm); Gift of Mr. and Mrs. Richard Thune, 1982; 1982.1299

THOMAS GIRTIN'S VIEW of the Tuileries belongs to the English tradition of topographical water-color, of which the Blanton Museum has numer-ous examples by such artists as J. M.W. Turner, John Constable, and Thomas and William Daniell. Turner, in fact, who once worked with Girtin copying drawings for their patron Dr. Monro, admired his friend's talent, commenting, "If Tom Girtin had lived, I should have starved."

Girtin visited Paris in 1801–1802 and made a series of etchings of the city, published the year after his death as *A Selection of Twenty of the*

Most Picturesque Views in Paris and Its Environs. The museum's drawing may have been a prelimi-nary study for one of these views that was never executed, or it may have been part of an abandoned plan to create a large panoramic painting of the city of Paris to display in London. The watercolor has been cut down from a larger composition and pieced back together at the left, with the two sections differently colored to suggest full daylight and twilight. It is his innovative handling of the watercolor medium that earned Girtin not only Turner's admiration but also a place in the history of landscape painting in England. He is said to have revolutionized watercolor painting by his use of broadly applied, strong washes, which freed the medium from its dependence on line drawing.

Joseph Mallord William Turner

London, 1775–Chelsea, England, 1851

Shields Lighthouse, c. 1826

Mezzotint on applied India paper, Rawlinson 801a, first state of five; Plate: 7⅜ × 9⅞ in. (18.8 × 25.1 cm); Sheet: 9⅞ × 14¾ in. (25.1 × 37.4 cm); Purchase through the generosity of the Still Water Foundation, 1996; 1996.253

THERE ARE FEW British landscape artists of greater renown than J. M.W. Turner. His constant experimentation with the genre in painting, watercolor, and engraving had a significant impact on the early development of modern art in the nineteenth century. The *Liber Studiorum* was a collection of prints after Turner's compositions, forming an encyclopedia of landscape types. This print is one of a series of twelve that Turner produced as *Sequels to the Liber Studiorum*, usually referred to as the "Little Liber." In these plates

Turner used mezzotint to translate the tonality and painterly qualities of a watercolor drawing. Never published, the prints remained the artist's best-kept secret, their existence revealed upon the discovery of the plates in his studio after his death. This is one of only four known impressions of this state. Turner may have been inspired to take up mezzotint after John Martin's very successful illustrations on John Milton's *Paradise Lost* (1825), a proof set of which the Blanton Museum also owns. Turner chose a dramatic moonlit scene for *Shields Lighthouse* to explore the effects of light reflecting off water. He expressed the quintessentially Romantic theme of the antithesis of man and nature by juxtaposing the pale beam from the lighthouse with the full moon, the masts of the ship appearing ghostlike in the eerie shadows.

EDWARD CALVERT

Appledore, Devon, England, 1799–London, 1883

The Chamber Idyll, 1831

Wood engraving, Lister 15b; Image: 1⅝ × 3 in. (4.2 × 7.6 cm);
Sheet: 10¹³⁄₁₆ × 14⁷⁄₁₆ in. (27.4 × 36.6 cm); Purchase through
the generosity of the Still Water Foundation, 1996; 1996.143.8/8

THE CHAMBER IDYLL was the last print Edward
Calvert undertook, and it is considered his most
poetic. With his friend and fellow artist Samuel
Palmer, Calvert fell under the influence of William
Blake's visionary Romanticism, impressed in
particular by the older artist's wood engravings
for an edition of Virgil's *Eclogues* (1820). Living
in Shoreham, Calvert and Palmer, along with
George Richmond, styled themselves as "Ancients,"
shunning all that was modern in art and society.
Instead they cloaked pastoral subjects inspired
by the English countryside in classical guise.

Heavy wooden beams hung with farm imple-
ments set the stage for this bucolic scene of lovers
preparing for bed. Although their hairstyles are
distinctly contemporary, the male figure in profile
derives from images of Apollo cut into ancient
cameos, and the female figure is patterned on a
gemstone showing Aphrodite preparing for a bath.
Calvert's naive treatment of the livestock in the
background, and the print's small scale, lend this
erotic scene an air of innocence.

Apart from very rare proofs, all impressions
of Calvert's wood engravings and engravings
come from their reprinting in his son's biography
of 1893. The museum possesses a fine copy.

Trial Proof - best State. *Samuel Palmer.*

SAMUEL PALMER

Newington (London), 1805–Reigate, Surrey, England, 1881

The Weary Ploughman or *The Herdsman*, 1858–1865

Etching, Hardie, Alexander 9, Cooke 8, Lister E8, fifth state of eight (trial proof); Plate: 7⁹/₁₆ × 10³/₈ in. (19.2 × 26.4 cm); Sheet: 11¹¹/₁₆ × 17¹/₈ in. (29.7 × 43.5 cm); The Leo Steinberg Collection, 2002; 2002.1296

OTHER THAN LEARNING TO DRAW from one William Wate, Samuel Palmer had no formal training as an artist. Despite this, he was already exhibiting at the Royal Academy by the age of fourteen. He met William Blake in 1824 and was much influenced by the older artist's visionary approach to art. Not long afterward he moved to Shoreham in Kent. Calling themselves the "Ancients," Palmer and his friends rejected the materialism that was taking hold in an increasingly industrialized England. Palmer's romantic landscapes of this period verge on the fantastical, but two years in Italy in the late 1830s led to a more restrained and classical treatment of his subjects.

Palmer did not attempt etching until 1850, when he became a member of the Etching Club. In *The Weary Ploughman*, Palmer laid bare his Romantic tendencies with a moonlit scene. His command of the tonal range possible with etching shows his debt especially to the seventeenth-century Dutch but also to French contemporaries. Critics were ambivalent at best, and proponents of the etching revival in England, namely Francis Seymour Haden and James McNeill Whistler, dismissed the efforts of the Etching Club as amateurish despite the shared concerns of the two groups of artists.

Charles Méryon

Paris, 1821–Charenton-le-Pont, France, 1868

Le Petit Pont, Paris, 1850

Etching on green antique laid paper, Delteil & Wright 24,
third state of seven; Plate: 10 × 7⁷⁄₁₆ in. (25.4 × 18.7 cm); Sheet:
10⁹⁄₁₆ × 7¹⁵⁄₁₆ in. (26.9 × 20.2 cm); Purchase from the Jack S.
Blanton Curatorial Endowment and through the generosity
of Susan Thomas, 2003; 2003.148

ETCHING WAS ESPECIALLY SUITED to the obsessive
detail and subjective feeling that were the hallmark
of Charles Méryon's work. In the first original
etching from his principal work, the *Eaux-fortes
sur Paris [Etchings of Paris]*, Méryon transformed
a familiar view of the city into something vaguely
menacing, not only reflecting his delicate state of
mind, but also prefiguring modern ambivalence
about the urban experience.

After a stint in the navy, Méryon moved to
Paris in 1848 and began his artistic career in the
painting studio of an academic artist. When he
was diagnosed with color blindness, he went to
study with a Barbizon artist, Eugène Bléry, who
taught him etching by having him copy the prints
of Adriaen van de Velde, among other Old Masters.
Méryon was one of the first proponents of the
Etching Revival in France. Printmaking in the early
nineteenth century had been dominated by the
persistent tradition of reproductive engraving and
the new technique of lithography. His interest in
Baroque artists, such as Rembrandt, prompted
Méryon's pursuit of etchings as a means of original
artistic expression. His juxtaposition of densely
hatched areas and pools of open space resulted in
a surface that throbs with tension and suggests the
macabre sensations affected by his deteriorating
mental state.

GUERRE CIVILE

EDOUARD MANET

Paris, 1832–1883

Guerre civile [Civil War], 1871–1873

Lithograph on chine appliqué, Moreau-Nélaton 81, Guérin 75, Harris 72, second state of two; Image: 15⁹/₁₆ × 20 in. (39.6 × 50.8 cm); Sheet: 19⅛ × 24³/₁₆ in. (48.5 × 61.5 cm); The Teaching Collection of Marvin Vexler, '48, 1999; 1999.21

WHEN CIVIL UNREST BROKE OUT in Paris in 1871 following the Franco-Prussian War, Edouard Manet witnessed the bloody street battles between government troops and insurgents, as well as the mass executions that quelled the insurrection. The sketches he made of these scenes resulted in two lithographs, one of them *Guerre civile*. This sheet was printed in an edition of 100 several years after the conflict, when political dissent was more likely to be tolerated.

In Manet's anti-heroic commentary on the French government's use of force against its own people, the subject of the composition, the dead soldier in the foreground, has been pushed off-center and dramatically foreshortened. Using a recumbent figure to signal victimhood was a well-established practice. Such figures appear, for example, in works by Pierre-Paul Prud'hon and Jean-Léon Gérôme. Manet himself repeated the pose from his earlier work. The violent cropping of the civilian's legs in the lower right corner, the loose handling of the crayon in the treatment of the background, and the stark contrast of the dead soldier with the white paper that surrounds him like a shroud all serve to communicate the chaos that immediately preceded this otherwise still scene.

Hilaire-Germain-Edgar Degas

Paris, 1834–1917

La sortie du bain [Leaving the Bath], 1879–1880

Electric crayon, etching, drypoint, and aquatint, Delteil 39, Adhémar & Cachin 49, Reed & Shapiro 42, eleventh state of twenty-two; Plate: 5¹⁄₁₆ × 5⅛ in. (12.8 × 13 cm); Sheet: 8¹⁵⁄₁₆ × 6½ in. (22.7 × 16.5 cm); Archer M. Huntington Museum Fund, 1982; 1982.705

Depicting scenes of a woman bathing, usually in the guise of a classical goddess or biblical heroine, is a long-held tradition in Western art, simultaneously satisfying the presumably male viewer's prurient interests while conveying a moral lesson about women's virtue. Edgar Degas's interpretations of the subject, however, were anything but idealized or conventional. Daring in his composition, Degas here has given us an essentially empty center formed by the white towel held behind the bather and a raking perspective that accentuates the awkwardness of the model. Unlike his predecessors and contemporaries, including fellow Impressionist Pierre-Auguste Renoir, Degas delighted in showing women as imperfect beings and frequently focused on what he perceived to be their "beastly" traits. He once admitted, "Perhaps I have considered woman too much as an animal." Along with horses and dancers, bathers were a favorite subject of the artist. Degas never meant *La sortie du bain* to be published or commercially distributed. It was instead a personal essay the artist worked and reworked over the course of a year. There are twenty-two states of this plate, variously done in etching, engraving, and aquatint. Recently, the museum acquired a very good impression of the cancelled plate as further demonstration of Degas's variation upon the theme.

Tirage à cent exemplaires n.°

PAUL CÉZANNE

Aix-en-Provence, France, 1839–1906

Les baigneurs (grande planche) [The Large Bathers], 1896–1897

Transfer and color lithograph, Venturi 1157, Druick 1, second state of three; Image: 16¾ × 20½ in. (42.5 × 52 cm); Sheet: 18¾ × 24⅞ in. (47.4 × 62 cm); The Teaching Collection of Marvin Vexler, '48, 1997; 1997.35

PAUL CÉZANNE TREATED the subject of the bather in more than two hundred works over the course of twenty years, approaching this most conventional of themes in a radically unconventional manner. He created this, his most elaborate print, after his painting of the same composition in 1876–1877 (Barnes Foundation, Merion, Pennsylvania; variation in Musée d'art et d'histoire, Geneva) at the insistence of the dealer Ambroise Vollard.

Uninterested in printmaking, Cézanne used transfer lithography for the project, relying on the printer Auguste Clot to translate his color into print. Each male figure is suspended in a swirl of vegetation, the lack of modeling denying them any volume, the disregard for perspective creating additional tension between representation and surface. Instead Cézanne gave the figures solidity and the composition stability by using bold contours, robust forms, and a rigorous pictorial structure. Yet the ambiguous relationship between man and nature remains, accentuated by the indifferent foreshortening of the thighs of the central figure. Desubstantiated, the figures become mere compositional devices in Cézanne's exploration of the line between traditional representation and a nascent abstraction.

GEORGES BRAQUE

Argenteuil-sur-Seine (Seine-et-Oise), France, 1882–Paris, 1963

Fox, 1911

Drypoint, Vallier 6, 44/100; Plate: 21⁹⁄₁₆ × 14¹⁵⁄₁₆ in. (54.8 × 38 cm); Sheet: 25¹³⁄₁₆ × 20 in. (65.5 × 50.8 cm); Purchase from the Severin Wunderman Collection Fund, 1998; 1998.118

FOX IS ONE OF A PAIR of drypoints created by Georges Braque and Pablo Picasso in August and September 1911. Its title and discernible motifs—a table with drawer and knob, a gin bottle, a playing card, a neon sign—refer to an English-style bar in Paris that was popular with the modernist circle. Later in 1911 Braque would elaborate upon this composition in a major painting, *Bottle and Glass* (Kunstmuseum, Bern, Switzerland).

Fox and Picasso's companion piece, *Bottle of Marc*, were commissioned by the avant-garde dealer Daniel-Henry Kahnweiler, who had been inspired by the dealer Ambroise Vollard's promotion of Paul Cézanne through prints. The two large drypoints mark the height of Picasso and Braque's collaboration and underscore the collective nature of their research. Analytical Cubism, as they called it, was a systematic attempt to eliminate distinctions between figure and field and to downplay the personality of the artist's hand while maintaining an almost classical equilibrium. *Fox* and *Bottle of Marc* are the most impressive prints and among the most significant statements of this fundamental modern style.

Fox and *Bottle of Marc* were printed first by the celebrated intaglio printmaker Eugène Delâtre and published by Kahnweiler in 1912. They were also reprinted perfunctorily in the 1950s. The present impression not only comes from the first edition but also displays the rich, textured line and the subtle veil of tone that characterize the earliest printings.

EMIL NOLDE

Nolde, Schleswig-Holstein, Germany, 1867–Seebull, Schleswig-Holstein, Germany, 1956

Liegendes Weib [Reclining Nude], 1908

Etching and aquatint on iron, Schiefler-Mosel 92, iv/iv, edition of 18; Plate: 12 × 18½ in. (30.3 × 47 cm); Sheet: 19½ × 24⁷⁄₁₆ in. (49.5 × 62.1 cm); The Jack S. Blanton Curatorial Endowment, 2002; 2002.2878

UNUSUAL IN EMIL NOLDE'S OEUVRE, the female nude served as the focus of ten prints executed between 1907 and 1908. Before this, Nolde's print production consisted of boldly carved woodcuts, a medium he embraced for its references to the origins of printmaking and for its seeming naïveté. For similar reasons, he chose iron rather than copper plates for his etchings: the earliest etchings were made by German artists using iron plates. The quality of the metal lent a coarseness to the line that may have been problematic for Renaissance artists, but this kind of primitivism was exactly what Expressionist artists sought. That this impression is so rare—there were only about 18—signals the experimental nature of the artist's efforts.

Unusually large, Nolde's *Liegendes Weib* emerges from the gray tone of the ground to confront the viewer. Unlike the conventional nude, she does not offer herself in a pose of abandon, but leans forward on her folded arms and makes eye contact with the onlooker. Exploiting the crudeness of the line produced in an iron ground, the figure's contours are sharp, irregular, broken, and discontinuous, seeming to violate the murky tone from which they have materialized.

KÄTHE KOLLWITZ

Königsberg, Germany (now Kaliningrad, Russia), 1867–
Moritzburg (Dresden), Germany, 1945

Die Eltern [The Parents], plate III from *Sieben Holzschnitte zum Krieg [Seven Woodcuts on War]*, 1922–1923

Lithograph, Klipstein 179, ivb/ivd; Image: 13¹³⁄₁₆ × 16⅞ in. (35.1 × 42.9 cm); Sheet: 18¾ × 25¹³⁄₁₆ in. (47.6 × 65.6 cm); The Karen G. and Dr. Elgin Ware, Jr. Collection, transfer from the Fine Arts Library, 1996; 1996.151.3/7

BORN INTO A COMFORTABLE middle-class family, Käthe Kollwitz focused her art on the desperate condition of the peasants and proletariat with whom she came into contact, first through literary sources and then directly through her husband's medical practice. She explained in an interview that these subjects interested her more for aesthetic than social reasons, but she is remembered as a socially engaged artist who protested vehemently against World War I. Here again she felt some ambivalence, as she supported her son's decision to volunteer to join the German army against her husband's wishes. His death in Flanders shortly after enlisting became the fulcrum upon which her later art balanced.

This powerful woodcut comes from her most famous series. About it she wrote in her diary, "Yet again I am not finished with the *War* series. Done the sheet 'Parents' over again. Suddenly it looks entirely bad to me. Far too bright and hard and distinct. Pain is totally dark." Although she was dissatisfied with the outcome, the woodcut medium, its heavy black planes slashed here with stark white highlights, aptly conveys the sense of nearly uncontrollable parental grief at the loss of a child.

Wassily Kandinsky

Moscow, 1866–Neuilly-sur-Seine, France, 1944

Lithographie für die Fierte Bauhausmappe, from *Bauhaus Drücke–Neue Europäische Graphik, 4te Mappe: Italienische und Russische Künstler [Lithograph for the Fourth Bauhaus Portfolio, from Bauhaus Prints–New European Graphics, Fourth Portfolio: Italian and Russian Artists]*, 1922

Four-color lithograph, Peters IV/8, Roethel 162, first state of two; Sheet: 14 × 12⅜ in. (35.5 × 31.5 cm); Gift of Mr. and Mrs. Richard Gonzales, 1989; 1989.102.8–11

WASSILY KANDINSKY's art and theoretical treatises, such as *Concerning the Spiritual in Art* (1911), were instrumental to the development of abstraction in the early twentieth century. Made during the artist's first year as a professor at the Bauhaus, this lithograph stands out as one of the few nonfigurative works in a portfolio that includes Surrealist, Cubist, and Futurist works. The print can also be read as a prefiguration of *Point and Line to Plane*, the textbook that he published for one of his classes in 1926. The book redefined the elements of composition and their relationships to each other in a work of art.

Using shards of primary color, overlapping geometric shapes, and competing gestural strokes, Kandinsky exploded the idea that expression and content in art depend on the figure. Distributed throughout Europe and the United States, the portfolio of which this lithograph is a part spread revolutionary ideas about the definition and function of art in an increasingly democratic and global society.

PABLO PICASSO

Malaga, Spain, 1881–Mougins, France, 1973

Minotaure aveugle guidé par une fillette dans la nuit [Blind Minotaur Guided by a Young Girl in the Night], plate 97 from the *Suite Vollard*, 1933–1934

Aquatint and drypoint, Bloch 225, Geiser 437; Plate: 9¾ × 13¹¹⁄₁₆ in. (24.8 × 34.7 cm); Sheet: 13⅜ × 17⁵⁄₁₆ in. (34 × 44 cm); The Leo Steinberg Collection, 2002; 2002.1987

BLIND MINOTAUR is one of the most celebrated images in a suite of one hundred that Pablo Picasso produced between 1930 and 1937 for the dealer Ambroise Vollard. Having exhausted Analytical and Synthetic Cubism, and after repeated visits to Italy where he explored ancient art, Picasso entered a classical phase. Focusing on the expressive potential of line, he reinterpreted ancient myths, such as that of the Minotaur, which for him represented the ideal union between man and beast, a combination at once passionate and conflicted. In this, the last image in a series of fifteen sheets treating the theme, the once powerful beast has been deprived of his sight and is dependent on a little girl for direction. Here Picasso has depicted the protagonist, who in earlier images seduced beautiful women, as enfeebled, while transforming the lovely female into a compassionate guide. The energetic line has been replaced by rich, velvety black surroundings, bright day turning into inky night.

Vollard died in a car accident before he could have the suite printed. It remained unpublished in its entirety until 1950, when another dealer, who had acquired the plates during the war, had them printed and signed by the artist.

63/77 bill
 70

Max Bill

Winterthur, Switzerland, 1908–Zurich, 1994

Untitled, 1970

Five-color screenprint; Image: 14³⁄₁₆ × 14³⁄₁₆ in. (36 × 36 cm);
Sheet: 22⁷⁄₁₆ × 19 in. (57 × 48.9 cm); Gift of Charles and Dorothy
Clark, 1975; G1975.1.5

A PUPIL OF WASSILY KANDINSKY'S at the Bauhaus
from 1927 to 1929, Max Bill later became a pro-
ponent of Concrete art, which he distinguished
from abstraction: "The term 'concrete art' refers to
those works that have developed through their own,
innate means and laws—in other words, works
that bear no relation to external phenomena, and
are not the result of any kind of 'abstraction'. . . .
Concrete art is autonomous." While he empha-
sized the difference between himself and abstrac-
tionists like Kandinsky, he nevertheless continued
in their spiritual vein. Bill's highly structured and

rigorous compositions are ruled by a mathemati-
cal or geometric mysticism, and they are some-
times construed as Buddhist symbols or prayer
wheels.

Equally adept as an architect, sculptor,
and author, Bill was elected to the Swiss Federal
Parliament in 1968. In 1975 the Albright-Knox
Art Gallery in Buffalo, New York, organized his
retrospective, where he was characterized as a
consummate craftsman who achieved the "ego-
less" and "collective" art that was the objective
of the Bauhaus.

Because of Charles Clark's interest in the
Concrete movement, the collection possesses a
large number of graphic works by its leading
figures.

JOSEPH BEUYS

Krefeld, Germany, 1921–Düsseldorf, Germany, 1986

Ohne die Rose tun wir's nicht! Da können wir ja nicht mehr denken [We don't do it without the rose! We wouldn't even be able to think.], 1972

Color offset lithograph; Sheet: 31⅝ × 22¼ in. (80.3 × 56.6 cm); Gift of Charles and Dorothy Clark, 1973; G1973.7.11

JOSEPH BEUYS ONCE WROTE: "For me the rose is a very simple and clear example and image of this evolutionary process toward the revolutionary aim, for a rose is a revolution relative to its origin. The blossom does not come about abruptly, but rather is the result of organic growth, constructed in such a way that the embryonic petals are encapsulated in the green leaves and derive from them. Green leaves are transformed into calyx and petals. Thus, relative to the leaves and the stem, the bloom is a revolution, although it has grown in organic transmutation."

Given this association, the political activist's face juxtaposed with the flower in this image identifies him as a revolutionary. Beuys expressed his evolution-as-revolution theme not only iconographically, but technically and conceptually as well. This lithograph evolved from a photograph by Wilfred Bauer published first in *Zeit* magazine in 1972. In Beuy's hands the portrait turned into a self-portrait. The revolution occurred when the artist-as-object was transformed into the artist-as-art, an idea Beuys promoted tirelessly in his performances and in what he called his "social sculptures," which he staged throughout his career.

CHRISTOPHER LE BRUN

b. Portsmouth, England, 1951

XIII, from *Fifty Etchings*, 1990

Sugarlift and openbite etching with scraping and polishing, 22/30;
Plate: 7 × 5¹⁄₁₆ in. (17.8 × 12.9 cm); Sheet: 19¹³⁄₁₆ × 16⁹⁄₁₆ in. (50.4 ×
42 cm); Archer M. Huntington Museum Fund, 1993; 1993.79

XXXV, from *Fifty Etchings*, 1990

Spitbite, openbite, softground, and creeping bite etching, 21/30;
Plate: 7 × 5¹⁄₁₆ in. (17.8 × 12.9 cm); Sheet: 19⁷⁄₈ × 16⁵⁄₈ in. (50.5 ×
42.3 cm); Archer M. Huntington Museum Fund, 1993; 1993.79

FIFTY ETCHINGS was Christopher Le Brun's first
attempt at etching since his years as a student at
Slade School of Fine Art in London in the 1970s.
Approaching the medium as a realm of technical
experiment, sequential revision, and personal
graphic expression, he attempted to reconcile
the contemporary concerns with gesture and the
artist's hand with the principles and ideals of
the grand tradition of etching. He produced the
series over the course of a year at Hope Suffer-
ance Studios in London. Some of the works are
more figurative and, in at least one case, very
nearly reproduce a painting. Most, like these,
are highly abstract, with barely recognizable fig-
ures emerging from the densely worked surfaces.
Simultaneous with his development of these
etching's motifs, he explored the range of effects
that could be achieved with the medium, from
images that read as simple line drawings to effects
generated by complex techniques such as spitbite,
openbite, and creeping bite etching, with layered
applications of stopping-out varnish and repeated
biting. The series is a technical tour de force, con-
sistent with his reputation as Britain's leading
contemporary figurative artist.

AMERICAN ART

WILLIAM T. RANNEY

Middletown, Connecticut, 1813–West Hoboken, New Jersey, 1857

Wild Duck Shooting—On the Wing, c. 1850

Oil on canvas; 30 × 50¾ in. (96.9 × 128.9 cm); Gift of C. R. Smith, 1973; G1973.14

ANTICIPATION: every hunter savors it, and the feeling is palpable in this classically composed duck-shooting scene by William Ranney, a noted painter of sporting pictures. Unlike its stylistic precedents in eighteenth-century British sporting art, Ranney's tight ensemble features robust American characters whose simplicity and vigor were emblematic of the national temperament, at least in the perception of its own proud citizens. Ranney created several versions of this popular and critically well-received image in both pen-and-ink and oil, and it acquired broad distribution through its translation into engravings and lithographs, the latter produced by the well-known firm of Currier and Ives.

ALFRED JACOB MILLER

Baltimore, 1810–1874

Wind River Mountain Range Scene, c. 1858–1874

Oil on panel; 10 × 16 in. (25.5 × 40.9 cm); Bequest of C. R. Smith, 1991; 1991.41

WHEN ALFRED JACOB MILLER traveled to the Wind River mountain range of Wyoming in 1837, he was the first non-native artist to explore this virtually undisturbed western wilderness. Hired to record the encounters and events of a fur-trading expedition to the Rocky Mountains, he spent six months absorbing landscapes like no other. Years later he was still painting from his sketches of the trip, especially views incorporating his favorite subject: the area's pristine alpine lakes, such as the one at the center of this luminous painting. With its dramatically lit sky and narrative foil in the lower left corner—leading the viewer to wonder what announcement will be made—the jewel-like canvas offers a serene romantic vision of a sheltered paradise on the brink of change.

ALBERT BIERSTADT

Solingen, Germany, 1830–New York, 1902

Sioux Village near Fort Laramie, 1859

Oil on panel; 12½ × 19½ in. (31.8 × 49.3 cm); Bequest of
C. R. Smith, 1991; 1991.22

WHEN ALBERT BIERSTADT PAINTED this inti-
mate study of a native encampment in 1859, he
was twenty-nine years old and on his first journey
to the American West. Accompanying an army
expedition as its recorder, he sketched firsthand
impressions of the new landscape and its people
in pencil and pen-and-ink. Bierstadt's spectacular
western landscapes would lead within a decade to
his celebration as the leading American painter of
the West, but in this modest early work, it was the
comparatively mundane details of native family
life that captured his interest. Certain features are
rendered with notable virtuosity—the lone, tall

tree and the left-most teepee—but in general this
work embodies a sense of quiet repose and time-
lessness, different from the theatrical vistas and
stunning sites for which the artist is best known.
Bierstadt was one of the first American observers
and recorders of native life, but his intent was less
scientific and anthropological than artistic: back
in the studio, where he composed his monumental
oil paintings, he often combined images from very
different locales for dramatic effect. The camera
tripod visible in this work is a remnant of another
study trip by Bierstadt, who inserted it presumably
to testify to his presence at the scene.

Thomas Worthington Whittredge

Near Springfield, Ohio, 1820–Summit, New Jersey, 1910

Buffalo on the Platte River, 1866

Oil on board; 19⅜ × 28¼ in. (49.2 × 71.8 cm); Gift of C. R. Smith, 1985; 1985.81

THIS IS A RARE western landscape by Thomas Worthington Whittredge: one of the best-known American landscape painters of his generation, he lived in New York and typically painted east coast subjects. But in 1866 he traveled with an army expedition along the eastern portions of the Rocky Mountains and New Mexico, finding himself drawn again and again to "capture the fleeting atmospheric effects of the low rolling landscape," as he stated in his autobiography. In his writings he reflected on the natural marvels he encountered, stating that he was never captivated by the obvious drama of the mountains, but instead loved the plains, with their vast expanses and uncanny silence. In this placid scene, most likely painted from sketches back in his studio, buffalo graze peacefully under banks of fog, while small disturbances on the water's surface are quietly noted.

THOMAS MORAN

Bolton, England, 1837–Santa Barbara, California, 1926

The Golden Hour, 1875

Oil on canvas; 9½ × 13⅝ in. (24.2 × 34.7 cm); Bequest of
C. R. Smith, 1991; 1991.42

THOMAS MORAN's romanticized view of the
towering cliffs of the Green River in southwestern
Wyoming is notable for the operatic power of its
imagery, despite the picture's modest scale. An im-
possibly fiery sunset suffuses the jagged outcrop-
pings in a golden light that exaggerates the glories
and grandeur of nature. Americans back east were
eager to discover the uninhabited western land-
scape through paintings like this and through re-
productions. To make an even more compelling
picture, Moran took certain liberties with features
of the undeniably spectacular landscapes he ob-
served on his trips to Wyoming during the summers
of 1871 and 1872. Loosely and impressionistically
painted, *The Golden Hour* is neither a major nor
a typical work by Moran, but its magical intensity
successfully communicates the artist's deep fond-
ness for the first western site he ever sketched.

JAMES McNEILL WHISTLER

Lowell, Massachusetts, 1834–London, 1903

Nocturne: The River at Battersea, 1878

Lithotint on blue-gray wove appliqué, Way 5, Levy 10, Chicago 8, second state of two, edition of 30 signed, large-sheet impressions from a total edition of 100 (1887); Sheet: 11⅛ × 14⁹⁄₁₆ in. (28.2 × 37 cm); Image: 6¾ × 10³⁄₁₆ in. (17.2 × 25.8 cm); The Teaching Collection of Marvin Vexler, '48, 1997; 1997.21

JAMES McNEILL WHISTLER spent much of his career working in London, whose dense urban landscapes were a frequent theme for this master of evocative realism. From his home in the riverside neighborhood of Chelsea, he could easily see the industrial tracts of Battersea on the opposite shore.

During the 1870s he developed the type of image for which he became best known—the evening landscape, or nocturne—in scores of oil paintings and lithographs. *Nocturne: The River at Battersea* is among his first and most successful experiments in lithography, which allows both fluidity of expressionistic effects and the rendering of specific detail.

Whistler and his printer, Thomas Way and Son, pushed the limits of lithography's expressive potential when they developed the lithotint, a method that produces subtle areas of tone by applying a fine aerosol spray of lithographic ink directly on the stone. The atmospheric effects of this haunting image, in which buildings seem to reflect and dissolve in the dusky light, were enhanced by the new technique. Whistler's use of a cool, blue-gray paper underscores the romantic mood of the scene, reinforcing its dreamlike quality and the musical allusions of its title.

THOMAS HILL

Birmingham, England, 1829–Raymond, California, 1908

*Indians at Campfire, Yosemite Valley,
California,* c. 1885

Oil on canvas; 29⅝ × 45½ in. (75.3 × 115.6 cm); Gift of
C. R. Smith, 1976; G1976.21.17

THIS IMPRESSIVE WORK by Thomas Hill depicts
the majestic Yosemite Valley as seen from Inspira-
tion Point, located three thousand feet above the
valley floor, purportedly the most beautiful and
striking vantage point in Yosemite. Whereas the
massive, snow-capped mountain peaks in the far
distance and the cascading waters of Bridalveil
Falls just off-center of the composition appear as
they might have been seen in the mid-1880s, the
small party of figures in the lower quadrant is an
artistic device symbolizing the romantic notion of
a time when people lived in harmony with nature.

In fact, the U.S. Army years earlier had evicted
the Indians who once inhabited the valley. And
in 1864 the federal government set aside a large
tract of land there for public recreation, prohib-
iting settlement as well as future mining and
development.

Shortly after Hill's earliest trip to Yosemite
in 1862, his gorgeous mountain views began to
enjoy both popular and critical success. In 1884
the British artist moved from his base in San Fran-
cisco and established a studio in Yosemite, where
he produced an estimated five thousand paintings
of the valley for the tourist market.

HENRY F. FARNY

Alsace-Lorraine, France, 1847–Cincinnati, 1916

Breaking Camp, 1891

Watercolor and tempera on paper; 9⁷⁄₁₆ × 16¾ in. (24 × 42.5 cm);
Gift of C. R. Smith, 1970; G1972.8.8

BREAKING CAMP is one of fourteen works in
the Blanton Museum's C. R. Smith Collection
by Henry Farny, a master of European-style real-
ism who earned international recognition for
his extensive body of work portraying American
Indians. Whereas his contemporaries Frederic
Remington and Charles Russell specialized in
depicting the lives of cowboys in robust paintings
and bronze sculptures, Farny made exquisitely
detailed, relatively small-scale paintings on paper
that describe Indian life in somewhat idealized
terms. Using quick-drying paints, he captured

subtle details of a lifestyle he considered rich in
simplicity, nobility, and romance.

The American market responded eagerly,
and he sold many works: his gracefully balanced
compositions and harmonious portrayals of
native events affirmed the public's wishful belief
that native life remained unblemished by the intru-
sions of white culture. *Breaking Camp* presents a
typical scene of Indian life, one portrayed repeat-
edly by Farny over the years; this handsome ver-
sion, evoking a change of season, is one of his
earliest.

Robert Henri

Cincinnati, 1865–New York, 1929

The Old Model (Old Spanish Woman), c. 1912

Oil on canvas; 23 × 20 in. (60.9 × 51 cm); Gift of Mari and James A. Michener, 1991; 1991.237

An INFLUENTIAL TEACHER and the outspoken founder of a new, progressive style of realism, Robert Henri is perhaps best known for his acutely sensitive portraits of common people, whom he sought out during his travels around the world. Unlike his contemporaries, who painted commissioned portraits of wealthy industrialists and their families, Henri preferred what he considered to be the deeper and more complex characters of workers, peasants, beggars, and entertainers. He was particularly fond of sitters in Spain, evident in this work, and visited there several times for lengthy painting excursions between 1906 and 1912, and again in 1923–1924.

In an article he wrote in *The Craftsman* in 1915, he said, "The people I like to paint are 'my people,' whoever they may be, wherever they may exist, the people through whom dignity of life is manifest, who are in some way expressing themselves naturally. . . . My people may be old or young, rich or poor. . . . But wherever I find them, . . . my interest is awakened and my impulse immediately is to tell about them through my own language—drawing and painting in color."

Perhaps because of the breadth of his foreign experiences, Henri was a champion of the particularities of regional character and encouraged artists in the United States to paint details of everyday American life.

WILLIAM ROBINSON LEIGH

Falling Waters, West Virginia, 1866–New York, 1955

The Roping, 1914

Oil on canvas; 45¼ × 38¼ in. (114.9 × 97.2 cm); Gift of
C. R. Smith, 1984; 1984.92

WILLIAM ROBINSON LEIGH began his career as
a magazine and book illustrator, but on the advice
of the well-respected landscape painter Thomas
Moran, he switched to oil paintings of the Ameri-
can landscape and experience. This vibrant work
is one of a series of images that Leigh painted of
cowboys on galloping horses. Quickly painted and
action-packed, it handily conveys the heat and dust,
the straining effort of the horse, and the compo-
sure and grace of its rider.

Leigh prided himself on the authentic details
of the clothes and gear that he depicted. Based
in midtown Manhattan, he would travel every

summer to the Southwest to sketch, study, photo-
graph, and collect artifacts that later figured
prominently in his studio-made works.

He noted in *The Western Pony,* a book that he
wrote and illustrated in 1933: "I find in the West
the truely [*sic*] typical and distinctively American
motifs, a grandeur in natural surroundings, a
dramatic simplicity in life which can be found
nowhere else. In that life, in those surroundings—
marvelously varied and abundant—the horse
plays a major role."

Max Weber

Belostok, Russia (Bialystok, Poland), 1881–Great Neck,
New York, 1961

New York at Night, 1915

Oil on canvas; 33⅞ x 20 in. (90.2 x 59.4 cm); Gift of Mari and
James A. Michener, 1991; 1991.338

Max Weber was one of the first American art-
ists to fully synthesize the principles of European
modernism and adapt them to a specifically
American subject matter. Well acquainted with
the debates and practices of Gertrude Stein, Pablo
Picasso, Henri Matisse, Henri Rousseau, and other
leading European artists and intellectuals whom
he met while living in Paris, Weber helped intro-
duce their avant-garde ideas to artists working in
the United States when he returned to New York.

His own influential pulpit was Alfred Stieglitz's
journal *Camera Work*. In its pages he proposed his
most important concept, the notion of a fourth
dimension, or the extension of space into another
realm beyond the three dimensions of the visible
world. His speculative ideas found clear expression
in the paintings he executed around 1910, which
incorporated representations of movement and
time.

New York at Night, completed five years later,
reduces his impressions of time and place to a
basic vocabulary of colorful geometric shapes and
intersecting planes seen from multiple perspectives
and enhanced by illusions of motion and reverber-
ating sound. In works like this, Weber conveyed
the speed, the action, and the dynamic energy
of the city more abstractly than ever before in
American painting.

GEORGE BELLOWS

Columbus, Ohio, 1882–New York, 1925

Splinter Beach, 1916

Lithograph, Bellows 63, Mason 28, only state, edition of 70;
Sheet: 16⁷⁄₁₆ × 20¹⁵⁄₁₆ in. (41.8 × 53.2 cm); Image: 15 × 19⁷⁄₈ in.
(38.1 × 50.5 cm); Archer M. Huntington Museum Fund, 1981;
1981.37

GEORGE BELLOWS was associated with the
Ashcan School, a group of American painters
that also included Robert Henri, John Sloan, and
George Luks, who were committed to conveying
the character of the new urban American experi-
ence through a nuanced realism. Best known for
his paintings (the museum owns a remarkable
seascape dating from 1913), Bellows began explor-
ing the medium of lithography in 1916.

Splinter Beach is one of his early lithographs,
made with printer George C. Miller. The complex
image presents a rare moment of leisure in these
workers' lives as, in various states of undress, they
prepare for a swim on a stretch of urban river that
was surely not meant for that purpose. Bellows
juxtaposes this teeming—and timeless—figurative
tableau against the contemporary engine of bur-
geoning commerce, literalized here by a boat forg-
ing through choppy waters. In the distance the
new metropolis beckons: the engineering wonder
of the Brooklyn Bridge and the new skyscrapers
surrounding it.

This was the future vision of America—
dynamic, productive, ingenious—and the topic
seems uniquely well suited to Bellows, a visionary
man. As the first well-known artist in the United
States to develop a complete body of lithographic
works, Bellows challenged preconceptions about
the medium, expanding its expressive potential.

Charles Marion Russell

St. Louis, 1864–Great Falls, Montana, 1926

Medicine Man, 1916

Oil on canvas; 27½ × 22½ in. (69.8 × 57.2 cm); Gift of C. R. Smith, 1976; G1976.21.30

CHARLES RUSSELL'S NAME is synonymous with a dynamic artistic chronicle of the American West, and his lively canvases call to mind popular images of "cowboys and Indians." But in his later years, Russell often painted to express his anger and regret about the rapid change that had overtaken the region.

Unlike many artists of his era who were quick to caricature the ways of native peoples, Russell, a decades-long resident of the West, spent months living among the Blackfeet nation, whose traditions and values he greatly admired. In works like *Medicine Man*, he was meticulous about representing particular details of tribal customs—in this case those of the Piegan, who lived in central Montana. Even the horse bears distinctive tribal markings, including the red spots circled by blue on its neck, which signified successful raids against an enemy.

The composition of the work—a mounted brave, his proud bearing signifying determination and courage, leading a procession across the barren plain, the sun setting behind them—symbolically conveys Russell's late-in-life fear that American business interests, with their drive to expansion, had destroyed the indigenous civilizations of the western territories.

STANTON MACDONALD-WRIGHT

Charlottesville, Virginia, 1890–Pacific Palisades, California, 1973

Synchromy in Purple Minor, 1918

Oil on canvas; 24 × 20¹⁄₁₆ in. (61 × 51 cm); Michener Acquisitions Fund, 1970; P1970.16.1

IN THE FIRST DECADES of the twentieth century, many American painters struggled to understand the visual properties of light, color, form, and space. A new analytical approach to art flourished, rooted in the painterly investigations of the French Impressionists and in a burgeoning public understanding of recent scientific advances.

Working in Paris among an international community of painters who were all pushing the boundaries of established ideas, American artists Stanton Macdonald-Wright and Morgan Russell developed a system of abstract painting based on color harmonies and their alignment with Western musical structures. *Synchromy in Purple Minor*, painted by Macdonald-Wright after his return to New York, is considered one of the masterworks of this system, called Synchromism. Using his studies of Michelangelo's sculpture, the *Pieta*, he described the abstracted female figure's sculptural dimension primarily through color, rather than line or form. Using color's capacity to suggest depth through juxtapositions that imply receding or advancing space, the artist generated illusionistic form without using traditional techniques.

Synchromy in Purple Minor charts an essential step in the evolution of this new abstract language, whose roots stem from the artistic and scientific discoveries of the day.

MARSDEN HARTLEY

Lewiston, Maine, 1877–Ellsworth, Maine, 1943

New Mexico Recollection #12, 1922–1923

Oil on canvas; 30 × 40 in. (76.6 × 101.7 cm); Gift of Mari and James A. Michener, 1991; 1991.232

INFLUENCED BY THE LATE nineteenth-century visionary painter Albert Pinkham Ryder and the poet Walt Whitman, whom he read avidly, Marsden Hartley painted in an expressive style and tried to depict the mood, rather than the literal description, of a subject. A native of Maine, Hartley was drawn to landscape painting, preferring to work from memory or from his imagination rather than relying on sketches or studies.

The influential New York art dealer and photographer Alfred Stieglitz encouraged him to look to the European avant-garde for inspiration. Hartley found it in the work of Wassily Kandinsky, who advocated personal expression with a spiritual aim.

Following World War II, Hartley traveled to Taos, New Mexico, to take a teaching job. Studying the new southwestern landscape, he first drew it realistically and then experimented with aspects of Cubism, Expressionism, and other modernist styles. Upon his return to New York and during a trip to Europe that followed, Hartley reworked his ideas about New Mexico in a series of highly stylized landscapes that exaggerate the dramatic sculptural qualities of the mountain environment. *New Mexico Recollection #12*, part of that series, evokes the psychological intensity associated with memories of places from one's past.

Yasuo Kuniyoshi

Okayama, Japan, 1889–Woodstock, New York, 1953

Waitresses from the Sparhawk, 1924–1925

Oil on canvas; 29 × 41 in. (74.7 × 105.5 cm); Gift of Mari and
James A. Michener, 1991; 1991.252

WAITRESSES FROM THE SPARHAWK is an early
work by Yasuo Kuniyoshi, painted just two years
after his first solo gallery show in New York. Set
in a popular resort in Ogunquit, Maine, where the
artist spent his summers for many years, the work
presents a seemingly delightful vignette about
female friendship—except for that brooding sky
and the slightly sinister tone of the surroundings.

This odd but intriguing combination of styl-
ized figures, abstracted landscape forms, and nar-
rative references reflects the distinctive synthetic
approach taken by Kuniyoshi and many American
artists during this period following World War I.

Painted in advance of the artist's first trip to
Europe, the work is an amalgam of undigested
influences, reflecting his interest in Japanese prints,
the modernist landscapes of Paul Cézanne, and
American folk art.

Characteristically quirky and mysterious,
Waitresses from the Sparhawk is an important
early painting by Kuniyoshi, the first living artist
ever to be accorded a career retrospective exhibi-
tion at the Whitney Museum of American Art,
New York.

Stuart Davis

Philadelphia, 1892–New York, 1964

Lawn and Sky, 1931

Oil on canvas; 18⅝ × 22⅝ in. (47.3 × 57.5 cm); Gift of Mari and James A. Michener, 1991; 1991.205

ONE OF THE MOST INFLUENTIAL early American abstract artists, Stuart Davis created images derived from simple observation, which he complicated by incorporating multiple and concurrent points of view. In essence, his works provide a simultaneous perception of both space and time.

Davis's groundbreaking synthesis of realism and abstraction developed over several decades as he worked to portray the immediate—and intangible—associations that accompany every-day perceptions. *Lawn and Sky*, a modest-size painting with the high-keyed colors and bold shapes and lines that exemplify Davis's style, is notable for the artist's experimental attempt to portray how simultaneity "looks." In this vivid work, Davis superimposed several views of Gloucester, his summer retreat in Massachusetts, within one composition.

The ambiguity of the image—where is the foreground, and where are we to locate the viewer in relation to the scene?—conveys how dynamic and complex the act of seeing is, and how personal reactions and mental adjustments to visual inconsistencies constantly inform our perception of the world. Davis's work gives visual form to the experience of relativity, a theoretical concept that gained currency in scientific, artistic, and philosophical circles in the years before World War II.

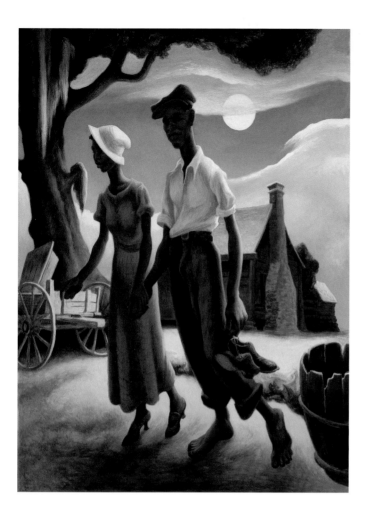

THOMAS HART BENTON

Neosho, Missouri, 1889–Kansas City, 1975

Romance, 1931–1932

Tempera and oil varnish glazes on gesso panel; 45½ × 33¼ in. (115 × 84 cm); Gift of Mari and James A. Michener, 1991; 1991.187

A PAINTER AND MURALIST celebrated for his regional scenes of daily life in the southern, midwestern, and western United States, Thomas Hart Benton was committed to portraying images of progress and satisfaction in the American heartland. Born to a family of statesmen, Benton was a patriot who saw his art as a means to generate social and political reform. His nostalgic and uplifting scenes of hard work, self-reliance, and individualism garnered broad popular appeal in post–World War I America. This work, painted when the artist was at the midpoint of his life, provides a lyrical view of a young couple on a relaxed evening stroll. Drawing on his knowledge of both Old Master techniques and modernist ideas, which he had gleaned from several years spent studying in Paris, Benton crafted a lively composition whose rhythmic alignment of forms conveys a sense of poignant familiarity.

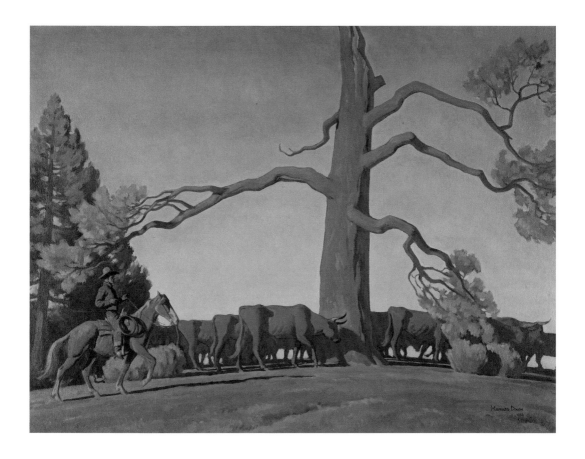

Lafayette Maynard Dixon

Fresno, California, 1875–Tucson, 1946

Top of the Ridge, 1932

Oil on canvas; 45 × 57¼ in. (114.3 × 145.4 cm); Gift of C. R. Smith, 1976; G1976.21.7

BOLD, SIMPLIFIED SHAPES, shallow representations of space, and absolute stillness distinguish Maynard Dixon's western images. His works are frequently described as more "modern" looking than those of his contemporaries, perhaps because the western genre tends toward the documentary and/or nostalgic. Indeed, unlike many of his peers, Dixon did have an interest in the new modernist ideas of abstraction. But his art was also greatly influenced by his passionate engagement with Hopi culture and its notion of constant time without beginning, middle, or end.

Technical considerations may have affected the look of Dixon's work as well. Prior to painting *Top of the Ridge*, the artist had spent most of a decade painting murals for private commissions. Of the five Dixon works that came to the Blanton Museum as part of the C. R. Smith Collection, this most resembles a typical mural subject, with its expansive horizontality anchored by a primary, almost centered vertical, and with its reliance on dynamic line and compositional rhythms rather than specific details.

It may also be relevant that Dixon was married to the noted photographer Dorothea Lange in the 1920s: in much the way that a photograph "freezes time," Dixon's canvases are silent and without motion.

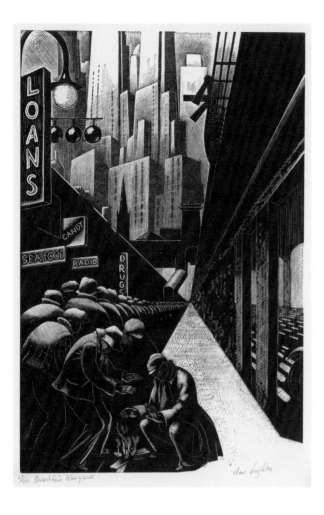

CLARE LEIGHTON

London, 1898–Waterbury, Connecticut, 1989

Breadline, New York, 1932

Wood engraving, Boston Public Library 198, only state, 27/100; Sheet: 14³⁄₁₆ × 10 in. (36.1 × 25.4 cm); Image: 12 × 8 in. (30.5 × 20.3 cm); Gift of the Still Water Foundation, 1992; 1992.226

BETWEEN THE EARLY 1920s in her native England and the mid-1970s in the United States, the country she adopted after 1939, Clare Leighton created nearly eight hundred wood engravings. These were primarily images for fine literary editions, illustrations of her own texts on nature and her craft, and independent prints showing human industry. All are characterized by brilliant technique and forceful personality, but above all they communicate a concern for the dignity of labor and the principles of democracy.

Fairly large in scale for a wood engraving of this time, *Breadline* is probably Leighton's most famous image, though in many ways it is atypical of her production. Unlike her usual rural meditations, it concentrates on the effects of the Great Depression in the city. Furthermore, her contrast of the massive office towers, which usually celebrate the capitalistic might and social optimism of New York, with the never-ending line of hungry men, is uncharacteristically ironic and therefore compelling.

With a donation from the Still Water Foundation in 1987, the Blanton acquired a virtually complete collection of Leighton's prints—most from the artist's own archive—and thus became the most significant repository of her graphic work.

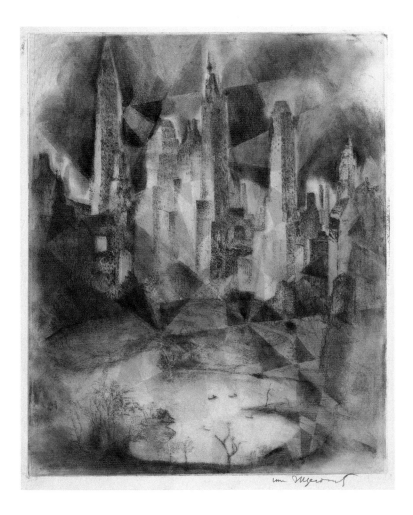

WILLIAM MEYEROWITZ

Eksterinoslav, Ukraine, Russia, 1886–New York, 1981

Manhattan, mid-1930s

Etching and aquatint from two plates, colored à la poupée; Sheet: 11¹⁵⁄₁₆ × 9¹⁵⁄₁₆ in. (30.3 × 25.2 cm); Gift of Girard Jackson, 1995; 1995.81

FOR MORE THAN SEVENTY YEARS, William Meyerowitz was a vital presence in the culture of New York. A Russian immigrant who settled as a young man on the city's Lower East Side, he studied painting with William Merritt Chase and etching with Charles Mielatz at the National Academy of Design. A talented musician, he supported himself during this period by singing baritone in the Metropolitan Opera chorus.

By the 1920s he had arrived at his mature artistic style, which integrated the personalized touch of the American Impressionists, the vivid palette of the Fauves, and the compositional structures of the European avant-garde. He is best known for his innovations in color printing, involving multiple runs, multiple plates, and complex inkings. *Manhattan,* one of his preferred subjects in the 1930s, is among the most imposing and vibrant of his color prints.

Setting exacting standards for himself, Meyerowitz created his own etching plates, mixed his own inks, and printed all of his works himself, manifesting a truly extraordinary commitment to a lifelong practice. The collection's 136 prints, including many in multiple states and different color schemes, form the most important holding of Meyerowitz's etched work.

PHILIP EVERGOOD

New York, 1901–Southbury, Connecticut, 1973

Dance Marathon, 1934

Oil on canvas; 60 × 40 in. (152.6 × 101.7 cm); Gift of Mari and James A. Michener, 1991; 1991.210

PHILIP EVERGOOD was committed to creating art that exposed and protested social injustice. An activist as well as a serious artist, Evergood was a force in several important Depression-era political organizations working to alleviate poverty, unemployment, and worker exploitation.

Dance Marathon, one of Evergood's master-works of social critique, depicts a phenomenon that swept the country during those years of hardship, in which couples competed for a cash prize by dancing as long as possible. The dense and garish painting combines evocative details—the exhausted couples, hastily thrown together

viewing stands, and crude promotional prize announcements—with allegorical symbols that convey the painter's (and, in his hope, the viewer's) attitude toward this travesty of enter-tainment. Subtle but insistent, these artistic flourishes include a skeletal hand that proffers money; the circular composition implying the never-ending nature of both the event and human exploitation; and Mickey Mouse (in a less endearing, more rodentlike early rendering), whose character suggests the alliance of corpo-rate interests and cultural spectacle.

Evergood's work, while rooted in the Great Depression, serves as a potent reminder of human desperation and cruelty, and as such is a timeless cautionary tale.

Jacob Lawrence

Atlantic City, New Jersey, 1917–Seattle, 2000

The Eviction, 1935

Gouache and collage on paper; 28 × 38⅜ in. (71.1 × 97.5 cm);
Michener Acquisitions Fund, 1969; P1969.12.2

A MASTER STORYTELLER and chronicler of
history, Jacob Lawrence was one of the leading
figurative painters of the twentieth century. He
was also the preeminent African American artist
of his generation, creating work characterized by
strong, simplified forms, a distinctive palette of
bold hues, and dynamic compositions that heighten
the drama or tension of his tales.

A childhood spent largely in Harlem during
the years of the Great Depression provided him
with subject matter that he returned to throughout
his long career. Inspired by the vibrant artistic and
intellectual energy that had fueled the Harlem
Renaissance, Lawrence studied visual art at an
early age, creating The Eviction when he was just
seventeen years old. It shows a typical Harlem
occurrence—a black family thrown out of their
home by a white landlord—a scene that, in a larger
sense, reflects the overcrowding, poverty, and fre-
quent displacements that the Great Depression
caused throughout America's urban communities.

But few painters were tracing the specific
narratives of African American experience, and
Lawrence vowed at a young age to remedy that
situation. Even in such an early work, he force-
fully communicated the immediacy of his story,
simplified to its essences, with clear and unwaver-
ing vision.

RAPHAEL SOYER

Borisoglebsk, Russia, 1899–New York, 1987

Transients, 1936

Oil on canvas; 37½ × 34⅛ in. (95.3 × 86.7 cm); Gift of Mari and James A. Michener, 1991; 1991.324

RAPHAEL SOYER was one of the leading proponents of a painting style called Social Realism, whose aim was to document the social and political mood of life during the years of the Great Depression. While other Social Realists, like Philip Evergood, were known for their searing indictments of poverty, Soyer's tone was gentler and more sympathetic, though no less a call to action.

His renderings of individuals, like these men waiting for public assistance, encourage the viewer to identify with the subjects and to empathize with their boredom and despair. Each weathered face in this group is an individual portrait—in fact, the figure on the left is Walter Broe, a homeless man who the artist employed as a model on many occasions, and the yawning figure toward the right rear is Raphael Soyer himself.

Drawing and painting from models provided the foundation for Soyer's practice, and he gained his carefully articulated insights from direct observation. His brand of realism was marked by its unflinching honesty and uncommon humanity. In many ways his paintings act as counterpoints to the great documentary photographs of the era taken by artists such as Dorothea Lange and Walker Evans.

Epreuve d'artiste MAZY Dickson. Reeder '37

DICKSON REEDER

Fort Worth, Texas, 1912–1970

Mazy, 1937

Etching and soft-ground etching with burin, artist's proof,
edition unknown; Sheet: 12¹⁵/₁₆ × 10¹⁵/₁₆ in. (32.8 × 26.2 cm);
Plate: 6¾ × 5½ in. (17.2 × 13.9 cm); Archer M. Huntington
Museum Fund, 1988; 1988.47

IN THE 1940S Fort Worth, Texas, enjoyed an
unusual degree of cultural sophistication and
firsthand exposure to the progressive works of
early European modernists, thanks to the patron-
age of several wealthy families and a group of
artists that has been called the Fort Worth Circle.
A central figure of that group was Dickson Reeder,
who had been trained in printmaking both at the
Fort Worth School of Art and at Stanley William
Hayter's esteemed Parisian workshop. Reeder and
the group were passionate about new ideas and
dedicated to exploring new approaches to art
making. Though they worked in a variety of
styles, they all synthesized modernist notions
of abstraction with traditional American repre-
sentation, producing some of the most avant-
garde work in the United States. Their graphic
experiments went against the Regionalist tide
and were unrecognized until quite recently.

Mazy, a portrait of Hayter's first wife, is
a very early and especially fine example of the
Circle's aesthetic concerns and graphic style.
The schematic masklike face indicates Reeder's
interest at that time in the so-called primitive
and abstract elements of Surrealist art. The
richly patterned image skillfully contrasts the
varied textural effects made possible by the
Hayter method of soft-ground etching.

JERRY BYWATERS

Paris, Texas, 1906–Dallas, 1989

Oil Field Girls, 1940

Oil on board; 30 × 24½ in. (75.3 × 62.2 cm); Michener
Acquisitions Fund, 1984; 1984.1

THOUGH JERRY BYWATERS enjoyed a long and
multifaceted career as an artist, writer, critic,
teacher, arts administrator, and museum director,
he is best remembered today for his participation
in the Dallas Nine, an enterprising group of young
painters active in the 1930s who helped establish
a regional artistic identity for Texas art. Like *Oil
Field Girls,* Bywaters's most popular work, their
paintings portray local conditions in expressive
detail even as they acknowledge a wide range of
sophisticated painterly influences gained from
the artists' studies in New York, Mexico City,
and Europe.

In *Oil Field Girls,* Bywaters used a somber
palette to describe the bleak and thinly populated
west Texas landscape. With its economically
depressed vistas, the town (if it can be called that)
is clearly godforsaken. By contrast, the women
poised to hitch a ride out of those sad environs are
vivid and forceful; although they are most likely
working as prostitutes, Bywaters made no appar-
ent judgment of them, instead vesting them with
a vitality, even ambition, that offers the picture's
only hope. A canny mixture of reportage and
editorial commentary, *Oil Field Girls* is a history
painting that captures a surprisingly humane
narrative of a specific time and place.

ARSHILE GORKY

Khorkom, Armenia (Turkey), 1904–Sherman, Connecticut, 1948

The Dialogue of the Edge (Study for Dark Green), c. 1946

Oil on canvas; 32⅛ × 41⅛ in. (81.5 × 104.4 cm); Gift of Mari and James A. Michener, 1991; 1991.223

ARSHILE GORKY, a charismatic émigré painter working in New York, helped forge the development of a more sophisticated language of American abstraction. His fluid, spontaneous style anticipated the achievements of the Abstract Expressionists in the late 1940s and 1950s. Exploring Surrealist ideas of automatic writing (drawing not consciously controlled), Gorky developed a singularly energetic line, which he combined with a variety of loose, painterly effects—the liberal use of thin washes of paint, occasional drips countered with heavily impastoed brushwork, and frequent scrubbing and scraping.

In this work, one of numerous studies Gorky made for a painting now owned by the Philadelphia Museum of Art, the right zone is dominated by the erotic allusion to an opening into deep space that reveals fragments of human anatomy. On the left, a single pinched form seems to approach the painting's divide. All the marks float in fields of amorphous color.

Gorky likely painted this mysterious and somewhat disturbing work on his in-laws' farm in Virginia in the summer of 1946, while recovering from both a studio fire that destroyed most of his recent paintings and cancer surgery a month later. During this period of extreme personal trauma, Gorky painted prolifically, creating some of his greatest works.

ADOLPH GOTTLIEB

New York, 1903–Easthampton, New York, 1974

Cadmium Red over Black, 1959

Oil on canvas; 108 × 90 in. (274.4 × 228.7 cm); Gift of Mari and James A. Michener, 1991; 1991.224

IN THE AFTERMATH of World War II, artists proposed that painterly abstraction could express complex feelings of both traumatic devastation and its antithesis, the heroic sublime. Adolph Gottlieb, along with William Baziotes, Mark Rothko, and other Abstract Expressionists working in New York in the 1940s, avidly discussed new psychological theories and explored dream interpretation and Jungian archetypes in their painting. Seeking to develop images that were mythic and universal, they drew from precedents established by European Surrealist artists such as André Breton and Roberto Matta, a Chilean working in Paris.

Gottlieb's painting of floating shapes evokes the eternal forces of nature. A key work from Bursts, one of his most important series, its imagery derives from sketches he had made years before in the Arizona desert. The distilled red and black shapes—one stained and static, the other dynamic and more vigorously brushed—suggest essential oppositions or dualities, a central precept of Gottlieb's painterly investigation. The tension between these two elemental forms, and the straightforward monumentality of their presentation, conveys intensity, drama, and the constancy of change.

Richard Anuszkiewicz

b. Erie, Pennsylvania, 1930

Plus Reversed, 1960

Oil on canvas; 75 × 58 in. (189.6 × 148 cm); Gift of Mari and James A. Michener, 1991; 1991.177

LIKE A SCIENTIST OBSERVING objective data, Richard Anuszkiewicz regards his paintings as experiments, investigations, and studies of color. A student of Josef Albers, the leading professor of color theory in the United States, Anuszkiewicz has developed a compelling painting style that gives visual form to scientific principles.

Plus Reversed is a key example of what has been called Optical art or Op art in the United States—a painting whose color and pattern conjunctions cause involuntary perceptual effects in its viewer. Here the artist paired the complementary colors of red and green in repetitive patterns of plus-shaped signs, reminiscent of the voltage symbols on a battery. The juxtaposition of colors intensifies their vividness and induces a flickering retinal effect. The patterning creates a further reverberation of its own by changing colors as it expands outward, suggesting movement.

Plus Reversed is one of Anuszkiewicz's most accomplished early works; shown in important exhibitions, it received wide critical review in the 1960s. It is also the first painting the artist ever sold: according to collector James Michener, who saw it displayed in a gallery window on Madison Avenue in New York, "It quite knocked me over and I bought it on the spot."

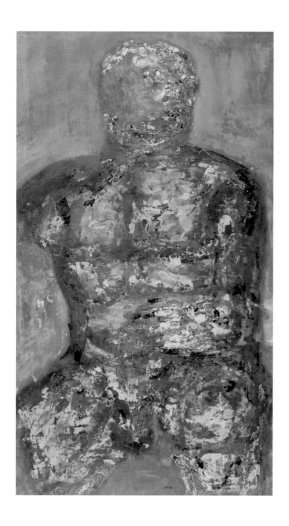

LEON GOLUB

Chicago, 1922–New York, 2004

Seated Boxer I, 1960

Lacquer and acrylic on canvas; 82 × 48 in. (206 × 119 cm);
Gift of Mari and James A. Michener, 1991; 1991.222

WHILE NEW YORK–BASED CRITICS embraced abstract painting in the years following World War II, some notable artists remained committed to the human figure and sought ways to invest this traditional form with the spirit and ideas of the postwar period.

Leon Golub's lifelong commitment to figurative painting has its roots in both aesthetic and ethical concerns. An outspoken critic of institutionalized power structures, Golub used his trenchant figurative paintings and their violent expression to critique governmental interventions and corporate wrongdoings. Even as a young artist, he explored allegorical representations of cultural values, mining classical history for images of corruption and decadence.

Seated Boxer I is an early work in this vein, painted while the artist was in Paris. Based on a photograph of a Roman copy of a Hellenistic bronze sculpture of a Greek boxer, the work serves as a platform for his existential musings. Working with the canvas flat on the floor and using loose, gestural stabs, Golub applied layer after layer of varnish and paint solvent, repeatedly scraping off the viscous substance as if debrading a wound. The result is a deeply scarred surface describing a horribly disfigured and anonymous fighter who embodies the tragic anxieties of modern life.

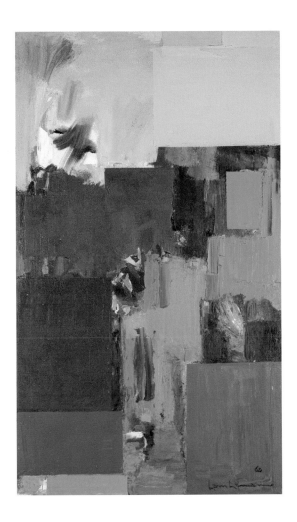

HANS HOFMANN

Weissenberg, Bavaria (Germany), 1880–New York, 1966

Elysium, 1960

Oil on canvas; 84 × 50 in. (214.9 × 127.7 cm); Gift of Mari and James A. Michener, 1991; 1991.239

GERMAN IMMIGRANT Hans Hofmann founded art schools in the mid-1930s in New York and Provincetown, Massachusetts, and quickly became the most influential art teacher of his generation. He provided countless American students with a thorough understanding of the principles of the European avant-garde, and stressed to them the importance of establishing a dynamic equilibrium of image, surface, and composition in abstract painting.

Noted for his brilliant understanding of theory and technique, Hofmann was the kind of gifted instructor who encouraged students to branch out in their own independent directions. Among those who studied with him were Louise Nevelson, Alfred Jensen, and Larry Rivers.

In his own vibrant works, including three in the Blanton's collection, Hofmann used a Cubist-like, grid-based pictorial structure to impose order upon the wild expressiveness of his high-keyed, opposing colors and rich, impastoed surfaces. His best paintings, like *Elysium*, created when he was eighty years old, achieve harmony within intensity, and embody both tension and balance. About the title, Hofmann said to collector James Michener, "It's where old artists go when they die. It's very clean and simple—only a nest of squares, but they tell everything."

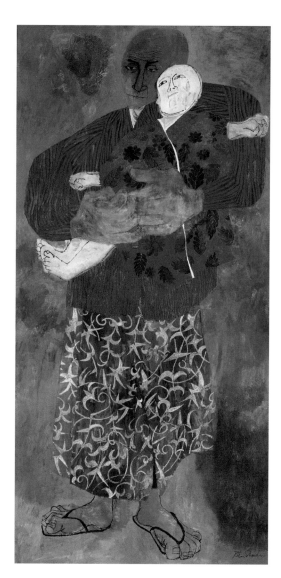

BEN SHAHN

Kovno, Lithuania, 1898–New York, 1969

From That Day On, 1960

Oil and tempera on canvas and board; 71½ × 35⅜ in. (181.7 × 89.9 cm); Gift of Mari and James A. Michener, 1991; 1991.322

THE LEADING CHRONICLER of social and political injustice in mid-century American painting, Ben Shahn was a persuasive artist whose bold works convey enormous compassion for human suffering. *From That Day On* belongs to the Lucky Dragon series of paintings that Shahn created to commemorate the deaths of the crew of the *Lucky Dragon*, a Japanese fishing boat caught in the radioactive cloud of a 1954 U.S. hydrogen bomb test in the Pacific.

Shahn, who believed he could best illuminate universal tragedy by focusing on specifics, here has honored the fisherman Aikichi Kuboyama, who died seven months after the bomb blast. Kuboyama's burned and darkened flesh is juxtaposed with the tender new skin of his baby daughter. This shocking contrast, along with the representation of living plants in the decorative textile patterns, denotes the cycles of birth and death. Kuboyama's enormous, grievously wounded hands underscore his innocence and helplessness. A dragon emerging from a red cloud at the upper left reminds the viewer of the event itself, the role of fate (the dragon is often a symbol of destiny), and what Shahn called "the ineffable, unspeakable tragedy" of atomic power, whose threat to civilization weighed heavily on his thoughts in the last years of his life.

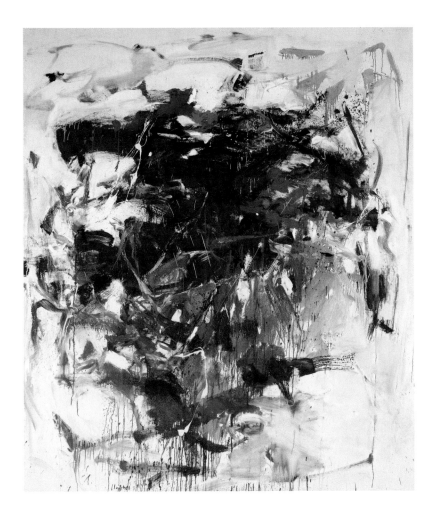

Joan Mitchell

Chicago, 1926–Paris, 1992

Rock Bottom, 1960–1961

Oil on canvas; 78 × 68 in. (198.2 × 172.8 cm); Gift of Mari and James A. Michener, 1991; 1991.276

THE MOST PROMINENT GROUP of Abstract Expressionists—Jackson Pollock, Willem de Kooning, Mark Rothko, Barnett Newman, and Hans Hofmann—distilled the problems of abstraction into a set of more or less clear questions to be addressed by succeeding generations. Departing from those artists' purely abstract precedents, Joan Mitchell and others explored the atmospheric effects of light and color in gestural painting, developing an understanding of pictorial space rooted in observations of the natural world. Rather than creating an overall flat field of roughly equivalent marks, shapes, and gestures, Mitchell located her loose and thickly brushed central image in an implied field of white, establishing figure against background, shape against space.

In *Rock Bottom*, a superb example of her work, landscape allusions abound. Though Mitchell once called it "a very violent painting," perhaps referring to its turbulent brushwork and the abrupt dissolution of forms into drips and splatters at the painting's edges, the work is harmonious, its compositional, color, and surface variations held in perfect balance.

HELEN FRANKENTHALER

b. New York, 1928

Over the Circle, 1961

Oil on canvas; 84⅛ × 87⁷⁄₁₆ in. (213.8 × 222.1 cm); Gift of Mari and James A. Michener, 1991; 1991.213

IN THE EARLY 1950S, inspired by the audacious drip techniques of Jackson Pollock, Helen Frankenthaler adopted an equally startling painting method in which she stained large, unprimed canvases with brilliant, diluted oil paints. Like Pollock, she worked on the floor, but instead of dripping paint with sticks, she poured, brushed, and applied the paint with cloths, rollers, and palette knives, all the while stepping in, on, and around the canvas to control the paint application.

By juxtaposing and overlapping the transparent planes of paint, she drew attention to the canvas itself: its surface texture, flatness, and edges. The amorphous shapes created by this process float in an indeterminate pictorial space, so that color and canvas, image and support appear to be totally fused. Frankenthaler's lyrical works extended the possibilities of gestural painting, moving its boldest characteristics— spontaneity, expansive scale, emotional directness —into new, more fluid territory.

In *Over the Circle*, a somewhat restrained canvas painted when the artist's career was in full force, we can trace the chronology of the work's making within the image itself: standing inside the large circle, Frankenthaler stretched out and drew the other forms suspended around it, finally signing the occupied area to "mark the spot."

MORRIS LOUIS

Baltimore, 1912–Washington, D.C., 1962

Water-Shot, 1961

Acrylic on unsized canvas; 84½ × 53¼ in. (214.7 × 135.3 cm); Gift of Mari and James A. Michener, 1991; 1991.257

HELEN FRANKENTHALER'S canny development of new working methods inspired other mid-century painters who were concerned less with artistic meaning and metaphor than with the formal and visual properties and processes of abstract painting. Morris Louis, a Washington, D.C.–based artist who was introduced to Frankenthaler by critic Clement Greenberg, took her staining process a step further, devising ways of soaking the canvas that involved neither brush nor gesture.

By pouring Magna acrylic paint down the surface of a vertically tilted canvas and aggressively manipulating its flow with careful movements, he avoided any personal touch or texture that would divert attention from the purely optical effects and the resulting dynamic striations of color. Greenberg said about the method, "The fabric, being soaked in paint rather than merely covered by it, becomes paint in itself, color in itself."

Louis's career was short, and he completed few series of paintings, although each was extraordinary in its own lyrical way. *Water-Shot* is from Stripes, his final series. Using nine hues to form the primary stripes, he achieved a complex chromatic range through overlaps and adjacencies, producing unexpected lushness with an economy of means.

ALFRED JENSEN

Guatemala City, 1903–Glen Ridge, New Jersey, 1981

Mayan Temple, Per II: Palenque, 1962

Oil on canvas; 76 × 50 in. (193.1 × 127 cm); Gift of Mari and
James A. Michener, 1968; G1968.84

A STUDENT OF HANS HOFMANN'S, Alfred
Jensen absorbed some of Hofmann's preferences
for high-keyed color, thickly painted surfaces,
and underlying systems of order. But Jensen was
a true maverick, developing his own theories of
painting by mining a wide range of interdisciplin-
ary sources, including the German poet Johann
Wolfgang von Goethe, whose writings explored
the interrelationships of color. These concepts,
coupled with a strong propensity toward cosmic
theology, led Jensen to create an almost incompre-
hensibly dense artistic system through which he
generated vibrant, patterned paintings unlike any
others of their time.

Born in Guatemala but raised in Europe and
the United States, Jensen met collector James
Michener in 1961–1962. Recently returned himself
from a trip to Guatemala, Michener commis-
sioned Jensen to create a new painting inspired by
his birthplace. Jensen responded with a series of
new works, from which Michener picked *Mayan
Temple* for his collection.

The painting's colors and their positions in
relation to one another are determined by the
physical plan of the temple of Palenque in modern-
day Mexico, which in turn was oriented along the
path of the North Star in the night sky. Despite its
complex conceptual underpinnings, the work is
jubilant, sensuous, and undeniably contemporary
in feel.

Yayoi Kusama

b. Matsumoto City, Nagano Prefecture, Japan, 1929

No. 62 A.A.A., 1962

Paint, mattress stuffing, and cardboard egg crates on canvas; 70 × 79 in. (178 × 202 cm); Gift of the Center for International Contemporary Arts, Emanuel and Charlotte Levine Collection, 1992; 1992.272

YAYOI KUSAMA HELPED FORGE a new awareness of women artists as audacious experimenters. Her unconventional paintings, constructions, objects, installations, and performances give public expression to her private compulsions. Kusama, a Japanese artist who worked in New York from 1958 to 1972, suffers from an obsessive-compulsive disorder that causes proliferating patterns to dominate her field of vision.

Beginning with small gouache paintings covered with vivid fields of repeated dots and cell-like shapes, she began employing collage techniques in the early 1960s to make her paintings more three-dimensional. *No. 62 A.A.A.* is a pivotal work. It is constructed of square egg cartons—the sort used for bulk egg deliveries in the 1960s and readily found in street garbage—arranged in a grid and joined by cotton stuffing salvaged from discarded mattresses. An overall coat of spray paint has unified the individual forms into one serial relief of concave hemispheres.

By using real-world objects, Kusama's painted construction anticipated the principles of both Pop art and Minimalism, yet it also refers explicitly to her own unique perceptual experience. The rhythms of its projecting and receding voids mimic the pulsations of the expanding fields she sees, translating the sensations of her body into concrete form.

Robert Indiana

b. New Castle, Indiana, 1928

Highball on the Redball Manifest, 1963

Oil on canvas; Sight: 60 × 50 in. (152.5 × 127 cm); Gift of Mari and James A. Michener, 1991; 1991.243

POP ARTISTS OF THE 1960S used the new vocabulary of advertising and consumer culture to make artistic statements exploring—and sometimes critiquing—the effects of America's expanding materialism and unbridled postwar economic growth. In his work Robert Indiana looked to emblematic road signs as symbols of American visual culture. Representational but not figurative, the signs' simple forms, clear texts, and bold numerals offer common images that communicate directly to diverse audiences.

In this simplified representation of an old steam locomotive, Indiana makes nostalgic reference to the pre–space age era. "Highball on the redball manifest" is an American railroading term that Indiana's grandfather, a retired railroad engineer, taught him. It stands for the signal that conveys "All clear for a fast express!" and was an apt statement for that time of rapid cultural and technological progress. By quoting both historical and contemporary American tendencies toward optimistic forecasts, the work provides an ironic perspective on future possibilities.

ROY LICHTENSTEIN

New York, 1923–1997

Crying Girl, 1963

Three-color offset lithograph, Bianchini 4, Zerner 6, Corlett II.1, unnumbered edition; Sheet: 18¹⁄₁₆ × 24 in. (45.8 × 61 cm); Image: 17¼ × 23³⁄₁₆ in. (43.8 × 58.9 cm); Gift of Charles and Dorothy Clark, 1976; G1976.11.17

BY ITS VERY NATURE, printmaking occupies a realm halfway between mass-produced, commercial imagery and painting or drawing, producing as it does multiple original works in several stages, each touched by the artist, the printer, and the printing press itself. Pop artists embraced modern print-making techniques with enthusiasm, as they were eager to incorporate into their works of art aspects of the real world of popular and consumer culture.

Crying Girl exemplifies Pop artist Roy Lichten-stein's subject matter and graphic style. Drawing on the easy entertainment value of the daily comic strip, he created a bold and unforgettable image that uses commercial art's simplified colors, its mechanical lines and benday dots, and its mood of frozen melodrama.

In the 1960s Lichtenstein's paintings and prints captured the spirit of the new age of mass media, contrasting tormented tabloid lovers, exploding wartime bomber planes, and the hard-sell housewives of American advertising with a cool and detached sensibility that countered the unbridled optimism and turbulent social changes of the postwar years. Although Pop artists seemed to embrace the burgeoning growth and material-ism of the new consumer culture, their relation-ship to it is best understood through a filter of irony and even skepticism.

JASPER JOHNS

b. Augusta, Georgia, 1930

Ale Cans, 1964

Color lithograph, 28/31; Sheet: 22¹³/₁₆ × 17¹¹/₁₆ in. (57.9 × 44.9 cm);
Image: 14 × 10¹⁵/₁₆ in. (35.6 × 27.8 cm); The Leo Steinberg
Collection, 2002; 2002.1985

JASPER JOHNS is a seminal figure in the Pop art
movement and in the history of twentieth-century
art. His work represents an important stylistic and
intellectual link between the emotion and philo-
sophical aspirations of Abstract Expressionism,
the heroic style championed in the years during
and following World War II, and the cooler, more
straightforward aesthetic of the 1960s.

Employing an ironic gestural mark, Johns
created iconic images of ordinary things that
challenge grand notions of high art and question
the relationship between an object and its repre-
sentation. His paintings of targets, flags, and light
bulbs suggest that art is simply a part of life, even
a commodity for consumption.

When he began printmaking in 1960, Johns
frequently recycled images from his paintings
and sculptures. *Ale Cans*, a lithograph from the
Leo Steinberg Collection, is derived from Johns's
landmark 1960 sculpture *Painted Bronze*, whose
subject is two cans of Ballantine Ale. Historians
consider *Ale Cans* one of Johns's most important
prints because it incorporates his newly refined
skill at lithography with one of his most signifi-
cant images. Leo Steinberg acquired *Ale Cans*
directly from the artist and used its image to
illustrate the cover of the reprint of his ground-
breaking 1963 study of Johns's work.

PETER SAUL

b. San Francisco, 1934

Criminal Being Executed, 1964

Oil on canvas; 75 × 63⅛ in. (190.6 × 160.4 cm); Gift of Mari and James A. Michener, 1991; 1991.321

PETER SAUL PAINTED *Criminal Being Executed* during his post-college years in Europe, but as with all of the work from this important early period, it comments directly and critically on the affluent American society he had left behind. Saul's work evokes the claustrophobia of a consumerist society and the lurid sensationalism of media-driven topical debate.

Like the contemporaneous New York–based Pop artists, Saul drew his themes from current events, the daily news, and especially American comic strips, which chronicled escalating melodramas and explored issues of class and difference in subversive ways. But unlike the ironic and iconic imagery of the Pop artists, Saul's hard-core humor and perversely provocative imagery can be read as a personal and political statement, intended to express his disdain for—and incite a response to— a way of life that he viewed as controlled by large, ambivalent forces.

In works like *Criminal Being Executed*, the young artist struck back at the realm of advertising with its own weapons of exaggeration—distorted scale, quick contrasts, emphatic colors, and labels and logos. His depiction of violence, both past and anticipated, calls for an end to complacency and ironic detachment.

Jo Baer

b. Seattle, 1929

Horizontals Tiered (Vertical Diptych), 1966

Oil and synthetic resin on canvas; Each of two panels:
52 × 72 in. (131 × 183 cm); Gift of Mari and James A. Michener,
1968; G1968.31

COLLECTOR JAMES MICHENER bought this spare, two-part painting during his first visit to the studio Jo Baer shared with her husband at that time, painter John Wesley. Richard Bellamy, a young New York gallerist who had a sharp eye for new talent, served as guide on these scouting excursions, a crucial part of Michener's process of selecting works.

Baer's work was notably forward-thinking for its time. She was committed to a rigorously formal approach to abstract painting: her interest was in the visual qualities of the work—its composition, surface, the relationship of depicted space to line and form—rather than in any implied meaning or message. Her aim was to create a painting that emphasized its frontal plane in a way that would echo the wall behind it, suggesting the architectural character of the painting's shape.

Indeed, the work echoes its own edges with its two interior border markings, and even replicates itself in two panels, yet it denies any allusion to a window, the conventional association that has accompanied the framed panel or canvas since Renaissance times. The artist has challenged the viewer to regard her minimal work, stripped of the more ingratiating aspects of painting, as absolute in its simplicity.

George Sugarman

New York, 1912–1999

Two in One, 1966

Polychromed wood installation of nineteen elements; 97½ × 286 × 134 in. (247.6 × 726.4 × 340.4 cm); Gift of the George Sugarman Foundation, Inc., 2003; 2003.154.1/19-19/19

George Sugarman came to art making relatively late in his life, but he was a real "artist's artist"—someone whose commitment and talent were highly respected by his peers. A disciplined and inventive artist, he found some measure of critical and popular success, but he is best remembered by those who observed his tenacious working process and admired his idiosyncratic innovations.

A pioneer of modern sculpture, Sugarman moved sculpture off the pedestal and across the floor sooner than most. He was committed to color as an indispensable aspect of sculpture,

experimenting with unusual and vivid hues that reinforced the mass and weight of his muscular forms. Like Stuart Davis, who was one of his inspirations, Sugarman was a student of jazz and sought lively visual corollaries to its atonal structure and syncopated rhythms. Davis's painterly concept of simultaneity encouraged Sugarman to experiment with multiple and interchangeable sculptural forms.

Two in One is among Sugarman's masterpieces. Looking like elements of an abstract painting that have spilled off the wall, nineteen joyfully painted, eccentric organic and geometric forms sprawl across the floor with palpable energy and determination, claiming the ground plane as an arena for raucous visual activity.

RICHARD TUTTLE

b. Rahway, New Jersey, 1941

Light Pink Octagon, 1967

Canvas dyed with Tintex; 56¾ × 53¹⁄₁₆ in. (144.2 × 134.7 cm);
Gift of Mari and James A. Michener, 1991; 1991.335

RICHARD TUTTLE's *Light Pink Octagon* challenges notions of what a work of art can be. A hybrid object—neither painting nor sculpture nor drawing, but containing aspects of all three—the modest, seemingly offhand work is from a pivotal early series that established Tuttle's interest in how objects define the spaces around them.

Light Pink Octagon commands attention, embodying the artist's unique sense of possibility and play. Made from a piece of cloth cut into an octagonal shape, hemmed on all sides, and dyed pale pink, it can be hung at any height on the wall and from any side or angle, or placed unceremoniously on the floor. Permanently wrinkled during the dyeing process, it looks more like a castoff than a work of art.

Indeed, its humble appearance and presentation deny the status most works of art seek to claim. Tuttle's means of making art is a way of asking questions. His unexpected and poetic use of materials embraces the value of looking without prior judgment—of observing with an open mind.

David Novros

b. Los Angeles, 1941

Untitled, 1967

Lacquer on fiberglass, six parts; Overall: 87 × 204 in. (221 × 518.2 cm); Gift of the Lannan Foundation, courtesy of the artist, 1999; 1999.99

AN IMPORTANT FIGURE among abstract painters working in New York in the late 1960s, David Novros has questioned painting's relationship to architecture for more than thirty years. Influenced by centuries-old mosaic and fresco traditions, he has created site-specific works, explored expansive scale and unusually durable surfaces, and investigated the "objectness" of painting—its capacity to be a thing in itself, rather than just a representation of something. Along with others of his generation, Novros experimented with the unconventional effects of industrial materials on shaped canvases that departed from the usual square or rectangular format.

One of Novros's first paintings on fiberglass, this untitled work blurs the distinctions between painting and sculpture, and emphasizes the work's architectural presence on the wall and in the gallery. The work's six L-shaped sections fit together to make a tight wall grouping. The right-angled shapes echo the surrounding architecture of the gallery, suggesting the dynamism of corners more than the flat planes of walls. Each section is painted a single rich hue of lacquer mixed with Murano, an iridescent pigment that causes the pearlescent colors to shift as viewers move before them. This changing palette of jewel-like colors rewards movement along the work's imposing seventeen-foot expanse.

BRICE MARDEN

b. Briarcliff Manor, New York, 1938

Fave, 1968–1969

Oil and beeswax on canvas; 72¼ × 66 in. (184 × 168 cm);
Gift of Mari and James A. Michener, 1979; 1979.30

FOR BRICE MARDEN, paintings are contemplative objects whose truths are disclosed slowly over time. A young abstract painter well aware of his relationship to history, Marden was studying the seventeenth-century painter Francisco de Zurbarán when he painted *Fave*. It was that mystical Spanish artist's dramatic sense of light that Marden wanted to recall in this apparently simple but elegant diptych.

Each side of this two-part work is painted a muted non-color, complementary variations of gray and beige that could easily be considered bland. But careful viewing reveals the unexpected lushness of these odd hues, carefully nuanced by their warm and cool underlayers. Marden's expressive paint surface is a rich mixture of oil paint dulled with beeswax, which he applied here with knife and spatula. The result is tactile and creamy, seeming to convey weight, and the paint glows with a soft light. Keeping certain livelier variables—gesture, line, and color—to a minimum, Marden instead invested his abstract work with subtle depth and tonal complexity.

LOUISE NEVELSON

Pereyaslav, Russia, 1899–New York, 1988

Dawn's Presence—Two Columns, 1969–1975

Painted wood; 116 × 67 × 31 in. (294.6 × 179.2 × 78.7 cm);
Purchase as a gift in memory of Laura Lee Scurlock Blanton
by her children, 2005; 2005.1

ACCLAIMED FOR HER DRAMATIC assemblage
sculptures made from scraps and bits of wood,
pieced together intuitively and painted rich black,
Louise Nevelson surprised the New York art
establishment in 1959 with the premiere of a new
series of works. *Dawn's Wedding Feast* was a
dense installation of multiple components, famil-
iar in their mass and form, but this time painted
creamy white.

Nevelson used monochrome paint to unify
her disparate materials and draw attention to
the edges of the wooden forms, which read like
graphic lines or gestures, and to her bold opposi-
tions of solids and voids. Her signature black
works, named after the dusk, are mysterious and
somber, while the rarer white series, graceful and
radiant, refers to the dawn.

Celebrated as the leading woman artist of her
generation, Nevelson was called by some critics
"an architect of shadows," and indeed the free-
standing, multipart elements in her works do
behave architecturally, mimicking the formal com-
plexities of the urban environments that inspired
her. *Dawn's Presence—Two Columns* is a particu-
larly lyrical example of her evocative work, its
totemlike forms referencing her lifelong interest in
African, American Indian, and pre-Columbian art.

ALICE NEEL

Merion, Pennsylvania, 1900–New York, 1984

David Bourdon and Gregory Battcock, 1970

Oil on canvas; 59¾ × 56 in. (151.8 × 142.2 cm); Archer M. Huntington Museum Fund, 1983; 1983.13

ALICE NEEL'S PAINTING of two well-known New York art critics is uncomfortably provocative. The unexpected intimacy of the subjects' poses, their opposing states of dress and undress, and their awkward, unflattering body language are not typical portrait conventions, especially for works that identify their sitters in the title.

Neel was an uncompromising observer of life. Best known for the portraits she painted throughout her long career—of her children, her neighbors, or the artists, critics, musicians, and writers with whom she socialized—she captured each sitter's state of mind as well as the details of their bearing. Her style was informal but intense; she quickly rendered those features and gestures that captured her subject's essences, then grounded them in particular settings—beds, chairs, and often the rooms of her own home, since she could rarely afford a separate painting studio.

Committed to the primacy of psychological truth, she looked for charged moments to portray, as in this pre-breakup vignette. Critically recognized only late in her life, Neel is now acknowledged as a master of realism.

TRADEMARKS
September 1970

Biting as much of my body as
my mouth can reach.

Applying printer's ink to each
bite & stamping bite-prints
like finger-prints.

Vito Acconci

b. New York, 1940

Trademarks, 1970/2001

Suite of seven black-and-white C-prints and one text panel,
edition 8/10; Overall: 14 × 76 in. (35.6 × 193 cm); Archer M.
Huntington Museum Fund, 2001; 2001.50.1/8-8/8

Vito Acconci began his career as a poet. He
has maintained his commitment to language
throughout many decades of creating performance
and photo-based works, film and video pieces,
installations, interactive sculptures and playscapes,
site-specific commissions, and more recently, archi-
tectural projects, both realized and theoretical.
Highly influential and always ahead of their time,
Acconci's multifaceted works trace the trajectory
of avant-garde ideas in the late twentieth century.
His themes have remained constant throughout:
the distinctions between private and public acts,
the shrinking of critical distance between self
and subject, the transformative capacities of both
body and culture, as well as the value of play.

Trademarks, the early photodocumentation
of an important performance piece of 1970, was
reissued in a new edition in 2001. Here photo-
graphs and text record Acconci's attempt to bite
as many parts of his nude body as he could pos-
sibly reach. In the final image, prints from the
bite marks confer a presumably collectible value
upon the proof of this abject act.

In 1970 many artists were protesting U.S.
foreign intervention in symbolic and allegorical
ways. In this and other body-centered perfor-
mances, Acconci drew attention to pointedly dis-
comfiting and repugnant personal acts, thereby
evoking the violence of the Vietnam era.

Robert Rauschenberg

b. Port Arthur, Texas, 1925

Treaty, 1974

Three-color lithograph and photolithograph on two sheets, edition 12/31; Upper sheet: 27 × 40³⁄₁₆ in. (68.6 × 102.1 cm); Lower sheet: 27 × 39¹⁵⁄₁₆ in. (68.6 × 101.4 cm); Archer M. Huntington Museum Fund, 1987; 1987.85

FIRST RECOGNIZED for his audacious assemblages and combine paintings of the 1950s and 1960s, Robert Rauschenberg has challenged definitions of media and style throughout his long career. In his radical and influential creative practice, he has sampled almost all the artistic traditions of his time: found object assemblage, collage, painting, sculpture, photography, performance, and printmaking.

In 1974 Rauschenberg began his Hoarfrost series, experimenting with layers of gauzy fabric and collaged paper in delicate arrangements. In *Treaty*, a work outside of the series but created during the same year, he collaged photomechanical reproductions of clothing and crumpled paper bags in a uniquely textured and expressive work. In this effortlessly elegant combination of unlike things, he juxtaposed a handkerchief, casually dropped on the plate and responsive to the natural and unavoidable law of gravity, with the rigid declaration of an exit sign, a manmade directive that is perhaps a reference to the politically charged process of détente then developing between the United States and the Soviet Union. Rich in metaphoric meanings, the work's title and its two-part structure acknowledge the difficulties of achieving balance—whether formal or political. *Treaty* is one of Rauschenberg's most admired prints, produced at Universal Limited Art Editions.

George Segal

New York, 1924–South Brunswick, New Jersey, 2000

Blue Woman in a Black Chair, 1981

Painted plaster and metal; 52 × 26 × 44 in. (132 × 66 × 111 cm);
Archer M. Huntington Museum Fund, 1983; 1983.25

GEORGE SEGAL's life-sized plaster casts of friends and acquaintances lead the viewer into uncanny and somewhat unsettling encounters. The subject of *Blue Woman in a Black Chair* seems oblivious to our presence. Captured in a private moment of reverie, she is unself-conscious—although exposed, even vulnerable, in her nakedness.

Interested in exploring the shared emotional resonance of private moments of contemplation and everyday routine, Segal created sculptural tableaux that present human forms within familiar settings that include pieces of furniture as well as architectural details. The works suggest true-to-life situations that have been frozen in time, an effect that is underscored by his use of monochromatic plaster—usually white or, more rarely, blue or black. Though the works are, in fact, portraits, they are rarely identified as such. Still, the personal connection the artist has to the sitter allows an exquisite degree of nuance and observed detail. Generalizing from these particular details, Segal makes works that aspire to universal understanding.

Segal's most ambitious public works, created in bronze during the last decades of his life, commemorate historical tragedies, such as the Holocaust and the Kent State shootings. His greatest works offer us quietly moving reflections on mortality and the human condition.

Ana Mendieta

Havana, 1948–New York, 1985

Guanbancex [Goddess of the Wind], from the
Rupestrian Sculptures series, 1981/1983

Photo etching on chine collé mounted on Arches cover paper;
7⅛ × 10 in. (18.1 × 25.5 cm); Purchase through the generosity
of The Judith Rothschild Foundation and the Michener
Acquisitions Fund, 1999; 1999.64

ANA MENDIETA's pioneering artworks investigate
identity, memory, and cultural history. Born in
Havana, Mendieta was sent to the United States
at the age of thirteen in the wake of the Cuban
revolution. Raised in foster homes, she moved
to New York in 1978 after college and quickly
became an active member of the feminist and
Conceptual art circles there. Before her untimely
death, she produced a body of radically intimate
and highly influential performance-based works.

Often site-specific and ephemeral, Mendieta's
works are known primarily through photographic
documentation. Created during her first trip back
to Cuba, the ten works in the Rupestrian Sculp-
tures series (of which the museum owns six) record
a series of wall carvings that she made in some
remote caves outside Havana. Simple but vital
images depict goddess figures drawn from the
mythology of the Taínos, the native inhabitants
of the island. Immersing herself in her studies
of this displaced culture, Mendieta selected a
number of documentary photographs of these
works from which to make photo etchings, which
she combined with a personal text in a limited
edition volume. Published posthumously, the proj-
ect echoes an essential theme in all of Mendieta's
work: the equivalence of the female body and the
earth as timeless sources of life.

Learning to speak English and understanding chickens were the hardest things for me during the primary grades.

1. The chicken will lay an egg today.

CELIA ALVAREZ MUÑOZ

b. El Paso, 1937

Enlightenment #4: Which Came First?, 1982 (detail)

Five color photographs, letterpress on rag paper, and graphite on Gekkeikan Homespun paper in curly maple box, edition 5/10; 1½ × 22¼ × 15 in. (3.8 × 56.5 × 38.1 cm); Purchase through the generosity of the Blanton Contemporary Circle, 2004; 2004.163.2/8

ONE OF THE LEADING Latina Conceptual artists in the United States, Celia Alvarez Muñoz is an ingenious strategist who exploits the full effects of the words and images she employs in her elegant and spare photo-based works. Asking questions about the borderlines of personal and cultural identity, and playing with the puns and double entendres of the English/Spanish language dance in Mexican American culture, each of the ten works in her Enlightenment series tells a visual/verbal story that seems part joke and part confession, ultimately calling into question how we acquire wisdom and what we choose to do with it.

Comprising multiple panels of photographs and text encased in a custom-made box (or exhibited on the wall or in a vitrine), these "bookworks" draw on fuzzy memories of childhood for their unexpectedly witty parables. Examining language as a key to knowledge and denoting its specific complexities for bilingual youth, Muñoz traces the circuitous paths of the routine lies that pass between adults and children. Her gently probing work makes us aware of the paradox of viewing photographs, reading literature, or depending upon any art form to convey truths about the past or the present.

MELISSA MILLER

b. Houston, 1951

Zebras and Hyenas, 1985

Oil on linen on canvas; 73⅝ × 84⅞ in. (183.7 × 213.1 cm);
Michener Acquisitions Fund, 1985; 1985.169

IN MELISSA MILLER's allegorical narratives, animal behavior mimics human foibles and follies. In this vividly expressive work completed early in her career, panicked hyenas have driven a herd of zebras into a stampede in response to a huge fire raging in the distance. Chaos ensues.

One can almost hear the sounds of the animals' terror, and smell the dust and acrid smoke in the claustrophobic scene. Teeming with sensory alerts, the lushly painted surface and the complex formal harmonies and contrasts of color and shape reinforce the image's urgency. Miller poses tough painterly problems—all those stripes!—in a dramatic tableau that calls attention to catastrophic forces both within and beyond human control.

Susan Rothenberg

b. Buffalo, New York, 1945

Stumblebum, 1985–1986

Twelve-color lithograph from two stones and sixteen plates, Maxwell 26, edition 31/40; Sheet: 87 × 42½ in. (221 × 100.8 cm); The Teaching Collection of Marvin Vexler, '48, 1987; 1987.25

THE ARTIST'S HAND is everywhere visible in the paintings and prints of Susan Rothenberg. A fierce tangle of gestures that resolves slowly into form, Rothenberg's imagery is most often figurative. Her agitated lines and dense compositions record an intense interrogatory working process as she moves between acutely attuned impulse and intellect. Because her mark is so transparently emotional, Rothenberg's works feel like intimate confessions.

Stumblebum is one of her largest and most ambitious prints, but its varied textures, subtle differentiation of colors, and extravagant movement are typical of all her work. A rich symphony of surfaces, this complex lithograph is the combined result of two printings from two stones, fifteen printings from fifteen stones, and one printing on an offset proofing press. The title character, based on Rothenberg's drawing of the back of her printer, Keith Brintzenhofe, appears to have stopped just momentarily, eager to move on, literally absorbed by his surroundings.

JAMES TURRELL

b. Los Angeles, 1943

First Light, 1989–1990 (detail)

Suite of twenty aquatints, edition 19/30; Sheet: 42½ × 29¹⁵/₁₆ in. (100.8 × 76 cm); Plate: 39¼ × 27⁵/₁₆ in. (99.7 × 69.4 cm); Purchase as a gift of Virginia and Ira Jackson, Houston, and through the generosity of the Still Water Foundation, 1996; 1996.6.1/20-20/20

FIRST LIGHT is James Turrell's subtle and nuanced meditation on time and space as conjured through the elusive image of a shaft of light. Comprising twenty aquatints, each made from a similarly over-sized plate, the work explores variations within a consistent framework, alluding to natural realms of perception and experience.

Trained in math and perceptual psychology before he became an artist, Turrell creates innovative, ethereal light installations that encourage viewers to become more aware of the process of seeing. Employing a skillful mix of engineering technique and optical illusion, the works use the phenomenon of light to evoke feelings of wonder and transcendence.

First Light is structured in four cycles, each directly related to Turrell's earliest light installations made with projectors and to his very first print project, *Deep Sky*. For the past thirty years, the artist has been engaged in an extraordinarily ambitious Land Art project, *Roden Crater*, the transformation of an extinct volcano in the Arizona desert into a celestial observatory. Like that project, *First Light* makes the simple beauty of the natural world heroic.

VERNON FISHER

b. Fort Worth, 1943

Evidence of Houdini's Return, 1994

Oil, blackboard slating, wood, and mixed media; 93 × 93 × 10 in. (236.2 × 236.2 × 25.4 cm); Purchase through the Michener Acquisitions Fund and with support from Linda Pace, 2001; 2001.94

VERNON FISHER CREATES complex visual narratives from enigmatic combinations of images, objects, and text. By placing together seemingly disjunctive elements—a photograph, a chalkboard, a cartoon—he challenges viewers to invent their own meanings from what they see.

Fisher's constructions primarily explore processes of memory. Working in his studio from an ever-expanding archive of texts and images, he shuffles and rearranges maps, charts, diagrams torn from scientific journals, personal photographs, and pictures appropriated from magazines and newspapers. When he can see a story unfolding, he embellishes it with drawings and handwritten text, presumably authentic statements in the artist's hand. But sleight-of-hand invariably trumps authenticity in these impeccably crafted works.

Evidence of Houdini's Return is one in a series of blackboard paintings that trick the eye with illusions. What is real? What is fabricated? What and how do we believe what we see? His tour-de-force trompe l'oeil painting technique is as sly as a magician's act. The fictional visual tale reads like memory itself—shifting, open-ended, and ambiguous.

RADCLIFFE BAILEY

b. Bridgeton, New Jersey, 1968

By the River, 1997

Acrylic, oil stick, Plexiglas, photographs, beeswax, gourd,
and tar on wood; 82 × 82 × 10 in. (208.4 × 208.4 × 25.5 cm);
Michener Acquisitions Fund, 1997; 1997.36

THIS VIVID CONSTRUCTION is Radcliffe Bailey's
deeply felt homage to his ancestors and their jour-
neys through the African diaspora. Richly sym-
bolic, it is an ambitious testament to history and
the means of its transmission and interpretation.

The literal centerpiece of *By the River* is a
black-and-white reproduction of a photograph of
a dignified African American woman, the picture
of a long-ago relative given to the artist by his
grandmother. Bailey has embellished the picture,
surrounding it with distinctly African references
as well as numerous words, numerals, and images

relating to the slave trade. The photo's placement
recalls Congolese Nkisi statues, votive sculptures
carved out of wood whose presumed supernatural
powers are indicated in their belly regions. The
bright blue that surrounds the picture evokes
Oshun, the Yoruban goddess of rivers, while the
gourd painted bright red connotes Shango, the
god of thunder. Many of the work's allusions
suggest water, recalling Bailey's grandfather and
father, both avid fishermen, as well as symbolizing
physical, psychological, and spiritual passage.

Bailey views his works as articles of healing.
Employing a wealth of texture and detail, he recon-
stitutes narratives of the past from a respectful,
contemporary perspective.

Byron Kim

b. La Jolla, California, 1961

Synecdoche, 1991/1998

Oil and wax on wood panel; Each of twenty panels: 10 × 8 in. (25.5 × 20.4 cm), overall 46 × 48 in. (116.9 × 122 cm); Michener Acquisitions Fund, 1998; 1998.77

A SKILLFUL TRIBUTE to the intersection of abstraction and representation in painting, *Synecdoche* is also a potent statement about identity.

At first glance, *Synecdoche* reads like a series of austere, monochromatic paintings, ranging from light pink to very dark brown. Then the viewer discovers a nearby list of twenty names in a gridded format that parallels the panels' arrangement and so concludes that these panels are, in fact, portraits. The hue of each panel replicates the skin color of each of the twenty people that Byron Kim randomly encountered on The University of Texas campus in Austin. As such, *Synecdoche* might be said to playfully literalize a comment made by modernist painter Brice Marden, who once referred to the surfaces of his own monochromatic paintings as "skin."

Synecdoche is a term in literary criticism meaning a part that stands in for a whole. Here it refers at once to the color of each panel (which stands in for the individual sitter) and to all of the panels together (which stand in for the university population). Yet by conflating painting and personhood in such an irreverent manner, the work points to the futility—the absurdity even—of reducing human beings to their skin color alone.

FABIAN MARCACCIO

b. Rosario de Santa Fe, Argentina, 1963

Total Paintant, 1999

GO inks on Tyvek, oil and acrylic paint, silicone, and poli-optics on aluminum structure; 100 × 240 in. (254 × 609.6 cm); Michener Acquisitions Fund, 1999; 1999.89

GROUNDED IN SEVERAL DISCIPLINES, Fabian Marcaccio's hybrid work incorporates painting, printmaking and digitizing techniques, photography, architecture, science fiction, and social theory in a sophisticated and incredibly dynamic synthesis. Rococo in their physical form, his "paintants," or mutant paintings, aim to subvert the traditional conventions of late modernist painting by representing linguistic, poetic, political, existential, formal, and spatial realities in one cacophonous expression.

Tautly stretched over hidden braces that intermittently push the surface of the work out toward the viewer, these vibrant constructions suggest complex systems that could interact in unpredictable ways. *Total Paintant* confounds the logic of how we usually look at a painting and challenges every assumption about what we expect to find within seemingly static works of art. Macro to micro and back again, Marcaccio's discrete clusters of imagery, like little theaters of activity, spread virus-like across the work's panoramic expanse. By offering us this analogue to the flux, speed, and daily intensity of contemporary life, the New York–based artist stakes a claim to the relevance—indeed the urgency—of art as a necessary discourse.

TERRY ADKINS

b. Washington, D.C., 1953

Single Bound, 2000

Metal and feathers; 84 × 3 × 69 in. (213.4 × 7.6 × 175.3 cm);
Purchase through the Archer M. Huntington Museum Fund
and with support from the Blanton Contemporary Circle,
2001; 2001.6

TERRY ADKINS'S WORK bridges past and present
in astonishing ways. For more than two decades,
he has made it his project to examine historically
resonant sites, then use salvaged cast-off materials
to create elegant, eloquent sculptures and instal-
lations that commemorate the particular people
and places at their source.

Invited to create a series of works in the
remains of the imposing Finesilver uniform-
manufacturing warehouse in San Antonio, Adkins
responded with a meditation on the long-ago,
unnamed factory workers and the early Texas
blues musicians who made pivotal recordings in
that city in the 1920s. Chief among this suite of
evocative new works was *Single Bound*. A metal
D-shaped hoop interlaced with lustrous black
rooster feathers, the sculpture projects outward,
hung perpendicular to the wall, forcefully claiming
—yet floating in—space. Whether seen from the
side or head-on (casting redemptive wing-shaped
shadows when directly lit), its mastery of every
dimension is absolute.

A tribute to the working life and to blues
troubadours whose sexual boasting fueled their
music as much as it did their hardscrabble lives
on the road, *Single Bound* asserts the heroism
of those who never got their due.

BILL VIOLA

b. New York, 1951

Anima, 2000

Color video triptych on vertical LCD flat panels, framed and
mounted on the wall; Overall: 16¼ × 75 in. (41.3 × 190.5 cm);
2002 Gala Selection Purchase; 2002.2841

SINCE THE EARLY 1970s, Bill Viola has used
video to investigate sensory perception and its
relationship to self-knowledge. His groundbreak-
ing installations explore universal themes of human
experience, including birth, death, and the unfold-
ing of consciousness. Viola's works are rooted in
both Eastern and Western aesthetics, and at the
intersection of a variety of ancient and contempo-
rary spiritual traditions, including Islamic Sufism,
Christian mysticism, and Zen Buddhism.

Anima, which means "soul" in Latin and is
the root of the word *animation*, is from a series
of works inspired by the transfiguration illustrated
in late medieval and early Renaissance paintings.
The panels show three people who have been
directed to express a series of emotions in a spe-
cific order—joy, sorrow, anger, and fear. Viola
shot the original footage of the complete emo-
tional cycle in one minute; by slowing the speed
of the video playback to eighty-two minutes,
he has made it nearly impossible to discern any
movement, blurring the distinction between por-
traits made with still photography and those
made with film.

Through these riveting portraits of three
anonymous individuals, Viola both conveys the
idea that time is eternal and addresses the notion
of the changing self.

ANNE CHU

b. New York, 1959

Castle Number One, 2001

Painted wood and resin with fiberglass and wood base;
98 × 69 × 63 in. (248.9 × 175.3 × 160 cm); Partial and pledged
gift of Jeanne and Michael Klein, 2001; T2001.2

ANNE CHU'S ENIGMATIC SCULPTURE morphs
from solid to void and from surface to volume,
its idiosyncratic forms suggesting both ancient
and contemporary art. Mixing up seemingly dis-
junctive references to Western European medieval
architecture (a castle with parapet), Chinese land-
scape painting (the way the castle merges with the
carved ripples of the jagged hillside), and modern-
ist design (the assertive but clunky rectangular
base), Chu has created an odd and unexpected
hybrid that blends artistic styles and iconic im-
ages from diverse traditions.

Fluent in the art of watercolor as well as
sculpture, Chu gives her three-dimensional works
an intentionally unfinished appearance, while
embellishing them with traces of color that define
motion rather than form. As massive and bulky,
even ungainly, as *Castle Number One* is, it feels
like a quick sketch, like something mutable and
transitory. Wondering what the tensions between
painting and sculpture, abstraction and represen-
tation, and Eastern and Western cultural idioms
"look" like, she has arrived at an open-ended
conclusion—much as the base of the sculpture
itself is open-sided at its back. Interrogatory by
nature, Chu's quirky castle comments on the
unprecedented change and flux that characterize
contemporary life and affect our perceptions of
the world.

TRENTON DOYLE HANCOCK

b. Oklahoma City, 1974

Painter and Loid Struggle for Soul Control, 2001

Mixed media on canvas; 103 × 119 in. (261.6 × 302.3 cm);
Partial and pledged gift of Jeanne and Michael Klein, 2001;
T2001.3

PAINTER AND LOID STRUGGLE FOR SOUL
CONTROL—it's hard to imagine a more intriguing title. Who are Painter and Loid? Whose soul is at stake and why? Does this wildly pieced together, wall-bound explosion of mostly cast-off materials provide answers? Trenton Doyle Hancock creates allegorical assemblages whose teeming surfaces and jumbled imagery play out the complex dramas of a unique personal mythology. This seminal work introduces viewers to Painter and Loid, superheroes who battle for the departing soul of the recently deceased Legend

(the striped, mound-shaped, quasi-human character in the lower right of the composition). Painter is represented by all-embracing strokes of bright color, and Loid by the absolute starkness of the black-and-white text that insinuates itself in branchlike shapes throughout the work. Their relationship to Legend seems intimate, yet perplexing. In a work that is funny, touching, and shocking all at once, the vitality and vulnerability of these highly abstracted characters speak of the human struggle against adversity.

Hancock's prolific body of work derives from a nimble imagination, highly refined technical skills, an encyclopedic knowledge of high and low art forms, and a fearless sense of materials and their presentation. A single chapter in an unfolding saga, this work offers hints of more ethical dilemmas to come.

SHAHZIA SIKANDER

b. Lahore, Pakistan, 1969

Intimacy, 2001 (detail)

Digital animation and painting (animation on DVD, and watercolor and dry pigment on wasli paper); Dimensions variable; Partial and pledged gift of Jeanne and Michael Klein, 2001; T2001.1.1/2–2/2

SHAHZIA SIKANDER EXPERIMENTS with the highly stylized and image-oriented genre of Indian and Persian miniature painting in exquisitely rendered figurative vignettes that question the meaning of both centuries-old and present-day painting traditions and the cultural conventions behind them. A master of layered imagery, she has crafted an artistic vocabulary that is neither personal nor cultural, but somewhere in between.

For Sikander, who was born in Pakistan and educated in Lahore and the United States, that means reexamining the ways in which Eastern art is read in the West, and exploiting the fascinating disjunctions that occur when she mixes references to high and low culture from Muslim, Hindu, and Western iconography into a single nonhierarchical space. By abstracting and recombining her fragmented images, Sikander generates intentionally ambiguous and open-ended narratives.

Intimacy was a groundbreaking work for the young artist. Created during a residency at ArtPace in San Antonio, it was the first work in which she incorporated animation technology, juxtaposing one of her traditional watercolors with a moving image that extends and constantly changes its meaning.

JEREMY BLAKE

b. Fort Sill, Oklahoma, 1971

Winchester, 2002

Digital animation with sound on DVD, edition 2/8;
18 minutes, continuous loop; Partial and pledged gift
of Jeanne and Michael Klein, 2003; T2003.1

ACCORDING TO JEREMY BLAKE, "*Winchester* is the first in a series of short, continuously looping films inspired by my interest in the Winchester Mystery House in San Jose, California. The mansion is an architectural wonder constructed by Sarah Winchester—widow of the heir to the Winchester rifle fortune—over the course of thirty-eight years, beginning in the late 1800s. After . . . the premature death of her husband and child, Winchester . . . decided that the angry spirits of those struck down by her family's guns had cursed her . . . [and she resolved to] build an enormously large house [to] ward off evil ones with the sounds of never-ending construction. The result is a sprawling mansion . . . with staircases going nowhere, doorways leading out into open air several stories above ground, and miles of darkened hallways to roam.

"This DVD work, which combines static 16mm shots of old photographs of the house and intricate frame-by-frame digital retouching, is meant to provide an abstract or emotional tour . . . of some of the more fearful chambers of Sarah Winchester's mind. Paranoiac glimpses of shadowy gunfighters, painterly gunshot wounds blossoming into Rorschach tests, and a spectral and embattled American flag derived from an old Winchester advertisement are all made visible to the careful observer."

DARIO ROBLETO

b. San Antonio, 1972

Hippies and a Ouija Board (Everyone Needs to Cling to Something), 2003–2004

Suitcase: cast and carved dehydrated bone calcium and bone dust from every bone in the body, microcrystalline cellulose, cold cast iron and brass, rust, antique syringe, crushed velvet, leather, thread, water extendable resin, and typeset; Ouija board, bottles, and medicines: cast and carved dehydrated bone calcium and bone dust from every bone in the body, typeset, home-brewed moonshine (potato-derived alcohol), homemade wine health tonics (water, sugar, fermented black cherries, yeast, gelatin, tartaric acid, pectinase, sulfur dioxide, and oak flavoring, fortified with: 100-year-old hemlock oil, devil's claw, witch hazel bark, swamp root, powdered rhubarb, pleurisy root, belladonna root, white pine tar, coal tar, dandelion, sarsaparilla, mandrake, mullein, skullcap, cramp bark, elder, ginseng, horny goat weed, tansy, sugar of lead, mercury with chalk and tin-oxide, calcium, potassium, creatine, zinc, iron, nickel, copper, boron, vitamin K, crushed amino acids, home-cultured antibiotics, chromium, magnesium, colostrum, ironized yeast, ground pituitary gland, ground wisdom teeth, ground sea horse, shark cartilage, coral calcium, iodine, and castor oil); Records: various 1960s 45-rpm records, cast in prehistoric whalebone dust, and typeset; 42 × 23 × 19 in. (106.7 × 58.4 × 48.3 cm); Purchase through the generosity of The Brown Foundation, the Michener Acquisitions Fund, and the Blanton Contemporary Circle, 2004; 2004.182

IN THIS REMARKABLE WORK, a young artist schooled in DJ culture and alchemy has collapsed multiple imagined and appropriated histories into one fictional narrative that allows a reconsideration of questions of faith (and faith healing) from a fresh point of view. The meticulous list of media answers the question: What reassurances, comforts, and potions would a 1960s hippie need today to heal the ailments from which he might be suffering?

AMY SILLMAN

b. Highland Park, Illinois, 1955

Letters from Texas (21), 2003

Oil on canvas; 26 × 40 in. (66 × 101.6 cm); Partial and pledged gift of Jeanne and Michael Klein, 2003; T2003.2.2/4

IN THE SPRING OF 2002, New York–based painter Amy Sillman spent several months working in Texas, where she found the particular quality of the light and the colors of the spring landscape compelling enough to inspire a series of more than thirty small paintings. Titled *Letters from Texas,* they comprise an assortment of improvisational responses to various sights, events, conversations, and dreams—sort of a diary of self-discovery, structured like correspondence with a friend.

Sillman's extraordinary sense of color and her lively, uncensored line animate the four paintings

from the series in the Blanton Museum's collection. There's no telling what the floating man signifies, but the informal and irreverent string of free associations is rich with painterly detail, comic incident, and formal complexity. Equal parts goofy and sophisticated, Sillman's work is a fresh amalgam of abstraction and figuration, humor and pathos, narrative and gesture.

RACHEL HARRISON

b. New York, 1966

Buddha with Wall, 2004

Wood, Styrofoam, white Portland cement, Parex adhesive,
acrylic paint, and plastic statue on plywood base; 80 × 82 ×
40 in. (203.2 × 208.3 × 101.6 cm); Partial and pledged gift of
Jeanne and Michael Klein, 2005; T2005.1.1/2–2/2

A PLYWOOD WALL, painted with a gaudy, abstract
white-and-gold pattern, is not standing anywhere
you'd expect a wall to be. It looks pretty clunky, if
vaguely familiar—are there images to decipher in
the pattern? But why are we looking at a freestand-
ing wall? Surprise! Around the wall, propping it up
in fact, lurks a huge, smiling plastic Buddha statue.

Rachel Harrison's startling combinations of
sculptural objects raise questions about value and
meaning. Contrasting handcrafted objects with
manufactured goods, she challenges both the wall-
that-aspires-to-be-a-painting and the sculpture-
that-is-just-a-kitsch-object by asking: Are art
and religion really roads to redemption? Citing
spiritual systems and aesthetic investigations that
commerce has trivialized, if not bankrupted, she
dares the viewer to make some kind of sense of
the seemingly random juxtapositions that bom-
bard us daily. Can this work's formal tension—the
bold visual and physical equilibrium of these two
unlikely objects—explain/resolve their absurd
dialogue? In ways that are completely unexpected,
each component reveals details and essences of
the other by virtue of their differences. Provoca-
tive and sly, this call-and-response between artist
and viewer, or object and experience, assumes no
fixed answers, only the same old puzzling ques-
tions about the meaning of art and life posed
from a fresh and irreverent perspective.

Oliver Herring

b. Heidelberg, Germany, 1964

Patrick, 2004

Foam core, museum board, digital C-print photographs, and polystyrene; 42 × 18 × 27½ in. (106.7 × 45.7 × 69.9 cm); Partial and pledged gift of Jeanne and Michael Klein, 2005; T2005.2

A MAN NAMED PATRICK posed for artist Oliver Herring over several studio sessions, during which time the artist photographed the model in intimate detail. He then carved a shape that resembled the seated figure and covered it with a skin made of bits of photographic images, in this way creating a new object—half photograph, half sculpture—whose finished form embodies and alludes to the passing of time, the perception of change, and the integration of small moments into the fabric of a life. Strongly flavored by the artist's laborious working process and exceptionally careful looking, *Patrick* nevertheless appears pensive and aloof from that voyeuristic gaze, closed away in a private state that belies his half-naked vulnerability.

LATIN AMERICAN ART

PABLO CURATELLA MANES

La Plata, Argentina, 1891–Buenos Aires, 1962

El guitarrista [The Guitarist], 1921–1924

Bronze with black patina; 13½ × 8⅞ × 7 in. (34.3 × 22.5 × 17.8 cm);
Archer M. Huntington Museum Fund, 1982; 1982.1249

IN COMMON WITH MANY Latin American artists
in the early twentieth century, Pablo Curatella
Manes studied in Paris. There he discovered the
avant-garde sculptures of Raymond Duchamp-
Villon, Alexander Archipenko, Henri Laurens,
and Jacques Lipchitz. The formal simplification
and abstraction of the human figure characteristic
of these European artists can be seen in *El guitar-
rista*, one of Curatella Manes's most important
works. The angular planes forming the abstract
figure of the musician have a rhythm that to
some extent echoes the movement in a musical
composition.

When the artist exhibited similar works in
Buenos Aires in 1924, critics greeted them with
scorn, although the avant-garde intellectuals
grouped around the journal *Martín Fierro* did
support Curatella Manes's experimental aspira-
tions. *El guitarrista* is symptomatic of the desire
on the part of many Latin American artists
in the 1920s to absorb European abstraction and
modernism, and then reintroduce it into Latin
America. Within a generation, artists would leave
behind this Eurocentric approach and start a more
aggressive and critical dialogue with the European
(and later the American) artistic avant-garde.

JOSÉ CLEMENTE OROZCO

Ciudad Guzmán, Mexico, 1883–Mexico City, 1949

Vaudeville in Harlem, 1928

Lithograph; Sheet: 14¹⁄₁₆ × 18¾ in. (35.7 × 47.6 cm); Image:
12 × 16 in. (30.5 × 40.6 cm); Archer M. Huntington Museum
Fund, 1986; 1986.89

IN 1927 JOSÉ CLEMENTE OROZCO moved to
the United States, remaining there until 1934. One
year after arriving in New York, he produced his
first ever lithograph: *Vaudeville in Harlem*. Of the
Blanton Museum's six New York lithographs by
Orozco, this one is unique in its representation of
a local urban scene. The Harlem theater would
have attracted Orozco, whose work often focused
on popular culture, and it is possible that he saw
a link between the Harlem Renaissance and the
emphasis that the Mexican Revolution placed
on Mexico's indigenous population and culture.

Vaudeville in Harlem uses the full tonal
range of lithography, from the dark shadows of
the audience to the spotlit stage, and the com-
position suggests that the artist was more inter-
ested in the social space of the theater than in
the vaudeville spectacle itself.

Despite the quality and sophistication of
his New York prints, Orozco soon found him-
self under pressure to produce more typically
"Mexican" scenes. Most of his subsequent
work in the United States depicts scenes from
the Mexican Revolution in the style for which
he was already famous.

DIEGO RIVERA

Guanajuato, Mexico, 1886–Mexico City, 1957

Russian Dock Worker, 1928

Watercolor and graphite on graph paper; 6¹¹⁄₁₆ × 7¹⁵⁄₁₆ in.
(17 × 20.2 cm); Archer M. Huntington Museum Fund, 1986;
1986.74

THIS SMALL WATERCOLOR SKETCH dates to
Diego Rivera's trip to the Soviet Union in 1927–
1928. He went there as head of the Mexican Labor
Delegation to commemorate the tenth anniversary
of the Russian Revolution. Rivera's watercolors
from this trip are justly celebrated—the Rockefeller
family purchased a sketchbook of his scenes from
a military parade that is today in The Museum
of Modern Art, New York.

Russian Dock Worker shows Rivera at his
best: as a sensitive observer of everyday labor.
The large body mass of the worker, whose facial
features are barely visible, provides a convincing
impression of men engaged in heavy manual labor
in a harsh climate.

Rivera's enthusiasm for Soviet communism
would soon wane as he became increasingly criti-
cal of Joseph Stalin, and his sympathy for Leon
Trotsky eventually brought about his expulsion
from the Communist Party. Through small inti-
mate works like this, we can get a clear sense of
Rivera's deep respect for the everyday conditions
of the working class, something that can be
harder to distinguish in his large heroic murals
or his more sentimental and populist portraits.

DAVID ÁLFARO SIQUEIROS

Mexico City, 1896–Cuernavaca, Mexico, 1974

Cuauhtémoc, 1940

Pyroxylin on Masonite; 20 × 23¹⁄₁₆ in. (50.8 × 58.6 cm); Archer M. Huntington Museum Fund, 1980; 1980.76

THIS IS ONE of David Álfaro Siqueiros's first depictions of a key moment in Mexican history. During the 1521 Spanish conquest, Hernán Cortés, in search of gold and silver, tortured the Aztec emperor Cuauhtémoc by burning his feet. Cuauhtémoc's refusal to give information has come to symbolize the spirit of resistance to colonization, an inspiration to Latin American liberation movements of the twentieth century.

In 1940, the year he painted *Cuauhtémoc*, Siqueiros was imprisoned for his part in an attack on Leon Trotsky's home in Mexico City. The work's small scale, its date, and its subject matter all suggest that this was one of the paintings the artist made in prison.

Of Los Tres Grandes [The Three Great Ones], the Muralists Diego Rivera, Siqueiros, and José Clemente Orozco, Siqueiros was the most experimental. His innovative use of pyroxylin (an industrial paint) can be seen in the fire at the bottom of the canvas: he probably applied the paint with a spray gun, then manipulated the pyroxylin while it was wet, a type of "controlled accident" that would later influence his student Jackson Pollock. The combination of Mexican history, left-wing politics, and formal experimentation in *Cuauhtémoc* is typical of Siqueiros's art.

María Izquierdo

San Juan de Los Lagos, Mexico, 1902–Mexico City, 1955

Caballista del circo [Circus Bareback Rider], 1932

Watercolor and gouache on paper; 11 × 8½ in. (27.9 × 21.6 cm); Gift of Thomas Cranfill, 1980; 1980.109

MARÍA IZQUIERDO OCCUPIED a special place within the Mexico City avant-garde of the 1930s. Although championed by Diego Rivera as a student, she soon rejected his brand of heroic Mexicanism, preferring to concentrate on the more introspective and marginal aspects of the city.

Caballista del circo is an excellent example of what many critics consider her finest body of work: the circus scenes. Izquierdo's choice of the circus reflected her interest in the European avant-garde, for whom the circus was a favored subject (as in works by Pablo Picasso and Georges Seurat).

The abrupt jumps in scale and the claustrophobic rendering of the arena, with that solitary cube on the right, also suggest her awareness of Surrealism.

The painting's "art for art's sake" approach, refusing to assume an explicit social agenda, was something of a novelty in Mexico in the 1930s, though a group of like-minded artists and intellectuals, including Rufino Tamayo, Carlos Mérida, and those individuals associated with the journal *Contemporáneos*, supported this type of more intimate and experimental work. Although her work was relatively unknown for years, and then was somewhat eclipsed by the rising fame of Frida Kahlo, Izquierdo has recently garnered greater attention in Mexico and internationally.

Rufino Tamayo

Oaxaca, Mexico, 1899–Mexico City, 1991

Shower, 1936

Watercolor and pastel on paper; 12⅜ × 8¹¹/₁₆ in. (31.4 × 22.1 cm);
Deposit from the Works Progress Administration, Federal Art
Project, 1943; G1943.1.45

MANY MEXICAN ARTISTS VISITED or moved
to New York in the 1920s and 1930s, including
José Clemente Orozco, Miguel Covarrubias, and
Jesús Escobedo. After his first trip in 1927, Rufino
Tamayo spent a considerable amount of time in
New York. He painted *Shower* during the Depres-
sion, when he was one of only a few foreigners
admitted into the Federal Art Project of the Works
Progress Administration, a relief program for
struggling artists. When the Project was later dis-
mantled, the federal government distributed its
share of artworks to museums across the country,
which is how this work came to the Blanton
Museum.

Aside from appreciating the financial support
of the Federal Art Project, Tamayo savored the
freedom in New York from what he felt to be the
suffocating presence of the official Muralist pro-
gram in Mexico. The small scale and everyday
subject matter of this work point to his interest
in a more modest and introspective art. Like
Orozco's early New York scenes, *Shower* focuses
on urban life—in this case its somewhat gloomy
side. The street scene's dark tones are far removed
from the intense color and spiritual subject matter
for which Tamayo would later become famous.

LEOPOLDO MÉNDEZ

Mexico City, 1902–1967

Concierto de locos [Concert of Madmen], 1943

Wood engraving; Sheet: 9¾ × 7¹³⁄₁₆ in. (24.8 × 19.8 cm);
Image: 5³⁄₁₆ × 5³⁄₁₆ in. (13.2 × 13.2 cm); Gift of Dr. Alexander
and Ivria Sackton, 1986; 1986.361.5/25

ALTHOUGH PUBLISHED in the 1943 portfolio
*25 grabados de Leopoldo Méndez [25 Prints of
Leopoldo Méndez]*, this image dates from 1932
and is one of Méndez's first satirical prints.
Méndez was one of the leading figures in the re-
vitalization of printmaking in Mexico in the early
twentieth century. From his early avant-garde
activity as a member of the Estridentista [Striden-
tist] group in the 1920s to his co-founding of
the Taller de Gráfica Popular [Popular Graphics
Workshop] in 1937, he was at the forefront of
experimental and socialist printmaking.

Mexican printmaking is very close to the
tradition of caricature, and in *Concierto de
locos* we see a lampooning of the great masters
of Mexican art: Dr. Atl, José Clemente Orozco,
Diego Rivera, and David Álfaro Siqueiros. Méndez
introduced elements parodying the positions taken
by these artists: for example, Rivera's professed
indigenismo (the poncho) or Orozco's apocalyptic
sensibility (the bells). Méndez was a master of
woodcut technique, and this work is characteristi-
cally vigorous, with dramatic transitions between
light and dark.

Méndez's contribution to Mexican art has
been somewhat overshadowed by the Muralists
and the more popular iconography of José
Guadalupe Posada, but his vast production
includes some of the great achievements of the
print medium.

ROBERTO MATTA

Santiago de Chile, 1911–Tarquinia, Italy, 2002

Untitled, n.d.

Crayon and pencil on paper; 9⅞ × 12⅞ in. (25.1 × 32.7 cm);
Archer M. Huntington Museum Fund, 1980; 1980.75

ROBERTO MATTA was one of the international pioneers of Surrealism: his first paintings of the 1930s, which he called "inscapes" or internal landscapes of the mind, caught the attention of the Surrealists in Paris, who briefly adopted him as a member of that movement.

After Matta fled Paris in 1939 for the United States, he participated in the development of the free and gestural style that was to become known as Abstract Expressionism. Although this drawing is undated, it is probably from that period in his career—the late 1940s or early 1950s. It is characteristic of Matta's compositions, which he typically centered on a vortex contained at its edges with the sketchy suggestion of fractured architectural planes. Viewing this work, it is not clear whether we are looking at a scene of cosmic forces or at a representation of psychological turmoil.

Matta was a master of dynamic composition, perhaps one of the greatest in the twentieth century, and even in this relatively modest drawing, we have a clear sense of confronting a universe of complex forces that the paper is barely able to contain.

Joaquín Torres-García

Montevideo, Uruguay, 1874–1949

Constructif en rouge et ocre [Construction in Red and Ochre], 1931

Oil on linen; 34 1/16 × 23 3/16 in. (86.5 × 58.9 cm); Gift of the Eugene McDermott Foundation in honor of Barbara Duncan, 1981; 1981.40

Joaquín Torres-García's importance for, and influence on, abstract art in the Americas cannot be overstated. Trained in Europe, he was at the heart of many of the most important avant-garde movements of the twentieth century, exhibiting alongside Theo van Doesburg, Piet Mondrian, and other pioneering abstract artists during the 1920s and 1930s.

This work dates from his Paris years, by which time Torres-García had rejected European and North American trends in abstraction as too materialist and limited. He instead looked to ancient cultures, particularly those of the Americas, to develop his utopian theory of Universal Constructivism, proposing a contemporary art that would be a synthesis of world art from all eras. For Torres-García, abstract art was a deeply spiritual and philosophical act, rather than a reductive mathematical exercise. *Constructif en rouge et ocre*, a magnificent example of his mature style, expresses those principles: the grid-like composition creates a structure containing various pictograms that make reference to a range of contemporary and ancient symbols.

Three years after painting this work, Torres-García returned to his native Uruguay, where he led a renaissance in abstract art and theory that would have a profound effect on future generations of artists across the continent.

Francisco Matto

Montevideo, Uruguay, 1911–1995

Composición sobre fondo negro [Composition on Black Ground], 1958

Oil on cardboard; 15 × 18 in. (38.1 × 45.7 cm); Gift of Judy and Charles Tate, 2004; 2004.172

IN 1942 FRANCISCO MATTO became one of the founders of the Taller Torres-García, through which he continued to develop his early interest in pre-Columbian art and to explore its relationship to contemporary abstraction.

The gridlike composition of *Composición sobre fondo negro* is rendered in a somewhat gestural style, with references to Navajo weaving, Inca stonework, Nazca pottery, and the grids of European abstract artists such as Piet Mondrian. In common with other members of the Taller, Matto sought a universal, transcultural, nonreductive meaning for abstract art. The two circles in the middle of the grid, which can be read as eyes even without a realist representation as such, have an anthropomorphism and humor that is typical of Matto's work, linking it to ancient cultures where utilitarian objects often contain suggestions of human forms.

The brown cardboard ground is visible in several places, reinforcing the Taller's interest both in ordinary, inexpensive materials and in the inherent flatness of painting, the latter a topic of debate in North American art of the same period, notably in Color Field painting.

JULIO ALPUY

b. Tacuarembó, Uruguay, 1919

Marina metafísica [Metaphysical Marina], 1962

Oil on incised, carved wood; 45¾ × 23 in. (116.2 × 58.4 cm);
Gift of the artist, 2004; 2005.150

JULIO ALPUY TRAINED in the seminal Taller
Torres-García, a workshop founded in Monte-
video, Uruguay, by Joaquín Torres-García to
transmit to a younger generation his style of
Universal Constructivism, an approach to abstrac-
tion inspired by a fusion of ancient American
forms with the European avant-garde. In 1961,
after almost two decades of working faithfully
in Torres-García's style, Alpuy moved to New
York where he was able to develop his own dis-
tinctive style, as seen in this work of 1962.

　　While the title *Marina metafísica* suggests
a marine landscape, what we see is the artist's
response to a new urban cityscape in a compo-
sition incorporating the timeless symbols (the
human figure, houses, images of fertility) that
would be a lifelong concern for him. By using
found and recycled materials—wood in this
case—Alpuy also explored what he saw as the
spirituality of used objects.

Gonzalo Fonseca

Montevideo, Uruguay, 1922–Seravezza, Italy, 1997

Graneros III [Granaries III], 1971–1975

Red travertine; 8 × 21¼ × 19⅝ in. (20.3 × 54 × 49.8 cm);
Archer M. Huntington Museum Fund, 1983; 1983.14

THIS BEAUTIFUL AND INTRIGUING sculpture
reveals Gonzalo Fonseca's fascination with ancient
history and cultures. As a young man, Fonseca
joined the Taller Torres-García, studying with the
great artist and teacher Joaquín Torres-García,
who gave him a deep understanding of the abstract
formal principles behind all art. However, unlike
other members of the Taller, such as Julio Alpuy
and Augusto Torres, Fonseca showed little or no
interest in real-world subjects. Instead his struc-
tures suggest timeless locales caught in magical
suspension. Fonseca's initial training as an archi-
tect gave him the ability to imagine and realize

complex three-dimensional forms and imaginary
nonfunctional architecture.

In *Graneros III* he left one side of the red
travertine marble unfinished as a sign of respect
to the raw material. This "truth to materials"
was also a guiding principle of the Taller Torres-
García, although Fonseca's choice of precious red
marble is in stark contrast to the Taller's taste for
everyday materials. According to art historian
Cecilia de Torres, the title refers not only to grain
storage, but also to a repository for knowledge.
This close relationship between form and knowl-
edge was at the heart of Fonseca's beliefs as an
artist.

AUGUSTO TORRES

Tarrasa, Spain, 1913–Barcelona, 1992

Interior con ventana al mar [Interior with Window Looking to the Sea], 1984

Oil on jute canvas; 26 × 32 in. (66 × 81.3 cm); Barbara Duncan Fund, 1985; 1985.31

AS THE SON OF THE GREAT modernist artist Joaquín Torres-García, Augusto Torres was exposed to art from a very young age. His father was a compulsive teacher, writer, and philosopher, so it is perhaps not surprising that he and his brother, Horacio, became significant artists in their own right. Through his father, Augusto Torres saw the most current avant-garde European art, but also the primitive art exhibited at the time in many European museums and galleries.

Interior con ventana al mar is an excellent example of his still-lifes, compositions in which the gridlike structure both complements and complicates the rendering of the objects in the painting. Indeed, in some sections of the painting, it is difficult to pick out the precise object being reproduced. The overlapping planes create multiple perspectives, as though we were viewing the scene through a series of mirrors. For Torres abstraction and realism were not two opposed ideas, and this painting suggests how both can be present within a single poetic and suggestive work.

José Pedro Costigliolo

Montevideo, Uruguay, 1902–1985

Untitled (poster design for IV Bienal de
São Paulo), 1957

Gouache on paper; 9⅞ × 6⅞ in. (25.1 × 17.5 cm); Anonymous
gift in honor of Charles Cosac, 2003; 2003.117

JOSÉ PEDRO COSTIGLIOLO, together with his
wife, María Freire, was a pioneer of Constructivist
art in Uruguay in the 1950s. They both whole-
heartedly embraced the European tradition of
rationalist "hard-edge" geometry, thus rejecting
the ancient American sources of Costigliolo's
contemporaries in the Taller Torres-García who
followed Joaquín Torres-García's principles of
Constructive Universalism. Although Costigliolo
produced his paintings by hand, he managed to
convey the impression of mechanical reproduction
that was so sought after by proponents of this
European geometric style, with its sharp contours
and flat colors.

He created this painting for the poster of the
Bienal de São Paulo, a biennial exhibition that was
the major international forum for the dissemina-
tion and defense of this type of abstract art. His
poster design pays homage to the international
aesthetic and its corollary belief in reason, prog-
ress, and mathematical order.

ALFREDO HLITO

Buenos Aires, 1923–1993

Espectro IV [Specter IV], 1960

Oil on canvas; 39¼ × 32 in. (99.7 × 81.3 cm); Gift of Barbara Duncan, 1974; G1974.18.13

IN THE MID-1940S, Hlito co-founded the Asociación Arte Concreto-Invención [Association of Concrete-Invention Art] in Buenos Aires. The Asociación promoted an extreme, Marxist-based, "hard-edge" type of abstract art, so it is perhaps surprising to find this sensual and subtle painting by the same artist. However, Hlito had become disillusioned with strict geometrical abstraction when he first traveled to Europe and saw that Piet Mondrian's paintings, viewed close up, were actually full of expressive and hesitant brushwork. From this moment on, he abandoned the harsh lines and impersonal geometry of his previous works, and began to concentrate on the individual brush stroke and the visible trace of the human hand.

Espectro IV is an extreme example of that experimentation. Hlito created a hazy effect by juxtaposing individual brush strokes that at a distance appear to shimmer. But the painting is still completely abstract, with not even a suggestion of forms. The oval shape around the edge of the canvas could be a reference to the early abstract works of modernist pioneers Pablo Picasso, Georges Braque, and Mondrian, who often used this oval frame within a rectangle—a sign perhaps of Hlito's attempt to recover and reexamine the origins of abstract painting.

GUNTHER GERZSO

Mexico City, 1915–2000

Mansión del agua [Water Mansion], 1965

Oil on canvas; 31⅞ × 39⁷⁄₁₆ in. (81 × 100.2 cm); Gift of John and Barbara Duncan, 1971; G1971.3.22

BOTH GUNTHER GERZSO and José Luis Cuevas, in very different ways, challenged the supremacy of the Mexican Muralist movement led by Diego Rivera, José Clemente Orozco, and David Álfaro Siqueiros. While Cuevas concentrated on the grotesque, scenes of urban life, and caricature, Gerzso took the opposite path toward abstraction, spirituality, and meditation. In *Mansión del agua,* a painting from his mature period, the subtle tonal gradations and overlapping forms create a mysterious, otherworldly sensation.

While the Muralists represented Mexico's vast indigenous traditions in a figurative and political manner, Gerzso concentrated on the abstract geometrical structures and figures found in Aztec stonework. The title of this work also alludes to the importance of water for Maya civilizations. While the composition seems to depict a stone construction, there is nothing illustrative or archaeological about the painting. Instead we have a more intuitive evocation of the ancient world.

Although Gerzso was somewhat marginalized in Mexico, his search for a contemporary relationship between abstract art and ancient American civilizations strongly echoed the interests of South American artists such as Jorge Eielson and César Paternosto.

Carlos Mérida

Guatemala City, 1891–Mexico City, 1984

Un canto al venado [A Song to the Deer], 1964

Oil on paper; 22½ × 31 in. (57.2 × 78 cm); Gift of John and
Barbara Duncan, 1971; G1971.3.32

ALTHOUGH HE IS JUSTLY COUNTED as one
of Mexico's great artists (despite being born in
Guatemala), Carlos Mérida's work marked a clear
move away from the folkloric style popular among
the Muralists at the time. After returning from
studies in Europe in 1929, Mérida attempted to
find a link between ancient American cultures and
current European art movements, particularly
Cubism and Surrealism.

Un canto al venado is a good example of
his mature style, using Cubist-like abstract forms
to suggest human or animal figures, while main-
taining an overall pattern reminiscent of pre-
Columbian textiles and carvings. The subject
("song to the deer") may refer to ancient Mexi-
can traditions such as the Yaqui Deer Dance, yet
Mérida's works are never straightforward illustra-
tions. He always combined his interest in local
traditions with the formal lessons he learned in
Europe as a young man.

His critical approach to Muralism would
be very influential on the group of Mexican art-
ists who followed, the "Ruptura [Rupture]"
generation.

Jorge Eielson

b. Lima, 1924

Quipus 58 B, 1966–1968

Canvas and acrylic on wood; 39⅜ × 41 in. (100.7 × 104.1 cm);
Gift of John and Barbara Duncan, 1971; G1971.3.18

A QUIPU IS AN ANDEAN COUNTING or mnemonic device in which knotted strings record and carry data. Jorge Eielson's series of Quipu paintings brings this ancient tradition firmly into the contemporary world.

At first glance, *Quipus 58 B* appears to be an abstract composition reflecting the international taste for the clean surfaces and simple pattern of 1960s Minimalism. With the help of the title, the viewer comes to understand the more traditional nuances of the work, which are literally incorporated into the single knot of the canvas.

Eielson's attempt to connect his deep interest in pre-Columbian art and ancient Andean cultures to his contemporary art practice has its roots in Joaquín Torres-García's philosophy of Universal Constructivism. This search for alternative models for abstract art in ancient indigenous cultures finds expression many times in the museum's collection, such as in the works of Eielson's compatriot and contemporary Fernando de Szyszlo and in the later works of Argentine César Paternosto.

FERNANDO DE SZYSZLO

b. Lima, 1925

Inkarri, from the series Puka Wamani [Red God], 1968

Acrylic on wood; 59¼ × 59¼ in. (149.9 × 149.9 cm); Gift of John and Barbara Duncan, 1971; G1971.3.48

FERNANDO DE SZYSZLO is one of several Latin American abstract artists who claim a non-European, specifically indigenous tradition in their work. *Inkarri* has long been considered one of his masterpieces. The title, which is in Quechua, the indigenous language of the Andes, indicates de Szyszlo's interest in connecting to ancient American traditions. Although the painting seems totally abstract at first, the title points to a specific narrative, allowing us to read the painting in symbolic rather than purely formal or abstract terms.

Inkarri refers to a legend in which the last Inca ruler, Tupac Amaru, whose body was torn to pieces in 1572 by the Spanish, returns to reclaim his kingdom from the colonizers. Unlike the earlier generation of Peruvian *indigenistas,* de Szyszlo used a totally abstract and contemporary language to communicate this revolutionary narrative. Rather than record the historical details of the Tupac Amaru legend, de Szyszlo has suggested the ruler's resurrection in floating and altarlike forms that seem to inhabit an evocative and magical universe.

JOSÉ LUIS CUEVAS

b. Mexico City, 1933

Still, from Self Portrait with Harry Langdon, 1966

Ink, wash, and watercolor on paper; 15½ × 20⅝ in. (39.4 × 52.4 cm); Gift of John and Barbara Duncan, 1971; G1971.3.16

JOSÉ LUIS CUEVAS has played a pivotal role in the development of Latin American art. As a young art student in Mexico City, he led a group of artists resisting the dominance of the Muralists, arguing that the latter's heroic and large-scale work had become little more than government propaganda.

In 1956 he published a manifesto, *La cortina de nopal [The Cactus Curtain]*, which was extremely influential across the Americas. This manifesto made a claim for recovering universal themes, particularly suffering and cruelty, in art. Cuevas supported drawing and small formats, far removed from the large-scale and unambiguous works of the Muralists, and his virtuoso drawing technique has led critics to describe him as one of the great draftsmen of the twentieth century. In *Still* we can see a range of influences, from Francisco de Goya to contemporary cartoons, while Cuevas's portrayal of himself alongside the stars of the 1924 silent comedy *Feet of Mud* reflects two of his passions: film and comedy.

Cuevas's revival of traditional themes and media changed Latin American art in the 1960s as he convinced artists to take on the role of explorer of inner truths rather than propagandist or social crusader.

ANTONIO BERNI

Rosario, Argentina, 1905–Buenos Aires, 1981

Detrás de la cortina [Behind the Curtain], 1963

Collagraph with relief halftone and hand-inking; 20⅛ × 16⅝ in. (51.1 × 42.2 cm); Gift of The Museum of Modern Art, 1982; 1982.8

ALTHOUGH BETTER KNOWN for his large-scale paintings and collages, Antonio Berni also produced a significant number of drawings and prints. In *Detrás de la cortina*, he fused subject matter bearing a social message with an experimental technique—embossing everyday objects, such as coins or machine parts, in high relief into wet paper to create a three-dimensional, almost sculptural, form.

Most of Berni's 1960s and 1970s work narrates the life of two marginal characters: the street urchin Juanito Laguna and his girlfriend, the prostitute Ramona Montiel. Here we see Ramona with a client in a print that presents a commentary on the exploitation of sex for money, but also raises wider issues of inequality and poverty: the television screen shows a starving child, reduced to a news footnote running unnoticed in the background.

The dramatic composition and unconventional technique indicate Berni's dissatisfaction with the conventional realist art that had become synonymous with social causes in Latin America and elsewhere. The use of recycled materials also became a centerpiece of Berni's art, reflecting his interest in finding poetry and pathos in the urban and the everyday.

LUIS FELIPE NOÉ

b. Buenos Aires, 1933

Cerrado por brujería [Closed for Witchcraft],
1963

Oil and collage on canvas; 78⅝ × 98⁵/₁₆ in. (199.7 × 249.7 cm);
Archer M. Huntington Museum Fund, 1973; P1973.11.3

LUIS FELIPE NOÉ in 1961 joined Rómulo
Macció, Ernesto Deira, and Jorge de la Vega in
founding the Nueva Figuración [New Figuration]
movement in Buenos Aires. The intellectual atmo-
sphere of Buenos Aires at the time was invigo-
rating, and the large expressive canvases of this
group are typical of the increased scale and con-
fidence in this period of new experimentation
in the visual arts.

Noé applied paint in a very loose and spon-
taneous manner, recalling contemporary Abstract
Expressionism in the United States. However,

unlike his American counterparts, he and other
Nueva Figuración artists always concentrated on
the human figure, bringing their work closer to
that of contemporary European painters such as
members of the CoBrA group.

Cerrado por brujería is an archetypal Nueva
Figuración work in its anxious energy and implicit
social critique. Critics have read the compartments
of the painting as Noé's response to the increasing
influence of television in the 1960s, and the mon-
strous figures would certainly suggest his discom-
fort with the deceptively bland "talking heads"
of television.

RÓMULO MACCIÓ

b. Buenos Aires, 1931

Vivir: A los saltos [To Live: By Leaps and Bounds], 1964

Acrylic, tempera and/or poster paint, and pencil on particle board; 72⅛ × 72 in. (183.2 × 183 cm); Gift of Barbara Duncan, 1973; P1973.11.2

RÓMULO MACCIÓ'S WORK typically takes a grim and sarcastic view of life. In this mid-1960s painting, the physical interruption of the composition seems to suggest that a more sinister and disturbing presence lurks behind everyday life. The central rectangle also might allude to a television screen, and certainly the influence of the popular media was one of the hotly debated political issues of the day. The work's incorporation of masks and deformed faces, which adds to the painting's urgent sense of horror, reflects the currency in Buenos Aires of Jean-Paul Sartre's philosophical ideas of Existentialism.

Macció was a co-founder of the Nueva Figuración [New Figuration] movement in Buenos Aires, and the titles of Nueva Figuración paintings are often nondescriptive and poetic to encourage a more indirect reading of the work. In this case the title *Vivir: A los saltos* implies simultaneously a positive call to action and an ironic critique of mass media and consumer society.

JORGE DE LA VEGA

Buenos Aires, 1930–1971

Caída de conciencia [Loss of Consciousness],
1965

Oil, glass, and fabric on canvas; 51⅜ × 43½ in. (130.5 × 110.5 cm);
Gift of Barbara Duncan, 1973; G1973.12.16

JORGE DE LA VEGA's collaged canvases of the
early 1960s are among the masterpieces of the
Buenos Aires Nueva Figuración [New Figuration]
movement. De la Vega, who was active as a car-
toonist before becoming a professional artist, was
the only member of the group to receive formal
artistic training. In his work he typically created
complex spaces in which reality and illusion be-
come confused.

The two figures in *Caída de conciencia* almost
seem to be reflections of each other, and the title
suggests that the linked processes of representation
and consciousness are somehow falling apart, a
topic prominent in the philosophical discussions
of the period. De la Vega constructed this work
through a mixture of painting and collage. He
created the rugged forms by laying crumpled can-
vas on top of the original surface, and he used
collaged elements, like buttons, to further compli-
cate the relationship between reality, object, and
illusion.

ERNESTO DEIRA

Buenos Aires, 1928–Paris, 1986

Untitled, 1966

Ink on paper; 14⅛ × 16¹¹⁄₁₆ in. (35.9 × 42.4 cm); Gift of Barbara Duncan, 1974; G1974.18.3

ERNESTO DEIRA was a member of the Nueva Figuración [New Figuration] group, which he helped form in Buenos Aires in 1961 with Jorge de la Vega, Luis Felipe Noé, and Rómulo Macció. While the movement is best known for its large-scale, expressionistic, and figurative painting, members of the group produced a number of works on paper, many of which are in the museum.

In this untitled drawing, we see the Nueva Figuración interest in expressive line and distorted figures, but with the delicacy of line and scale that is characteristic of the drawing medium. This drawing provides an important link to the tradition of cartoon and caricature in Argentina, which was also experiencing a revival at this time.

Carlos Alonso

b. Tunuyán, Argentina, 1929

. . . que corrían mordiéndose [. . . Those Who Run Biting Each Other], 1968

Colored ink on paper; 19¹³⁄₁₆ × 27⁹⁄₁₆ in. (50.4 × 70.1 cm);
Gift of John and Barbara Duncan, 1971; G1971.3.3

ALTHOUGH HE WAS NOT a formal member of the Nueva Figuración [New Figuration] movement that revolutionized figurative art in 1960s Argentina, Carlos Alonso's work shares many of the characteristics of this movement: a loose and gestural line, anxiety-ridden subject matter, and dynamic composition. Unlike the Nueva Figuración artists, but like his Mexican contemporary José Luis Cuevas, Alonso largely limited his production to small-scale works on paper.

In *. . . que corrían mordiéndose*, we see the scene from Dante's *Divine Comedy* in which Virgil observes doomed souls fleeing from the torment of birdlike creatures. Here a massed grouping of ancient and contemporary characters emerges from the dense, nervous calligraphy, including a policeman and what appear to be Roman soldiers. The cloudlike forms at the top of the image, showing an Abstract Expressionist influence, are the source for the nightmarish creatures.

That Alonso also published satirical cartoons in many of the major magazines of the time points to the rich cross-pollination between high and low art forms that occurred in 1960s Argentina.

ANTONIO SEGUÍ

b. Córdoba, Argentina, 1934

El académico [The Academic], 1963

Oil and industrial lacquer on canvas; 59¹/₁₆ × 59¹/₈ in.
(150 × 150.2 cm); Gift of Barbara Duncan, 1991; 1991.420

THE 1960S SAW A RENEWED INTEREST in expressive and satirical painting all across Latin America. In large part this was a reaction against the formal abstraction of the 1950s, further driven by the need to respond to the deep social and political changes of the 1960s.

El académico is one of a series of satirical portraits that Antonio Seguí produced in the early 1960s. These portraits poke fun at the pomposity of people in power, from executives to politicians, academics, and even Napoleon (as in another work in the museum). The use of a generalized title (we don't know who this specific academic is),

the work's grotesque distortion, and the inclusion of a written caption link this work to Argentina's strong cartoon tradition. However, unlike a cartoon, the painting is not humorous, but instead is charged with existential angst. The nightmarish colors and liquid distortions in the face engage the viewer in broad and deep questions of human existence.

FERNANDO BOTERO

b. Medellín, Colombia, 1932

Santa Rosa de Lima según Vásquez [Santa Rosa de Lima after Vásquez], 1966

Oil on canvas; 49⁹⁄₁₆ × 53½ in. (125.9 × 135.9 cm); Gift of John and Barbara Duncan, 1971; G1971.3.8

FERNANDO BOTERO is one of the most famous living Latin American artists. His fame and the widespread presence of his later works have somewhat overshadowed the mordant social and religious critique contained in his early works, of which this is a good example.

Santa Rosa de Lima (1586–1617), the first Latin American to be canonized, is the patron saint of the Americas. She was known for her physical beauty, which she tried to deny through mortification and fasting. Legend has it that when her mother placed a crown of roses on her head

to make her look beautiful for a social gathering, Santa Rosa used the thorns to pierce her skin in an echo of Christ's suffering with the crown of thorns.

That moment of mortification is represented in this painting, which is a reinterpretation of a famous posthumous portrait of the saint by the Colombian painter Gregorio Vásquez Ceballo (1671–1711). Botero's respect and admiration for Old Master painting is evident in his handling of paint in this work, which subtly translates the seventeenth-century religious overtones and artistic conventions typical of Vásquez's work into the present.

CARLOS COLOMBINO

b. Concepción, Paraguay, 1937

Cosmonauta [Cosmonaut], 1968

Oil on carved wood; 39¼ × 39¼ in. (99.7 × 99.7 cm); Gift of
Robert Michael, 2003; 2003.96

CARLOS COLOMBINO is a renowned Paraguayan
artist, architect, and cultural activist. In this work
he has rendered a monsterlike cosmonaut in an
expressive painted plywood carving. Colombino
developed this *xilo-pintura* ("woodcut-painting")
technique, which is characteristic of his work;
it involves first carving the surface of the wood
as though to make a woodcut, and then apply-
ing oil paint to the wood relief.

When he made *Cosmonauta*, Paraguay was
still languishing under the forty-four-year dictator-
ship of General Alfredo Stroessner, and something
of the repressive and isolated feeling of the times

can be sensed in the dark and crowded composi-
tion. The subject of the astronaut is fairly com-
mon in Latin American art of this period: artists
viewed the unparalleled technological advances
of the developed world with a mixture of wonder
and uncertainty, living as they were in a world far
removed from the benefits or comforts of high
technology.

JOSÉ ANTONIO FERNÁNDEZ-MURO

b. Madrid, 1910

Al gran pueblo argentino . . . [To the Great Argentine Nation . . .], 1964

Acrylic wash over aluminum foil gilt construction on canvas with wooden strip frame; 69 × 57⅛ in. (175.3 × 145.1 cm); Gift of John and Barbara Duncan, 1971; G1971.3.19

JOSÉ ANTONIO FERNÁNDEZ-MURO rose to national attention in Argentina as a pioneer of the lyrical geometrical abstraction common in the 1950s. His work of the period already showed an interest in the tension between strict geometry and more tactile expressions. Then in 1963 he moved to New York, where he began to use metal foil to emboss signs and manhole covers for inclusion in his work, thus introducing elements from the real world while still keeping a commitment to formal geometry.

In *Al gran pueblo argentino . . .*, he has placed the foil manhole cover among a jumble of letters and numbers embossed from street signs. The whole has an urban, gritty feel, but the arrangement of the elements in the image also recalls the Argentine national flag, a reference that is underscored by the title, which comes from the national anthem: "Al gran pueblo argentino, salud! [Greetings to the Great Argentine People!]." To complete the quoted reference, the word *salud* ("greetings") appears written out along the bottom of the painting.

While the overall somber mood of this work may seem to suggest a difficult or complex relationship to his homeland, the artist has denied any overt political intention in his work.

León Ferrari

b. Buenos Aires, 1920

Untitled, 1964

Ink on paper; 19 × 12 in. (48.3 × 30.5 cm); Archer M. Huntington Museum Fund, 2001; 2001.43

Like that of Mira Schendel and Gego, León Ferrari's work examines the overlap between drawing and writing. However, unlike the other two artists, he rooted his practice in a strong left-wing political discourse.

In 1964, the same year he made this work, he produced his famous *cuadro escrito* ("written picture") in which descriptive text on the drawing surface replaces more traditional visual representation. He also produced a series of "letters to a General," drawings in which the calligraphic writing dissolves into illegible symbols.

Rather than pointing to a formal or self-reflexive exploration into line and writing, Ferrari's drawings of the period suggest a more urgent and critical breakdown in communication linked to the military then in power in Argentina. For Ferrari the issues of representation and control cannot be divorced from one another. The decision to produce illegible "quasi-text" like this drawing is part of his ongoing investigation into the many transactions of power involved in looking at a work of art.

Mira Schendel

Zurich, 1919–São Paulo, 1988

Untitled, 1970

Oil stick, pencil, and Letraset on rice paper hinged to a creme wove paper; 20¼ × 10¾ in. (51.5 × 27.3 cm); Archer M. Huntington Museum Fund, 1970; P1970.3.3

MIRA SCHENDEL'S DELICATE and understated work has earned a singular place in the history of Brazilian art. While many of her contemporaries were developing work that engaged new materials and audiences through performance or video, Schendel proposed a much quieter and more modest approach by concentrating on the smallest and most intimate form of art making: producing lines on a surface.

Early in her career, Schendel became interested in systems of written language and their visual characteristics. We can clearly see this here in marks that recall scribbled sentences or mathematical equations, without ever defining actual words or numbers. The work also incorporates commercially produced Letraset punctuation marks (commas and periods), which further underline the linguistic references.

Although this work seems to have been drawn directly on the paper, it is in fact a monoprint, a unique impression taken from a glass plate. The thin rice paper barely holds the ink, giving an unusual and mysterious quality to the lines and distancing them from the more straightforward nature of a doodle or sketch.

CARLOS SILVA

Buenos Aires, 1930–1987

Arco viejo [Old Arch], 1971

Oil on canvas; 31⅜ × 31⅜ in. (79.7 × 79.7 cm); Gift of Barbara Duncan, 1973; G1973.12.14P

CARLOS SILVA is one of Latin America's finest, though lesser known, Optical artists. Unlike other artists who first trained as graphic designers, Silva did not appropriate the clear compositions and bright colors of commercial design. Instead his paintings possess a certain mystery and a strongly sensuous quality.

In *Arco viejo* Silva drew the oval shapes that make up the central area in pencil by hand. The delicate hesitation in the pencil marks creates a certain tension with the overall dynamic of the work in all its space-age composition. Silva seems to be suggesting that art is still essentially a human activity, one that cannot be replicated by machines.

Another difference between Silva's painting and the repetitive patterns of much Op art can be seen in the orange margin along the top and right-hand sides of the canvas. The orange color implies a fading light source, like a sunset, further complicating the already complicated three-dimensional effect of the painting.

ROBERTO AIZENBERG

Federal, Entre Ríos, Argentina, 1928–Buenos Aires, 1996

Pintura [Painting], 1971

Oil on canvas mounted on board; 39⅛ × 29 in. (99.4 × 74.3 cm);
Gift of Barbara Duncan, 2002; 2003.4

WHILE NEVER AT THE CENTER of the main-
stream of Argentine art, Roberto Aizenberg was
still influential and respected in that world. Despite
a flourishing experimental literary scene, Buenos
Aires never produced a fully fledged Surrealist
movement in the visual arts, making Aizenberg
perhaps the closest thing to an Argentine Surrealist.

He developed a unique painting technique,
applying wet-on-wet oils onto canvas that he
mounted on hard board. The result was a series
of paintings that glow with a characteristic inte-
rior light, recalling Renaissance panels in their
clearly defined detail and luminosity. Aizenberg's
subjects were often strange cityscapes punctuated
with towers, and *Pintura* is a radiant example
from that body of work. The light emerging from
behind the towers here has an ominous quality,
suggesting either a smog-filled urban sunset or
perhaps a more otherworldly presence.

GEGO (GERTRUD GOLDSCHMIDT)

Hamburg, 1912–Caracas, 1994

Trece líneas paralelas, no. 62 [Thirteen Parallel Lines, No. 62], 1967

Ink on paper; 25¾ × 19⅞ in. (65.4 × 50.5 cm); Gift of Mrs. Patricia Phelps de Cisneros and the Gego Foundation in honor of Professor Jacqueline Barnitz, 1998; 1998.71

GEGO (THE NAME THE ARTIST TOOK from the first letters of her full name) trained as an architect and engineer before turning to sculpture, drawing, and printmaking in the 1950s. Her remarkable treatment of lines in space gained attention in the art world of 1960s Venezuela with the advent of that country's Kinetic art movement. While many of her peers made artworks that incorporated physical or optical movement, Gego concentrated on subtle structures that play on the relationship between line, weight, and substance.

She produced many graphic works, either as studies for her intricate sculptures or as finished works. In these drawings, which include the finely understated *Trece líneas paralelas, no. 62,* we see her obsession with line as both a structuring and an organic element. While the structure in this drawing could never be translated directly into sculptural form, it successfully conveys her interest in the subtle relations of lines in space.

Carlos Cruz-Diez

b. Caracas, 1923

Physichromie no. 394, 1968

Vinyl paint, plywood, cardboard, plastic, and metal frame;
47¾ × 24½ × 2½ in. (121.3 × 62.2 × 6.4 cm); Gift of Irene
Shapiro, 1986; 1986.333

Carlos Cruz-Diez, along with his compatriot
Jesús Rafael Soto, is one of the international
pioneers of Kinetic art. The Physichromie series,
which he started in 1959 and continues to this
day, consists of constructions that generate optical
effects as the viewer moves past them. He con-
structs these objects from rows of colored strips,
whose colors are reflected and refracted through
transparent or translucent plastic strips, thus
generating color and form according to the angle
of vision and light.

The idea that motion is necessary to create
form and color is essential to Cruz-Diez's artis-
tic practice. According to him, a static artwork,
like a photograph, can never illustrate or emulate
the complexity of visual experience. The title
of the series, Physichromie, is a combination of
the words *physical* and *chromatic*, a reflection
of Cruz-Diez's lifelong ambition to make color
a physically tangible phenomenon.

César Paternosto

b. La Plata, Argentina, 1931

Pintura abstracta [Abstract Painting]:
Rust, Gold, Black, 1974

Acrylic on canvas; Part A of three: 28⅞ × 9¹⁵⁄₁₆ × 3½ in.
(73.3 × 25.2 × 8.9 cm); Part B of three: 28⅞ × 9¾ × 3½ in.
(73.3 × 24.8 × 8.9 cm); Part C of three: 9¹⁵⁄₁₆ × 41⅞ × 3½ in.
(25.2 × 106.4 × 8.9 cm); Gift of Cecilia de Torres, 2003;
2004.129.1/3–3/3

In 1970, soon after moving to New York from Buenos Aires, César Paternosto began a series of paintings in which he explored, literally, the limits of the painted surface by leaving the front of the canvas white and painting forms on the edge of the stretcher. These works were a synthesis of earlier Argentine explorations into the sculptural possibilities of painting (by the Madí movement in the 1940s) and more recent American developments in Minimalism.

By 1974 he was making multipart paintings, such as *Pintura abstracta,* in which the white wall between the panels further complicates the physical and sculptural presence of the work. To look at this work, the viewer has to physically move around it, reconstructing a composition that cannot be seen from a single viewpoint. Although responding to Minimalism, Paternosto was also making a claim for the continued relevance of painting by rejecting the industrial materials favored by his American peers.

This was one of Paternosto's last paintings in this stark style; when a 1977 trip to Peru and Bolivia opened his eyes to a more ancient tradition of abstract art in Inca stonework and textiles, he embarked on a long and fruitful investigation into the pre-Columbian sources of abstraction.

Gyula Kosice

b. Kosice, Hungary (Slovakia), 1924

Hidroluz [Hydrolight], 1975

Plexiglas, light, motor, and water in a wooden case; 47½ × 20⅛ × 9¾ in. (120.7 × 51.1 × 24.8 cm); Gift of Barbara Duncan, 1986; 1986.304

SCIENCE, OR MORE SPECIFICALLY science fiction, has been at the heart of Gyula Kosice's work since he co-founded the avant-garde Madí movement in Buenos Aires in 1946. At that time he was a pioneer in introducing movement into sculpture and letting the viewer manipulate the work. By the 1960s he was experimenting with modern materials like Plexiglas, neon, and electrical motors.

His utopian belief in the ability of science to create new and better worlds led in the early 1970s to his project for Hydrospatial City, an imaginary environment suspended in space where artworks are no longer necessary because the aesthetic experience has been unified with everyday life. *Hidroluz*, with its modern materials, is typical of the work he was making as he developed his plans for the City. The jet of water against the Plexiglas sphere creates an infinite variety of forms and a dematerialized sculptural experience.

While many of Kosice's avant-garde colleagues of the 1940s abandoned art altogether or turned to more conventional work, Kosice continued to believe in the transformative power of art and the need to create new utopian models for living. More than a wall relief, *Hidroluz* can be considered a fragment of a new living environment.

KAZUYA SAKAI

Buenos Aires, 1927–Dallas, 2001

Filles de Kilimanjaro III (Miles Davis), 1976

Acrylic on canvas; 78¹⁵/₁₆ × 78¾ in. (200.5 × 200 cm); Archer M.
Huntington Museum Fund, 1977; 1977.21

KAZUYA SAKAI'S INTERNATIONALISM (he was
born in Argentina of Japanese parents and lived in
Argentina, Japan, Mexico, and the United States)
has ironically obscured his contribution to Latin
American art. Few art histories mention him,
perhaps because he is too difficult to categorize.
Not only did Sakai move all over the world, but his
activities included painting, teaching, translating,
and lecturing on everything from Zen Buddhism
to experimental music.

Sakai's painting started with an informal,
expressive abstraction, somewhat influenced by
Japanese calligraphy. By 1965, when he moved to
Mexico, he had adopted the more "hard-edge"
abstraction visible in *Filles de Kilimanjaro III
(Miles Davis)*. In Mexico City he was the graphic
designer for *Plural* magazine, where he worked
alongside the poet Octavio Paz and an influential
group of intellectuals. Then in 1977 Sakai moved
to Texas, teaching at The University of Texas
at Austin and the University of North Texas at
Dallas.

This painting reflects Sakai's passionate inter-
est in jazz (the title pays homage to a Miles Davis
album of the same name). Although the deliberate
composition and structure are far from the impro-
visation of jazz, the overall "funkiness" of the
painting recalls the popular culture of the 1970s.

ANTONIO HENRIQUE AMARAL

b. São Paulo, 1935

Alone in Green, 1973

Oil on canvas; 59⅜ × 59 in. (150.8 × 149.9 cm); Gift of Barbara Duncan, 1975; G1975.22.1

FOLLOWING THE 1968 MILITARY COUP in Brazil, many artists left that country for New York. Antonio Henrique Amaral, who arrived in 1973, became one of the most successful of those artists, both critically and commercially, earning fame with his iconic images of bananas. Critics have read *Alone in Green,* with its overripe, tied, and bruised banana, as a metaphor for political violence and torture, pointing out that the vertical ropes in the upper half of the painting recall prison bars. But the predominant yellow and green colors of the painting are the same as those of the Brazilian flag, meaning the banana can also be interpreted as an ironic comment on the popular perception of Brazil as an idyllic tropical paradise.

Like many Latin American artists of the 1970s, Amaral heavily coded his denunciation of a cruel political system by subverting the stereotypes that dominate international perceptions of Latin American culture. Amaral's deadpan realistic style shows links to contemporary American Pop art, yet his political double-meanings and his emphasis on the banana's vulnerability suggest a world far removed from a straightforward fascination with consumer society.

LUIS FERNANDO BENEDIT

b. Buenos Aires, 1937

Proyecto para un pez a reacción 2 [Project for a Jet-Propelled Fish 2], 1974

Pencil and watercolor on paper; 17¾ × 27½ in. (45.1 × 69.9 cm); Archer M. Huntington Museum Fund, 1986; 1986.65

LUIS FERNANDO BENEDIT, who trained and still practices as an architect, in the 1970s produced a large series of technical drawings, many of them prototypes for mechanized animals such as the jet-propelled fish shown here. Like many Conceptual artists in Argentina at this time, Benedit was interested in systems of information and communication. He was particularly interested in the natural world and how biological systems can provide a metaphor or model for human society.

On the one hand, we can view *Proyecto para un pez a reacción 2* as an ironic and humorous denunciation of the human need to control and improve upon nature. On the other hand, if we consider the widespread political violence and uncertainty that plagued Argentina during these years, the idea of meddling with nature and producing false mechanized creatures takes on more sinister overtones.

Armando Morales

b. Granada, Nicaragua, 1927

Nude, Horse, Incinerator, 1974

Oil on canvas with wax varnish; 51 5/16 × 63 13/16 in. (130.3 × 162.1 cm); Barbara Duncan Fund, 1975; G1975.33.1

ARMANDO MORALES has often been associated with magical realism, an aesthetic born out of the 1960s Latin American literary "boom" led by authors such as the Colombian Gabriel García Márquez and the Cuban Alejo Carpentier. The fantastic narratives of magical realism are related to Surrealism, but rooted in the specific conditions of Latin American landscape and history. Morales's dreamy, otherworldly paintings seem to correspond exactly to the tenets of this literary style.

The intriguing figures in this work seem to emerge from, and disappear into, the humid landscape without a clear narrative to explain who they are or why they are there. Morales's remarkable technique involves cutting and pasting together pieces of canvas, and building up many layers of paint, which he then scrapes away with a razor blade. The result is a painting that seems to glow from within, the lack of a visible light source further emphasizing the mystery of the fantastical scene.

ANTONIO BERNI

Rosario, Argentina, 1905–Buenos Aires, 1981

Mediodía [Noon Time], 1976

Paper and photograph on canvas; 78 × 78⅜ in. (198.1 × 199.1 cm);
Barbara Duncan Fund, 1977; 1977.97

ANTONIO BERNI was one of the great painters
of social themes and critical commentary in the
twentieth century. Although less known interna-
tionally, his work merits comparison with that of
the Mexican Muralists. Unlike the Muralists, Berni
was never part of a large government-sponsored
art program. And while he remained committed to
themes of social justice shared with the Muralists,
he adopted a range of different artistic styles, from
his experiments with Surrealism and Socialist
Realism in the 1930s, to his subversion of Pop art
in the 1960s and 1970s.

Like many Latin American artists, Berni
moved to New York in the 1970s, escaping politi-
cal uncertainty and persecution at home in Argen-
tina. He painted *Mediodia* in New York, and
while the subject is clearly Argentine (the sign is
in Spanish), the treatment of the professionally
painted advertising sign indicates his awareness
of American and European Pop art. However, the
stark contrast between the brightly colored sign
advertising new cars and the humble black and
white used in depicting the workers who produce
those consumer goods shows an explicit political
conscience missing in much American Pop art of
the period.

Luis Caballero

Bogotá, 1943–1995

Untitled, 1985

Charcoal on paper; 49 × 74⅝ in. (124.5 × 189.5 cm); Archer M. Huntington Museum Fund, 1986; 1986.2

Luis Caballero was a key figure in the revival of expressive drawing in Latin America from the 1960s through the 1980s. In part as a rejection of the grandeur and pomposity of the Mexican Muralist movement, many artists in those years reclaimed the traditional medium of drawing to explore some of the more personal and psychologically charged aspects of art.

Caballero's subject was always the human figure, particularly the male nude, which he has rendered here with virtuoso boldness in charcoal. This work is typical in that it does not show the model's face, but rather concentrates on the physical expression and tension contained in the figure's musculature. Caballero was not interested in laying out a narrative in his work, but rather used drawing to suggest a physical and emotional state. His modeling reflects his early interest in Michelangelo's loose drawing style.

Working from his own identity as a gay man, Caballero evoked the beauty and eroticism of the male nude in his drawings, but also the social anonymity of homosexuality in a traditional society like Colombia's.

LILIANA PORTER

b. Buenos Aires, 1941

Historia sin fin [The Unending Story], 1980

Acrylic, silk-screen, drawing, and collage on canvas; 62⅛ × 84½ in. (157.8 × 214.6 cm); The Barbara Duncan Fund in memory of Rocío Duncan, 1981; 1981.31

LILIANA PORTER'S WORK is deceptive in its apparent simplicity. At first glance, this painting seems to be a straightforward depiction of objects, almost like a traditional still-life. However, once we pay attention to the different media (paint, photo silk-screen, and collage), we realize that it is more of a complex meditation on representation itself.

Several forms, such as the cube, pyramid, and sphere, appear several times, in each instance represented in a different way. At times actual objects have been fixed to the surface, such as the paintbrush that seems to have been abandoned in the process of painting or the two geometrical shapes on the shelf (the sphere is intentionally not included in a "real" version).

The composition of the painting recalls written sentences, so the viewer looks at it from top left to bottom right, again suggesting parallels between how we read text and how we "read" images in art. The literary association is underlined by the image of the book in the top right corner, open to a description of the pool of tears in *Alice in Wonderland*. Like Alice, Porter inhabits a world that seems to be lighthearted, but in fact has many layers of complexity behind its apparent innocence.

Her fragrance lingered on.

LUIS CAMNITZER

b. Lübeck, Germany, 1937

Her fragrance lingered on, from the Uruguayan
Torture series, 1983

Four-color photo etching; Sheet: 29½ × 21¹³⁄₁₆ in. (75 × 55 cm);
Image: 9³⁄₁₆ × 11⁹⁄₁₆ in. (23.3 × 29.4 cm); Archer M. Huntington
Museum Fund, 1992; 1992.253.8/35

LUIS CAMNITZER is one of the most sophisti-
cated artists on the international scene analyzing
political issues through Conceptual art practices.
Following his move to New York in 1964 from
his adopted country of Uruguay, Camnitzer
co-founded the New York Graphic Workshop
with Liliana Porter and José Guillermo Castillo.
Much of Camnitzer's career since that time has
focused on a questioning of the print medium
and on a political and ethical analysis of art
and its role in society.

In 1983 he produced one of his most signifi-
cant print series, Uruguayan Torture, in response
to the torture being carried out by Uruguay's mili-
tary government. The series consists of thirty-five
photo etchings that juxtapose photographs of
the artist's own body and various everyday items
with text. The resulting combination is disquiet-
ing and eerie, making allusions to torture without
ever being explicit.

Her fragrance lingered on shows string tied
around the artist's finger, with levels of mean-
ing from physical constraint to electric shock.
Through this elliptical reference, Camnitzer
avoided either the hysterical denunciation or the
preachy didacticism of so much "political" art
in favor of a complicated and nuanced image
that encourages the viewer to explore his or her
own reactions and assumptions.

EUGENIO DITTBORN

b. Santiago de Chile, 1943

Sin rastros (Pintura aeropostale num. 13)
[No Tracks (Airmail Painting No. 13)], 1983

Photo screenprint; 68⅞ × 57⅜ in. (174.9 × 145.7 cm); Archer M.
Huntington Museum Fund, 1991; 1991.85

DURING THE POLITICAL VIOLENCE of the 1970s
and 1980s, many artists in Chile, as in most of
the southern cone countries, chose to produce
highly coded works that hid their political message
so as to escape detection by government censors.
Eugenio Dittborn's response to the Augusto
Pinochet regime was to develop a series of "air-
mail paintings," works that could be folded up
and circulated through the postal service. When
the painting arrived at its exhibition venue, it
was unfolded and displayed alongside the envelope
in which it had been delivered. Thus Dittborn's

work makes transparent, and provides an alterna-
tive to, the normal channels of circulation and
distribution, an issue of particular relevance to
artists working under systems of government
repression and/or outside the American/European
exhibition mainstream.

The portraits that have been transferred
from newspaper photographs in *Sin rastros* make
references to the "disappeared," victims of politi-
cal violence. Memory, a key theme in much of
Dittborn's art, becomes a moral imperative in
an oppressive political climate, and the title here,
which translates as "No Tracks," can be read in
terms of Dittborn's stated intention to "salvage
memory within a political climate that attempted
to erase virtually every trace of it."

Gonzalo Díaz

b. Santiago de Chile, 1947

La lumpérica (tríptico) [La lumpérica (Triptych)], 1988

Paint, photography, silk-screen, photomechanical process, and Mylar on mat board and Masonite; Each of three panels, framed: 27¼ × 36 × 5 in. (69.2 × 91.4 × 12.7 cm); Archer M. Huntington Museum Fund, 1989; 1989.105.1/3–3/3

IN COMMON WITH MUCH Chilean Conceptual art of the 1980s, *La lumpérica (tríptico)* presents a web of hidden and codified meanings, addressing subjects ranging from the complex perceptual issues related to language and syntax, to the more specific repressive political situation under the dictatorship of General Augusto Pinochet. The title of this work comes from a contemporary novel by Diamela Eltit, a feminist experimental writer in Chile, and in this triptych Gonzalo Díaz combined the same concern for progressive politics and avant-garde sensibility that characterizes Eltit's book.

Working outside of the long tradition of political realism in Latin America, Díaz, like his compatriot Eugenio Dittborn, uses some of the devices of international contemporary art (we could think of Robert Rauschenberg's screen-prints, for example) to respond to a distinctly Latin American political situation.

REGINA SILVEIRA

b. Porto Alegre, Brazil, 1939

Masterpieces: In Absentia (M. D.), 1983

Digital image, printed as self-adhesive vinyl cutout, and wood panels; 38 × 166 in. (96.5 × 421.6 cm), variable; Gift of the artist and the Archer M. Huntington Museum Fund, 2000; 2000.92

REGINA SILVEIRA'S WORK uses optical illusions to raise conceptual questions about art history, perception, and memory. In *Masterpieces: In Absentia (M. D.)*, a real stool stands in front of a vinyl cutout representing a dramatic shadow. The shadow follows the outline of the stool, but also includes the shadow-shape of a bicycle wheel, a reference to Marcel Duchamp's famous 1913 "ready-made" sculpture of a bicycle wheel atop a stool. With this work Silveira seems to be suggesting that even though the original object (Duchamp's sculpture) is not physically present, its memory is so strong that it can literally cast a shadow across our perception.

Cildo Meireles

b. Rio de Janeiro, 1948

Missão/Missões [Mission/Missions]
(How to Build Cathedrals), 1987

600,000 coins, 800 communion wafers, 200 cattle bones,
80 paving stones, and black cloth; 11¾ × 11¾ × 8⅝ ft.
(3.6 × 3.6 × 2.6 m), variable; Purchased from the artist with
funds from the Peter Norton Family Foundation, 1998;
1998.76

CILDO MEIRELES HAS GAINED an international reputation for his effective combination of Conceptual art with explicit social and political critiques. In *Missão/Missões (How to Build Cathedrals)*, he makes reference to the seventeenth- and eighteenth-century Jesuit missions in southern Brazil, Paraguay, and northern Argentina. The missions were established as communities to convert the indigenous Tupi-Guaraní people to Catholicism, and many of the Jesuit and Franciscan churches remain among the jewels of Latin American Baroque architecture.

Meireles's evocative contemporary "cathedral" exposes the hidden agenda behind these missions, highlighting in particular the relationship between wealth (600,000 coins on the ground) and agricultural exploitation (two hundred suspended cattle bones), and religion's role in the transformation of one to the other (a column of communion wafers connecting the "land" and the "heavens"). The installation draws attention to the fact that the conquest of the Americas was as much about economics as it was about religion or saving souls.

VÍCTOR GRIPPO

Junín, Argentina, 1936–Buenos Aires, 2002

Esfera (Serie desequilibrios) 1-I [Sphere (Imbalance Series) 1-I], 1993

Glazed wooden box, plaster, and paint; 17 3/8 × 13 1/2 × 4 9/16 in. (44.1 × 34.3 × 11.6 cm); Blanton Museum purchase, 2003; 2003.107

VÍCTOR GRIPPO TRAINED as a chemist, carrying his interest in chemical reactions, elemental properties, and experimental structures into his art. In *Esfera (Serie desequilibrios) 1-I*, the artist explored the notion of disequilibrium. What we see is a sculptural composition consisting of a white cup, broken debris, and two red balls—one solid and one painted on a panel. As if studying a completed scientific experiment, we try to reconstruct the sequence of events and conclude that a suspended red ball apparently fell onto a cup and shattered it.

However, Grippo's work confounds our narrative expectations. Can a weightless, two-dimensional drawing of a ball shatter a real cup? Why is there a second plaster ball, three-dimensional and heavy, unassumingly at rest on the shelf? In its careful combination of objects that oppose and complement each other, this work might resemble a chemical experiment, yet it is wrought with poetic rather than scientific thinking.

Waltercio Caldas

b. Rio de Janeiro, 1946

Velázquez, 1996

Offset printed book, edition of 1,500; Closed: 12⅛ × 10½ × ¾ in. (30.7 × 26.8 × 1.9 cm); Open: 12⅛ × 21¾ in. (30.7 × 55.2 cm); Archer M. Huntington Museum Fund, 2003; 2003.9

IN *VELÁZQUEZ* Waltercio Caldas has subverted the expectations of the art history textbook. By appropriating and altering the well-known and widely reproduced images of the seventeenth-century painter Diego Velázquez, this contemporary Brazilian artist has succeeded in destabilizing the greatest painter of the Spanish School.

To create this work, Caldas produced an immaculate replica of an art history coffee-table book showing Velázquez's famous works, but all the images and text are slightly blurred, and the human figures in the reproduced paintings are absent. A sense of visual frustration and fascination grows as we try, in vain, to decipher the information contained within. The book asks us to consider whose work we are seeing: Velázquez's or Caldas's. The question is heightened by our general belief that an art book is a source of reliable and true information about the history of painting.

FLAVIO GARCIANDÍA

b. Caibarién, Las Villas, Cuba, 1954

Untitled, de la serie El síndrome de Marco Polo
[from The Marco Polo Syndrome series], c. 1986

Acrylic and glitter on canvas; 39 × 51 in. (99.1 × 129.5 cm);
Gift of Fran Magee and Gallery 106, 2002; 2003.83

FLAVIO GARCIANDÍA, who is perhaps one of
the most important Cuban artists of the last
three decades, in 1981 helped organize *Volumen I*
[Volume I], an exhibition in Havana that sparked
a renaissance in contemporary Cuban art.

This painting is from a series called The
Marco Polo Syndrome, which Garciandía exhib-
ited at the 1986 Havana Biennial. In making this
series, he appropriated a popular Cuban comic-
book character, Elpidio Valdés, and took him on
a magical mystery tour through China and the
Far East. The kitschy use of glitter and decorative
elements appropriated from Chinese restaurants
show the artist's growing interest in popular cul-
ture and the aesthetic potential presented by the
tension between high and low art forms. Likewise,
his combination of specifically Cuban elements,
with a concern for defining Cuba's place in the
world, mixed with a sophisticated humor, is
typical of Cuban art.

Many young Cuban artists acknowledge
Garciandía's influence and consider him an
"artist's artist."

ABEL BARROSO

b. Pinar del Rio, Cuba, 1971

Internet de madera [Wooden Internet], 2000

Wood, ink, and paper; 21¹¹/₁₆ × 22 × 15³/₁₆ in. (55.1 × 55.9 × 38.6 cm); Gift of Fran Magee and Gallery 106, 2002; 2003.82

ABEL BARROSO'S WORK uses humor and a low-tech interpretation of modern communications to comment on contemporary Cuban society and politics. Barroso, who trained as a printmaker, constructs his sculptures from used woodblock plates that are themselves made from everyday materials such as plywood packing cases.

In *Internet de madera*, the artist has created a "third world Internet" from carved plywood: a printed scroll serves as a "screen" that the viewer/user can move by manually turning the levers on the side. The consumerist use of the Internet is emphasized, though the series of photographs displayed on the "screen" were taken in the street markets in Cuba, thus conflating the fantasy of e-commerce with the reality of everyday transactions.

This hybrid Internet machine/cash register is full of comical references to the high-tech global world to which Cubans have little access. For example, a credit card (American credit cards are illegal in Cuba) made of wood and carved with the word *fantasía* ("fantasy") and a wooden 3½-inch floppy disk both lie on the keyboard. This eternally unplugged and unconnected Internet machine is a powerful metaphor for Cuba's place in the world and also a critique of the consumerist fantasies of developed societies.

JOSÉ A. TOIRAC

b. Guantánamo, Cuba, 1966

Díptico (En el desierto) [Diptych (In the Desert)], 2000–2001

Oil on canvas; Each of two panels: 37¾ × 51 in. (95.9 × 129.5 cm);
Gift of Fran Magee and Gallery 106, 2002; 2003.85.1/2–2/2

FOR SEVERAL YEARS José Toirac has been investigating and taking apart the meaning of Cuba's official media images. *Díptico (En el desierto)* is based on a newspaper photograph of Fidel Castro taken in the northern Chilean desert in 1970. The large scale of this work and the beautifully painted abstract desert draw attention to the heroic, quasi-religious way that the Cuban leader is routinely portrayed in the country's popular media.

The first panel shows the original image untouched by obvious artistic intervention. But by blurring that precise photo-realism in the second panel, the artist has undermined the apparently stable documentary nature of the image. The work reclaims for painting the ability to produce a less black-and-white version of how history is told.

Feliciano Centurión

San Ignacio, Paraguay, 1962–Buenos Aires, 1996

Soledad [Solitude], c. 1996

Hand-embroidered pillow; 10¼ × 16¹⁵⁄₁₆ in. (26 × 43 cm);
Blanton Museum purchase with funds provided by
Don Mullins, 2004; 2004.178

Until his early death in 1996, Feliciano Centurión was a key figure in the 1990s generation of artists in Buenos Aires. His work is a joyful, almost comic, celebration of kitsch and sentimentality. Its recovery of traditionally feminine activities such as embroidery places Centurión's work within the movement of "light" art that emerged in opposition to the severe Conceptualism or heavy painting characteristic of the 1980s.

Soledad is one of a series of pillows that the artist made when he was in the hospital receiving treatment for a terminal illness. The delicate handwriting of the embroidery radiates vulnerability, making the decorative lace along the edge (a strong tradition in his native Paraguay) all the more poignant and moving. Centurión's work is a poetic meditation on the transitory nature of life, providing a glimpse into the private world of the soul.

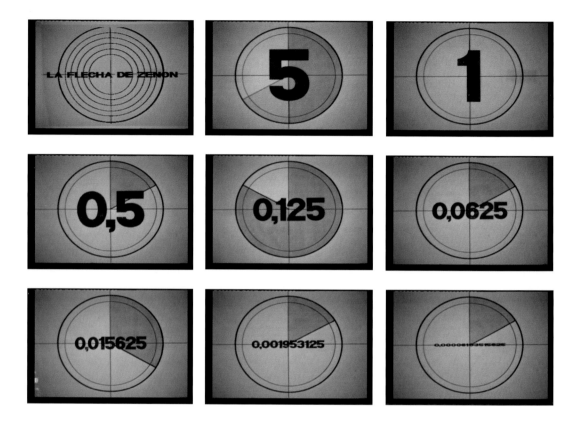

JORGE MACCHI

b. Buenos Aires, 1963

La flecha de Zenón [Xeno's Arrow], 1992

DVD created with David Oubiñas (Argentina), edition of 4; 1 minute, 20 seconds; Blanton Museum purchase, 2003; 2003.91

THE GREEK PHILOSOPHER Xeno of Elea (c. 450 B.C.) stated that an arrow flying toward a target can never logically reach it, because the distance between the moving arrow and the target is always mathematically divisible by two and hence infinite. From a strictly logical point of view, then, time and motion cannot exist. Jorge Macchi and David Oubiñas have taken this ancient paradox and applied it to a modern convention of temporal movement: the countdown before the start of a film.

The DVD starts with a regular countdown, showing numerals changing from 10 to 1. When we would expect the film to start, however, in the moment following the appearance of 1, we see instead 0.5, then 0.25, 0.125, 0.0625, and so on until the number is so long as to be illegible. The anticipated movie never starts as we remain stuck in this eternal, but rigorously logical, time warp. The philosophical humor, formal simplicity, and everyday reference of *La flecha de Zenón* are characteristic of Macchi's sophisticated approach to art.

PABLO SIQUIER

b. Buenos Aires, 1961

Untitled *(0010)*, 2000

Acrylic on canvas; 74¾ × 74¾ in. (189.9 × 189.9 cm); Blanton Museum purchase, 2005; New acquisition

IN THE 1990s a number of artists in Buenos Aires looked back to Argentina's mid-century Constructivist tradition and began to reintroduce abstract forms into the country's largely figurative contemporary art. Pablo Siquier was one of the key figures in this movement. His striking black-and-white abstract compositions suggest architectural spaces, organic structures, and even circuit boards.

Unlike the earlier abstract artists, Siquier seems to encourage multiple readings and connotations in his works by skillfully exploiting the ambiguities of positive and negative space. Works like this untitled painting suggest that abstraction is meaningful in art not as a pure or absolute language, but as the generator of several different, even contradictory interpretations.

JOSEFINA FONTECILLA

b. Santiago de Chile, 1962

Delirios [Delirium], 1998

Brocade fabric; Each of five panels: 66¹⁵⁄₁₆ × 105³⁄₁₆ in. (170 × 270 cm); Gift of the artist, 2005; New acquisition

JOSEFINA FONTECILLA creates objects that invoke a sense of loss and nostalgia. By displaying the effects of time on the ordinary objects that form the backdrop to our lives, she draws our attention to the slow processes of decay that are implicit in life. In *Delirios* the artist used the brocade wall fabrics typical of upper-class Chilean houses at the beginning of the last century. By removing sections of this fabric from a turn-of-the-century home and exhibiting them in a gallery, she evokes in the viewer a sense of nostalgia for the missing house. The darker, ghostlike forms on the panels are a trace of the objects (pictures or mirrors) that once hung on them. These negative forms, created by the bleaching effects of the sun on the uncovered fabric around them, serve as a double memory: the shadow of a vanished object and the record of passing time in this once domestic space.

ÁLVARO OYARZÚN

b. Santiago de Chile, 1960

El autodidacta [The Self-Taught], 1998

Mixed media on paper; Dimensions variable; Gift of the artist, 2005; 2005.5

Since 1987 Álvaro Oyarzún's work has consisted of large installations of accumulated drawings, paintings, and photographs spread over a gallery wall. The subject of his work is his own training as a self-taught artist and his navigation through the complexities of the contemporary art world.

El autodidacta shows us the universe of the artist as a solitary and sometimes arbitrary place, demonstrated by the jumps from different kinds of representation (for example, from botanical illustrations to comic-book drawings). He takes some of his images from the pages of illustrated encyclopedias, while others come from his own imagination. The work covers everything from the tenets of landscape painting to the documentation of large-scale installations, providing a confusing and sometimes overwhelming commentary on the difficulties of being an artist today.

INDEX OF ARTISTS

CONTRIBUTORS

LARRY R. FAULKNER
Faulkner was the 27th president of The University of Texas at Austin, serving from 1998–2006. He oversaw a highly successful capital campaign that raised $1.62 billion. During the campaign, UT constructed several major facilities; completed renovations; significantly increased its collections of art, photography, and historic archival materials; established new academic centers and institutes; and created innovative scholarship programs that helped to strengthen UT's minority student enrollment.

JESSIE OTTO HITE
Director of the Blanton Museum of Art since 1991, Hite has overseen the enormous growth of the museum's collection as well as a major capital campaign, which is nearing its successful conclusion. Her achievements have resulted in the new Blanton Museum of Art. When completed in 2006–2007, the museum complex will be the third largest museum in Texas and the largest university museum in the country.

JONATHAN BOBER
Bober has been the Blanton Museum's curator of prints and drawings since 1987. In that time, the collection has grown by 10,000 works, including 3,500 prints from the collection of Leo Steinberg, to become one of the most important collections on an American campus. With the acquisition of the Suida-Manning Collection in 1998, Bober assumed curatorial responsibility for the museum's European paintings. Largely as a result of that acquisition, the museum became a significant repository of Italian paintings and drawings and of Baroque art generally.

CHERYL SNAY
Snay joined the Blanton Museum as assistant curator of prints and drawings in 2004. She works with Jonathan Bober to oversee the Blanton's large and encyclopedic collection of prints and drawings. Pages 75–79, 92–100, 103–113, and 115–121.

ANNETTE DIMEO CARLOZZI
Curator of American and contemporary art at the Blanton Museum since 1996, Carlozzi presides over a collection that traces the history of artistic achievement in the United States from the mid-nineteenth century to the present day, with particular breadth in painting. During her tenure, the Blanton has built a dynamic collection of contemporary art in all media by a culturally diverse group of emerging and established artists.

GABRIEL PÉREZ-BARREIRO
Pérez-Barreiro, the Blanton Museum's curator of Latin American art, came to the museum in 2002. The Blanton's Latin American art collection is one of the oldest, largest, and most comprehensive in the country, and includes works by many artists not represented elsewhere in U.S. collections. The collection is particularly strong in Mexican graphics of the early 20th century and post-1970 paintings and drawings from South America, and has grown substantially in size and reputation under Pérez-Barreiro's leadership.